PINUPS PAST & PRESENT

Introduction by Nathalie Rattner

Brimming with creative inspiration, how-to projects, and useful
information to enrich your everyday life, Quarto Knows is a favorite
destination for those pursuing their interests and passions. Visit our
site and dig deeper with our books into your area of interest:
Quarto Creates, Quarto Cooks, Quarto Homes, Quarto Lives,
Quarto Drives, Quarto Explores, Quarto Gifts, or Quarto Kids.

First published in the USA in 2018 by Chartwell Books, an imprint of The Quarto Group,
142 West 36th Street, 4th Floor, New York, NY 10018, USA
T (212) 779-4972 F (212) 779-6058 www.QuartoKnows.com

Published under license from Graffito Books Ltd, 2018
www.graffitobooks.com

Chartwell Books titles are also available at discount for retail, wholesale, promotional, and bulk purchase. For details,
contact the Special Sales Manager by email at specialsales@quarto.com or by mail at The Quarto Group, Attn: Special
Sales Manager, 401 Second Avenue North, Suite 310, Minneapolis, MN 55401, USA.

10 9 8 7 6 5 4 3 2 1

ISBN: 978-0-7858-3670-4

Research Editor: Lucy Radford-Earle
Art Director: Karen Wilks

Printed in China

PINUPS PAST & PRESENT

Introduction by Nathalie Rattner

CHARTWELL
BOOKS

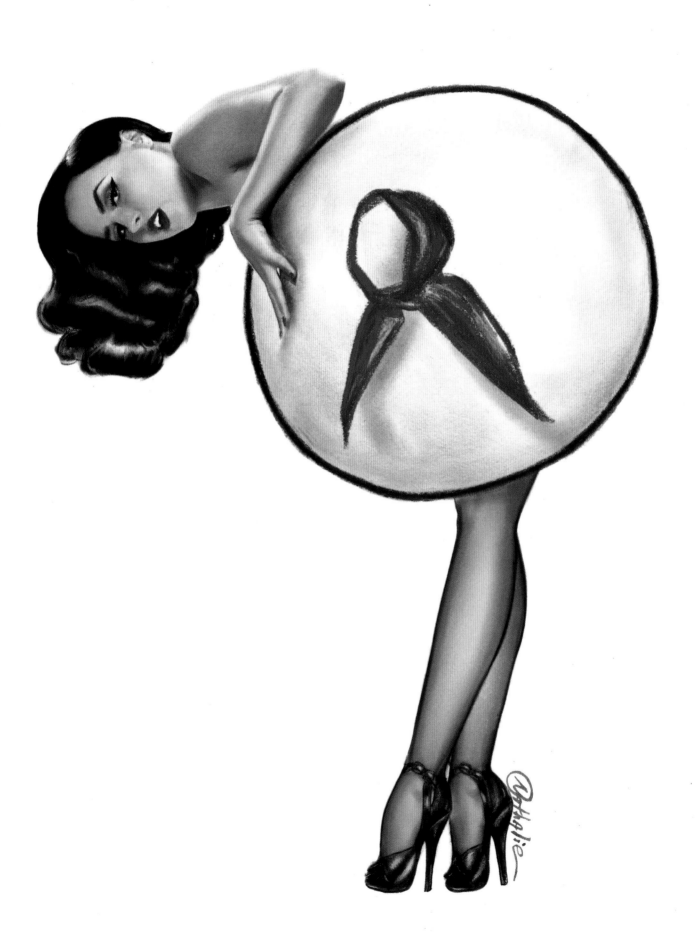

Contents

LEFT: Hats Off To You
Nathalie Rattner

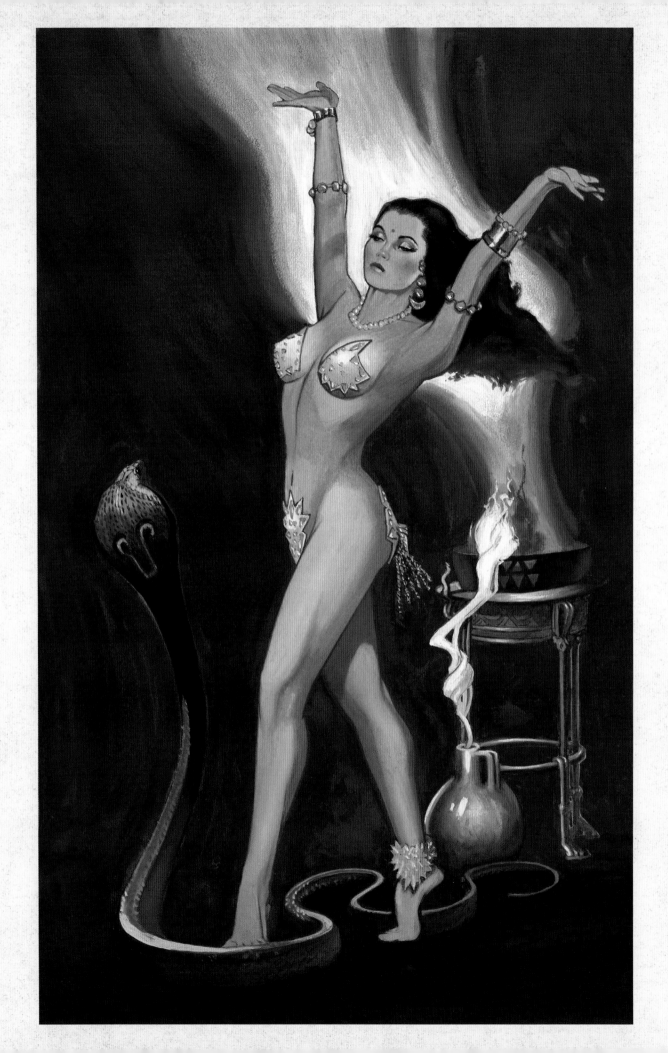

Introduction

Pinup art is a little slice of fun and beauty in which to get lost. It can be sexy, sultry or cheeky, but its essential quality is that it leaves something to the imagination. Its subjects of course celebrate their sensuality and sexuality, and pinup models are in addition powerful, confident and dignified. They celebrate life. They are more often than not well-rounded characters, who represent many facets of what it is to be a woman. And for the viewer they are not only a source of pleasure; many fans have told me that pinups have given them a welcome escape in times of struggle in their lives.

For an artist, the creation of a pinup piece can be a joyous journey, a long and involved puzzle, or a rollercoaster ride where the artwork takes on a life of its own. Sometimes the core idea hits you like a lightning bolt, fully formed, and then it's a race to get the image from brain to paper before it fades away. Other times the idea evolves gradually, taking its time. Every artist has a different way of working. I like to do rough test pieces to iron out the kinks before painting the final piece. Sometimes I use live models, who come into the studio to pose in various figure studies. At other times I create an imaginary girl from scratch. Both are equally enjoyable.

There's no typical path to becoming an artist, but what every artist needs initially is inspiration. That's where *Pinups Past and Present* comes into play. Here you'll find a great variety of genres, each reflecting the era in which they were created. It's also the case that really classic genre styles, like pinups from the 1940s, '50s and '60s, can still be reinterpreted for artworks created today in a deliberately retro style. Take Jim Silke. His work seems to be straight out of the 1950s. Yet he was the Executive Art Director at Capitol Records, before, in 1991, aged 60, he started creating graphic novels. It was fans of his graphic novels who began to seek out his paintings of pinups, and thus a third career, that of a pinup artist, emerged. For me the catalyst was working with Claire Sinclair, the *Playboy* Playmate of the Year, 2011. Not only is she a brilliant model – fun, confident, totally at ease with her body, and full of inner, positive, outgoing energy – she also gave me the confidence to know that I was on the right path artistically. So, each artist has a unique story, but the thing I think they all have in common is that they push forward, they persevere and never give up until they have achieved their goals.

Certain pinups have become iconic, and the subjects of many different artists' attentions. It really is a case of what the French call *je ne sais quoi*. Think of Bettie Page, Marilyn Monroe or Dita Von Teese. They all have that 'elusive' quality but in such different forms. Yet they also have an enduring ability to form a deep bond with their audience. It is because they are complex and rounded, combining many qualities such as strength, intelligence, class, sass, vulnerability and wit into one beautiful package, that they resonate with fans across many generations.

My tip for any aspiring artist is: Do it! Put pencil, pen, watercolor and whatever else you have to paper and start creating. Don't get caught up in the idea of fame. Seek inspiration. But first and foremost, the world needs more beauty in it, so get out there and add what you can.

Nathalie Rattner,
Calgary, Canada.

LEFT: The Lost World
Jim Silke

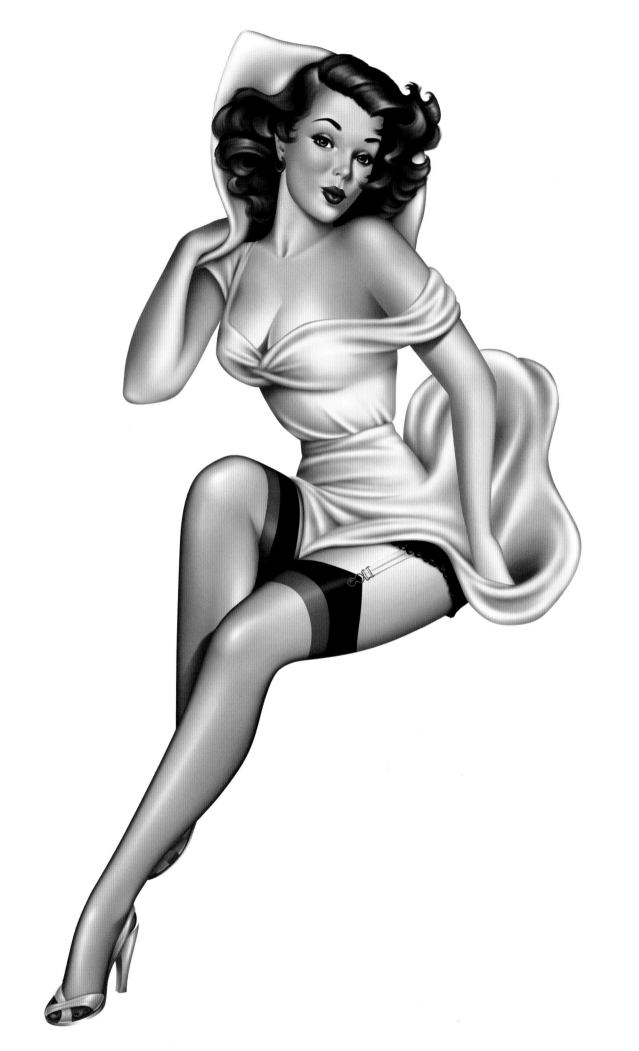

Classic American Pinup

The classic American pinup can be traced back to US illustrator Charles Dana Gibson's turn-of-the-century depictions of the 'New Woman'. The Gibson Girls represented a new social and sexual independence for women – they had a hold over men, they were deeply attractive and sported tiny waists with ample bosoms and derrieres. Then, during the Jazz Age of the Roaring Twenties, art deco depictions of good-time-girls appeared on the covers of magazines like *Film Fun* and *Tattle Tales*, and artists including Enoch Bolles and Rolf Armstrong pushed boundaries of decency with their scantily-clad strumpets. During the Depression muted female styles were back in vogue, but as the USA bounced back in the '30s, men's magazine *Esquire* did the great service of bringing us George Petty's iconic 1930's Petty Girls and Alberto Vargas' 1940's Vargas girls. These were divine, perfectly-proportioned goddesses but also cheeky, sweet and all-American – just the sort you'd like to pin up on your wall – and in 1941, the word 'pin-up' was born. These girls, along with Gil Elvgren's (who is generally considered the best artist of the type) were so well-loved they were famously used as 'nose art' good luck charms on B52 bombers during the Second World War, to remind the USAF what they had to look forward to back home. It wasn't until the liberated, nude-friendly 1960s that these classy pinups lost their illicit thrill and magazines like *Playboy* turned them into raunchier dames.

An innocent attitude is key when looking for a classic American pinup. As one great contemporary artist in this style, Fiona Stephenson, says, "I don't consider it pin-up if the girls are overtly sexual; pin-up is cheeky and not cynical. The girls are not crude or sleazy but accidentally show a bit of leg or cleavage." This has to be the ultimate classic American pinup convention: the pout of surprise as a shapely, stocking-clad thigh is so unfortunately revealed to the viewer by a mischievous dog or misplaced wind-up toy. Classic artists like Art Frahm took this one step further and had a hilarious but brilliant series of 'falling panties' images, featuring an understandably startled pinup.

LEFT: Rose
Michael Landefeld

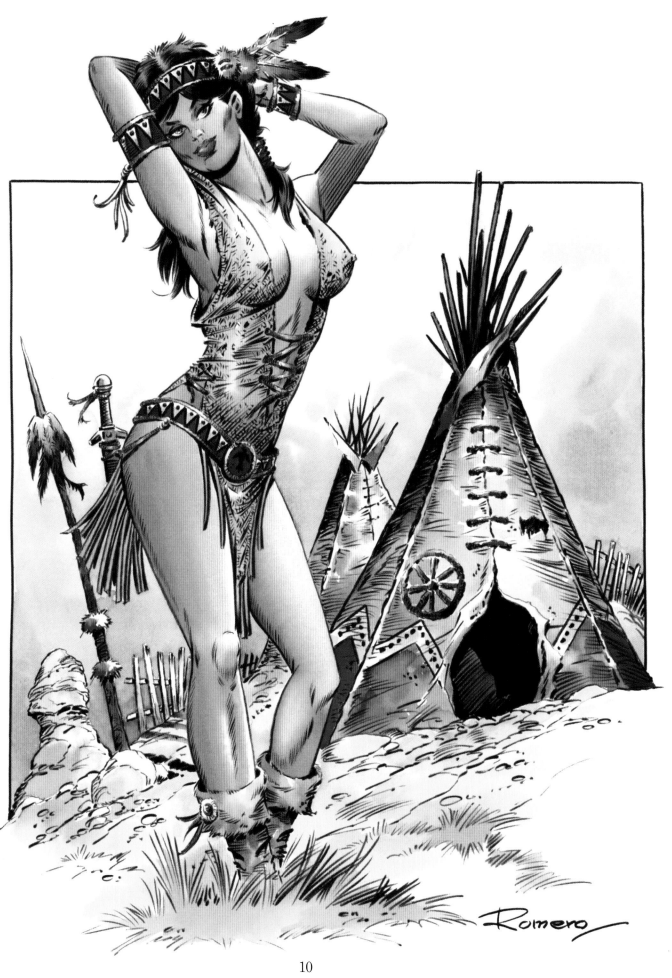

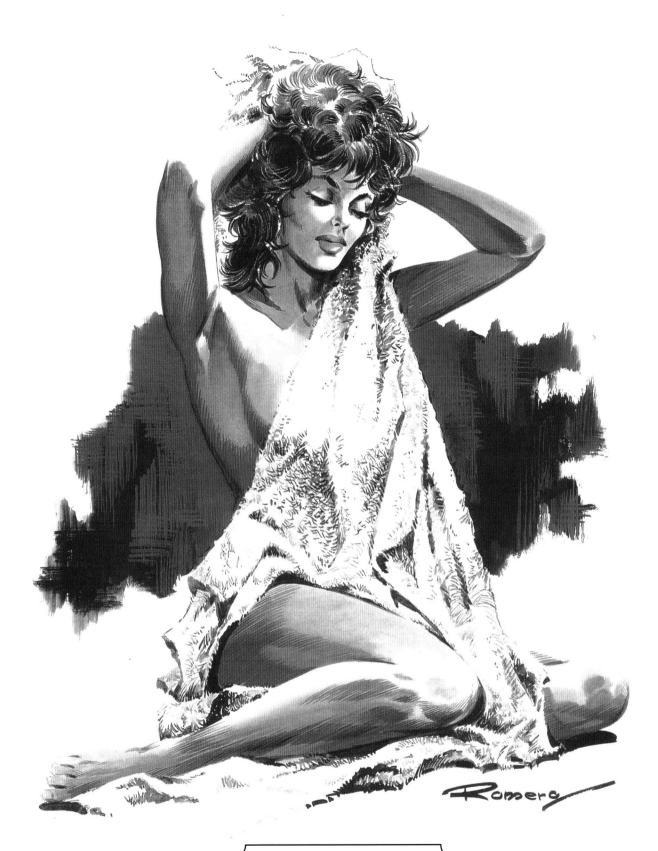

LEFT: Red Skin Pacifies
Enric Badia Romero

ABOVE: After the Bath
Enric Badia Romero

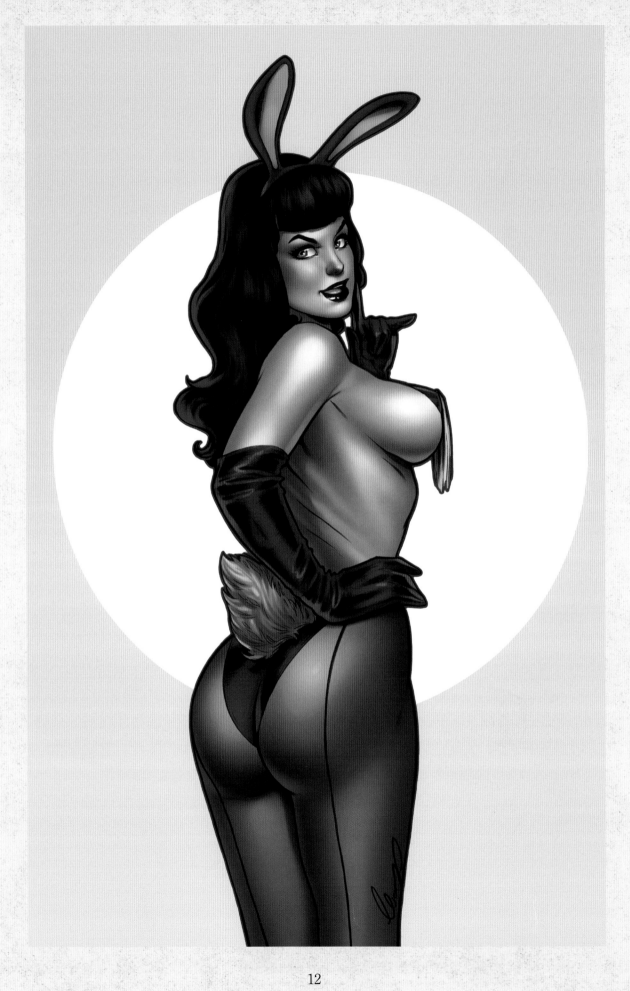

12

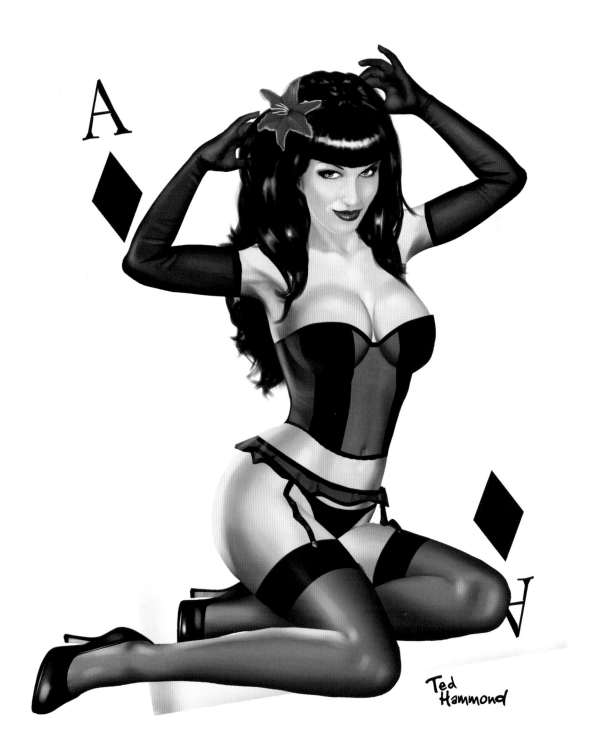

A

LEFT: Bettie Bunny
Elias Chatzoudis

ABOVE: Ace of Diamonds
Ted Hammond

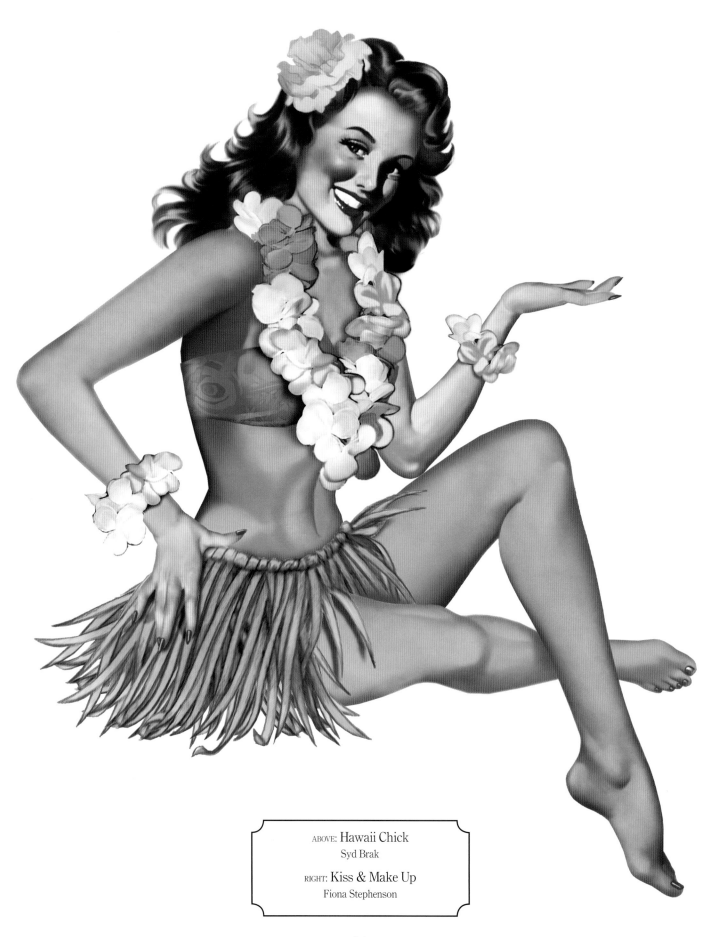

ABOVE: Hawaii Chick
Syd Brak

RIGHT: Kiss & Make Up
Fiona Stephenson

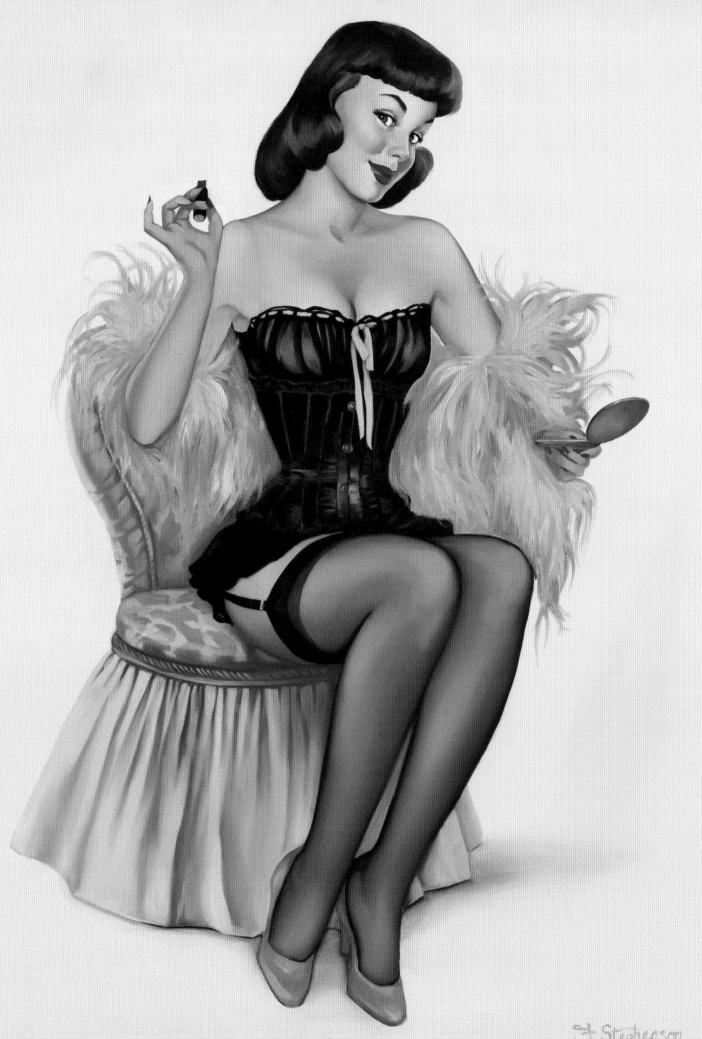

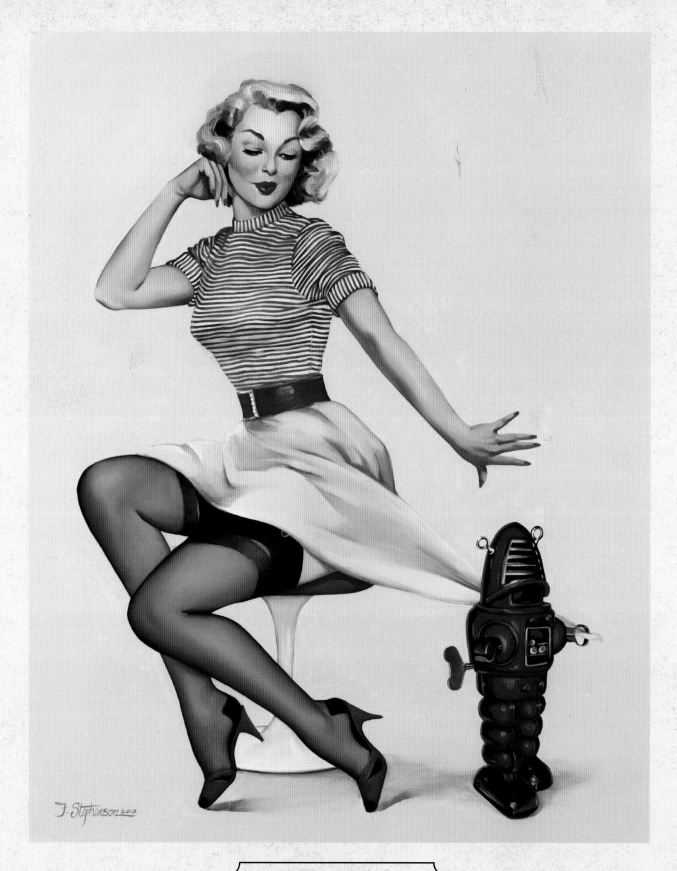

ABOVE: All Wound Up
Fiona Stephenson

RIGHT: Moon Rocket
Fiona Stephenson

16

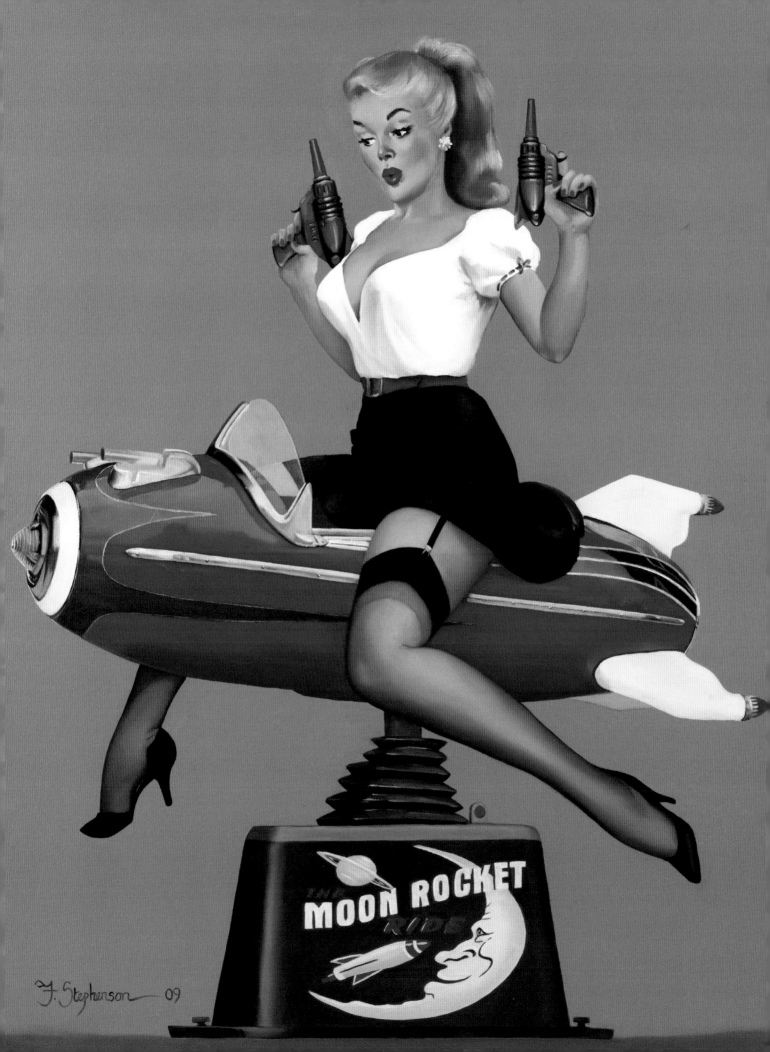

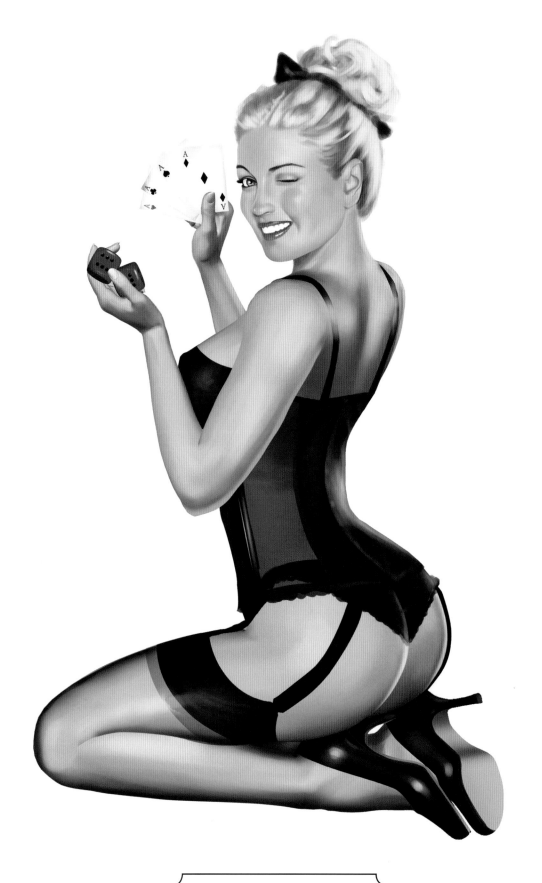

ABOVE: Wink
Ted Hammond

RIGHT: It's Fur Yoo-Hoo!
Fiona Stephenson

18

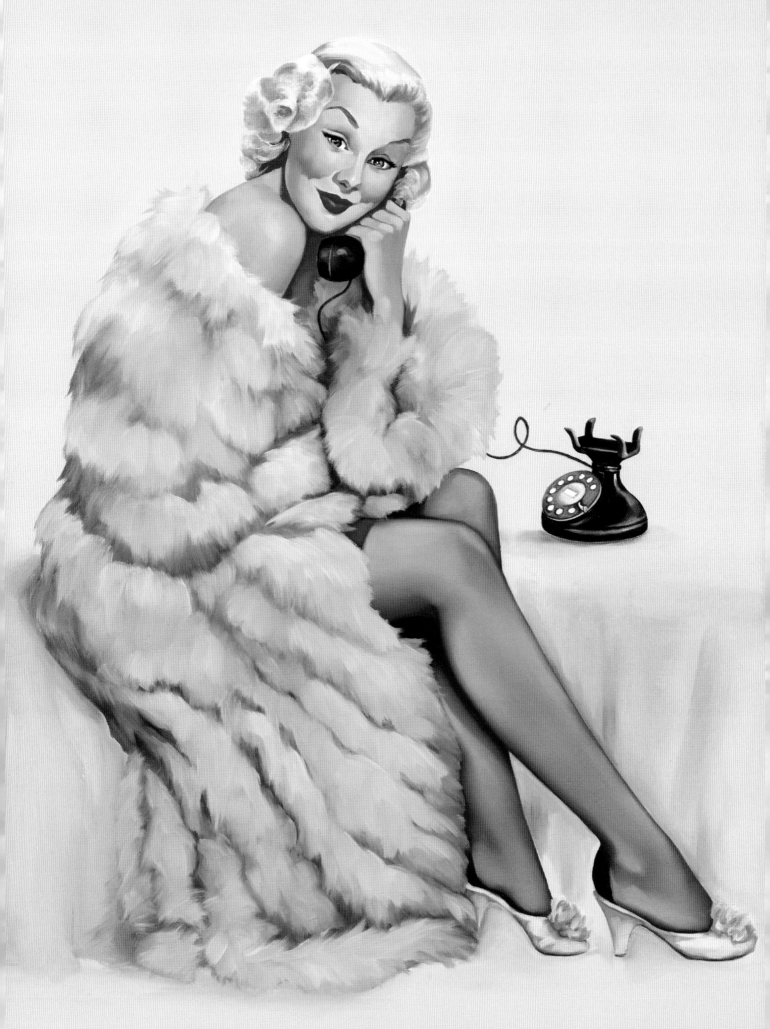

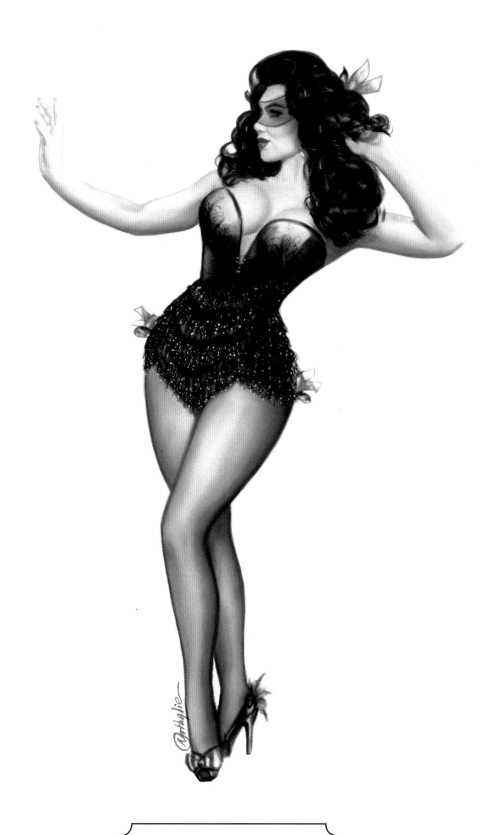

ABOVE: De-Lovely
Nathalie Rattner

RIGHT: It's a Cinch
Nathalie Rattner

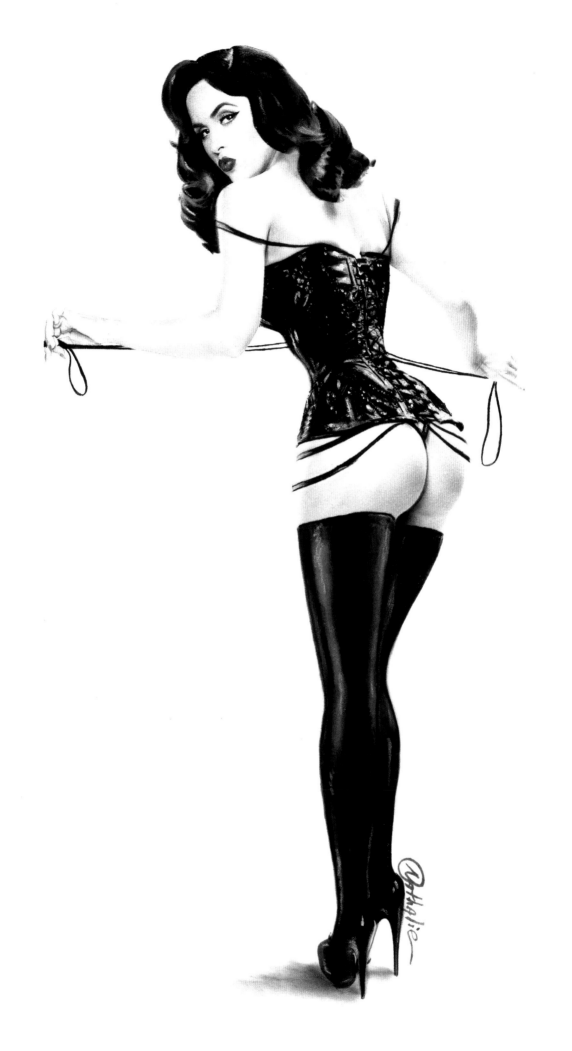

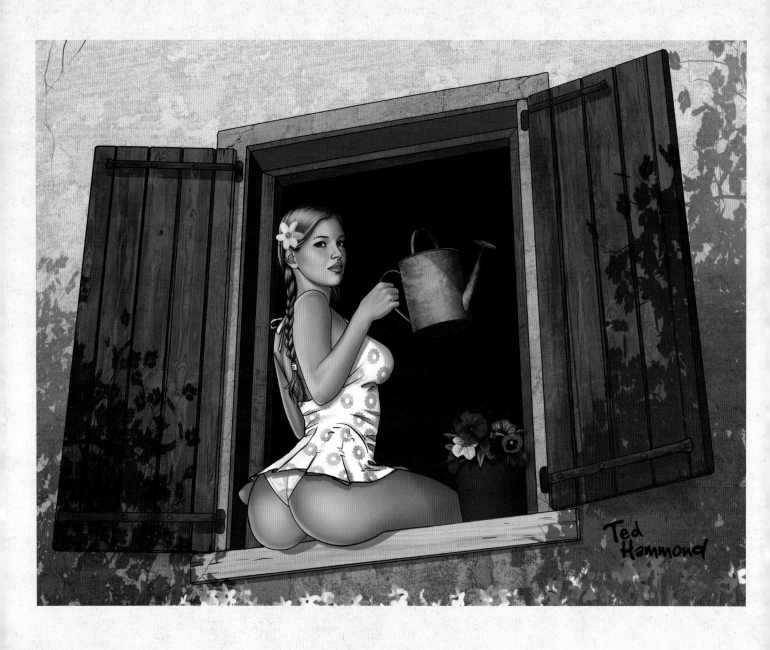

ABOVE: **Farmer's Daughter**
Ted Hammond

RIGHT: **A Revealing Yarn**
Fiona Stephenson

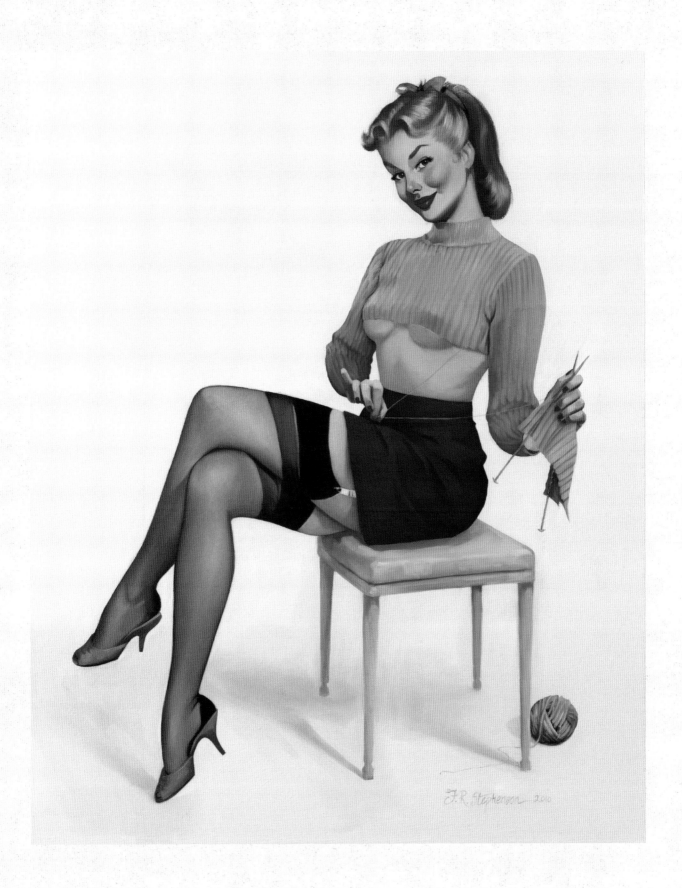

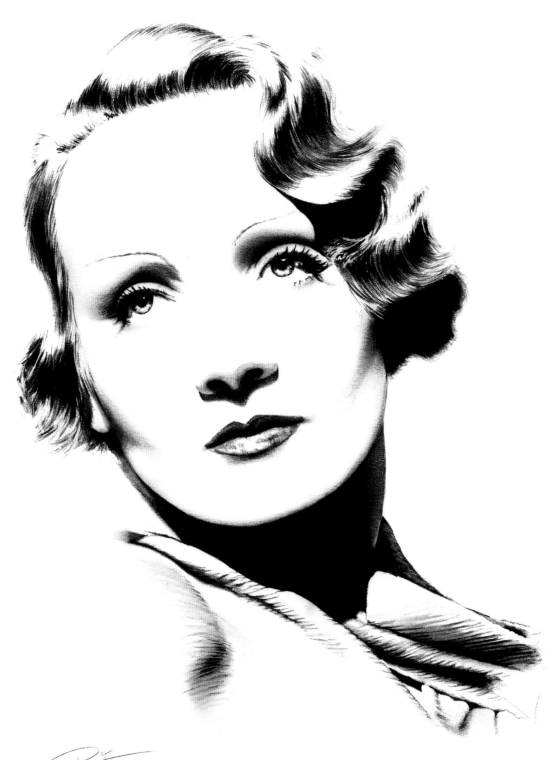

ABOVE: Marlene Dietrich
Dirk Richter

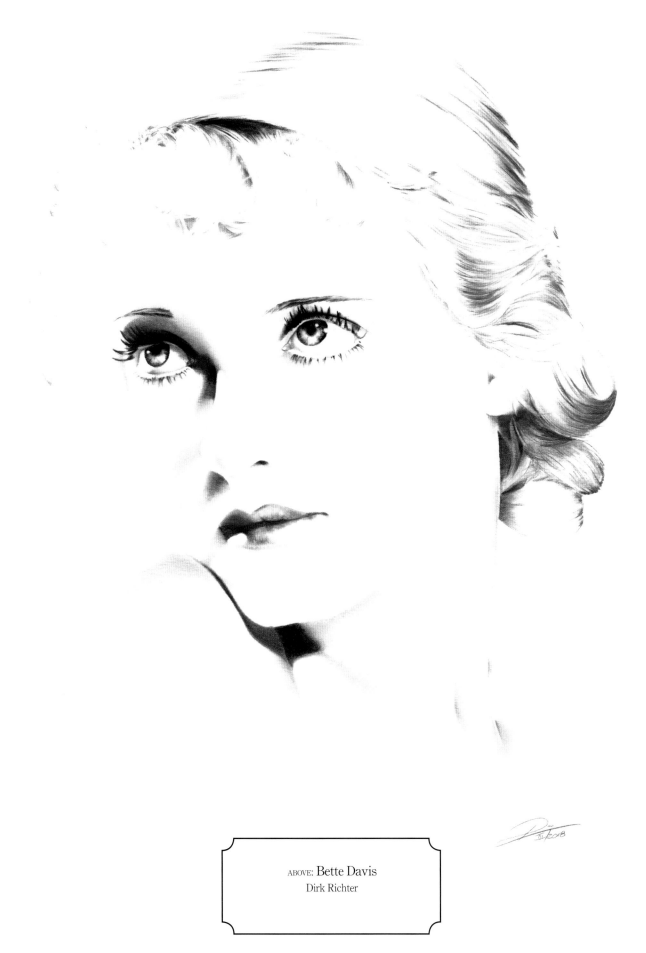

ABOVE: Bette Davis
Dirk Richter

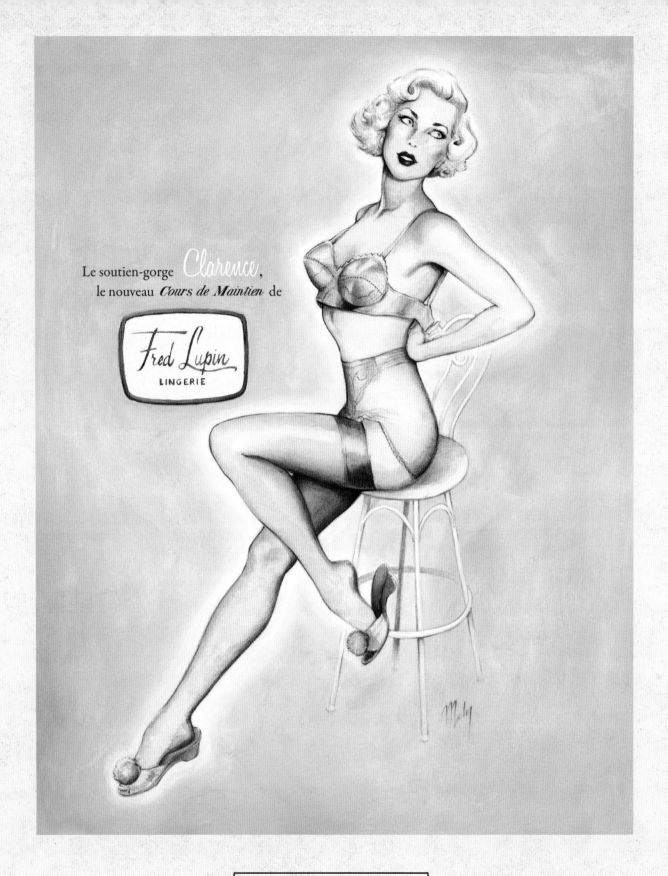

Le soutien-gorge *Clarence*,
le nouveau *Cours de Maintien* de

Fred Lupin
LINGERIE

ABOVE: Clarence
Siri

RIGHT: Bernie Dexter
Siri

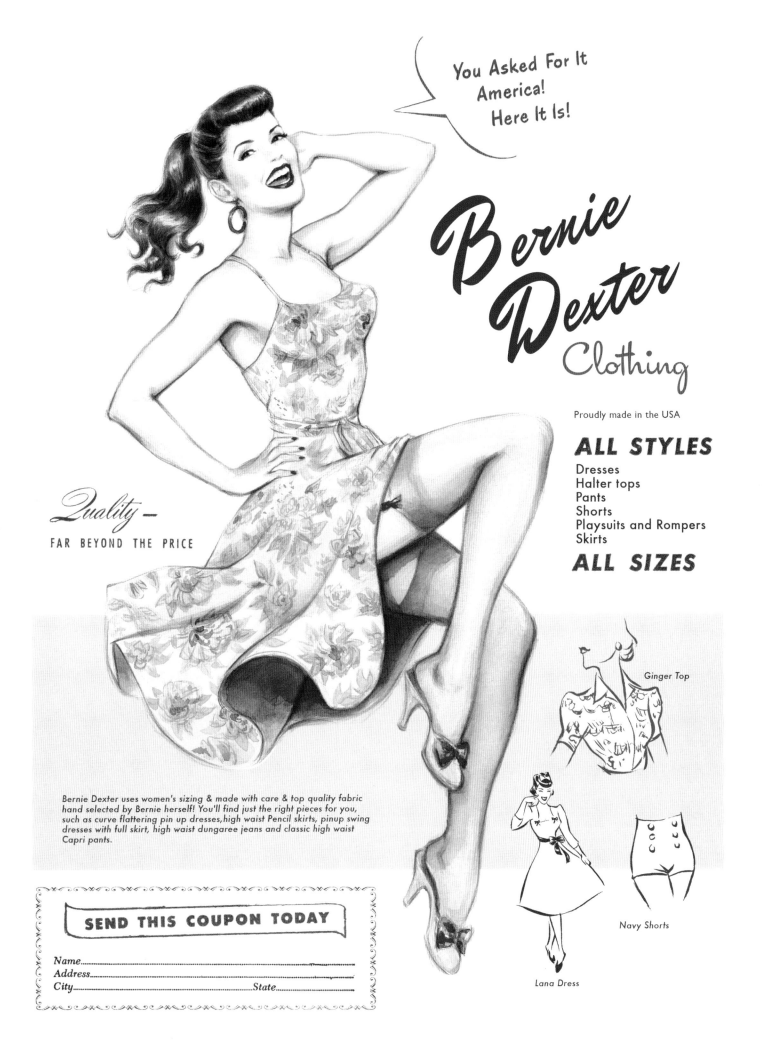

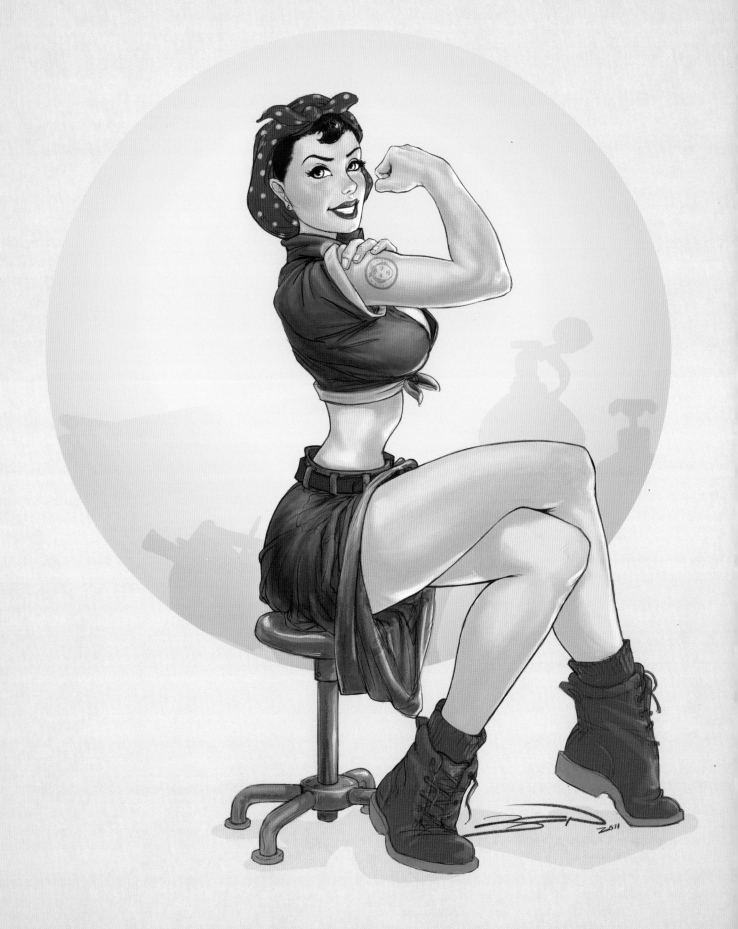

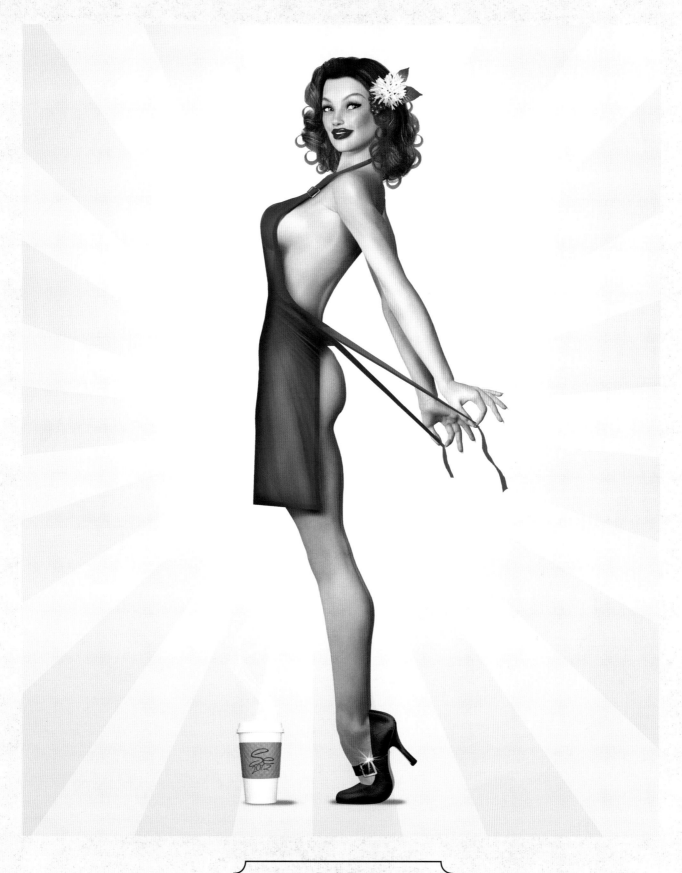

LEFT: Rosie Brunette
Ben Tan

ABOVE: Double Tall Xtra Hot
Sean Earley

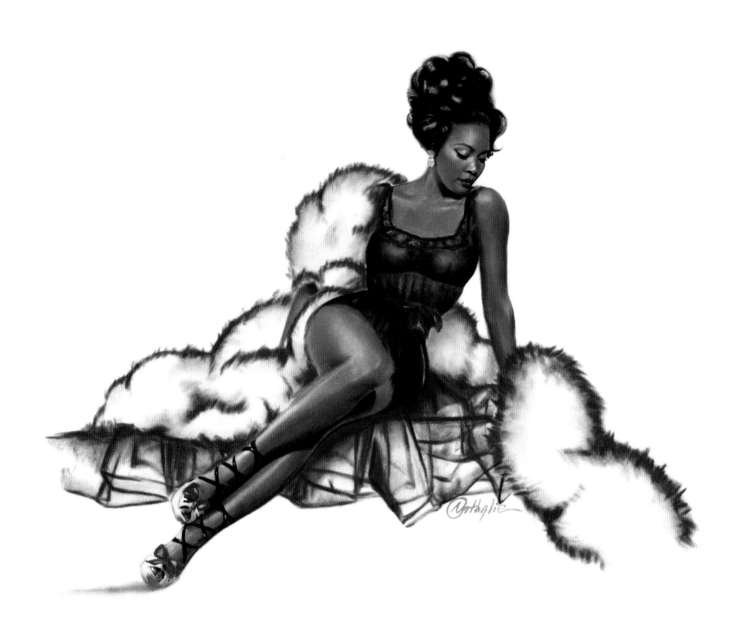

ABOVE: Pure Elegance
Nathalie Rattner

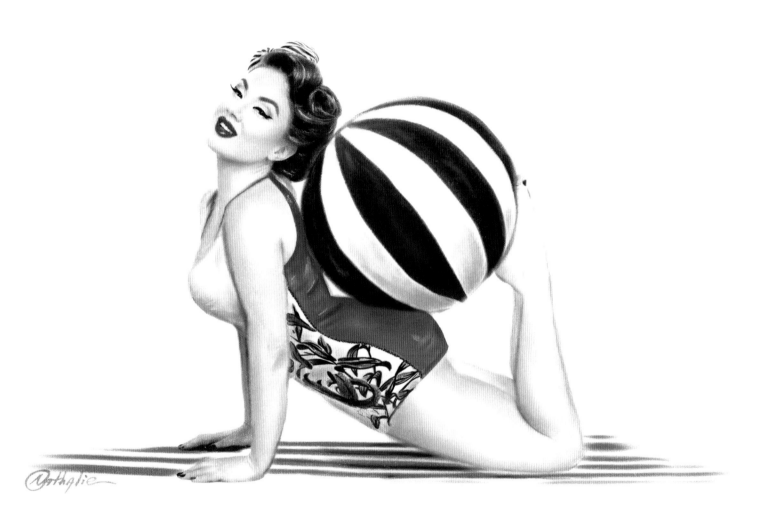

ABOVE: Beach Time
Nathalie Rattner

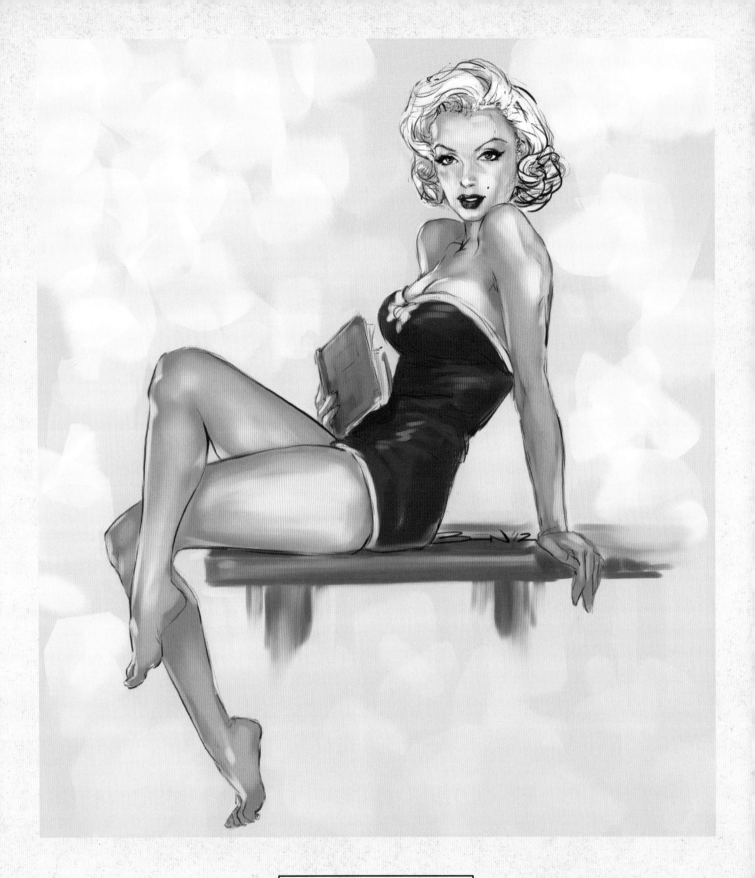

ABOVE: Marilyn
Ben Tan

RIGHT: Red
Ben Tan

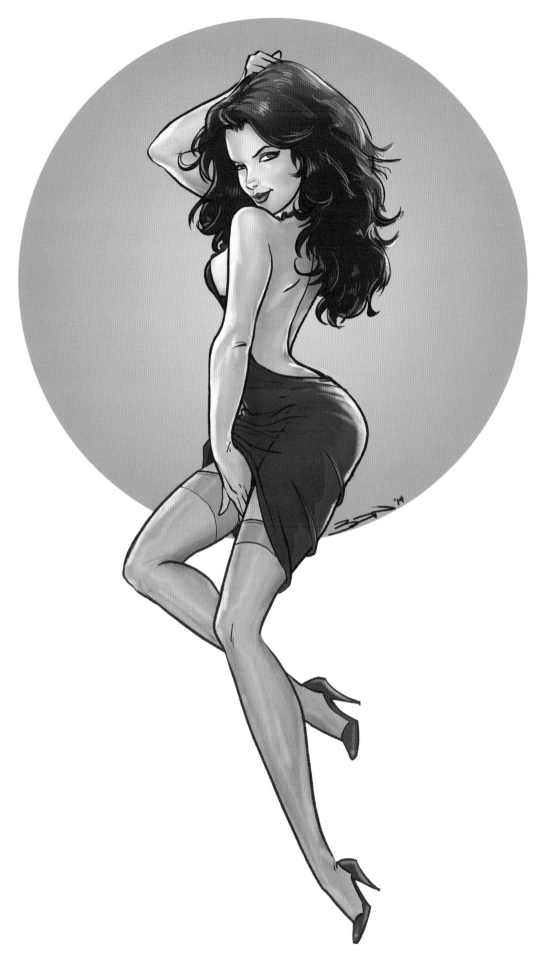

33

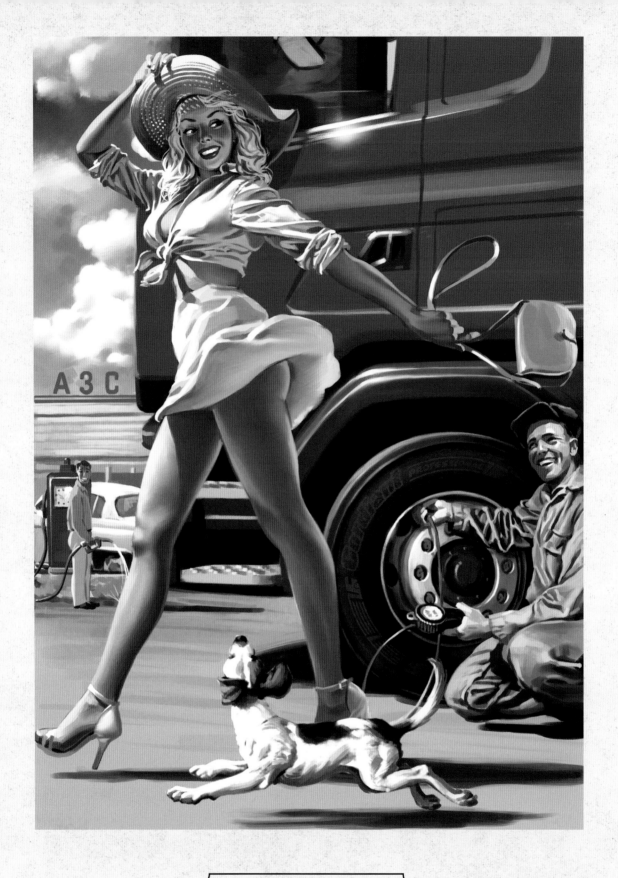

ABOVE: Nice and Firm
Valery Barykin

RIGHT: Rosie Blond
Ben Tan

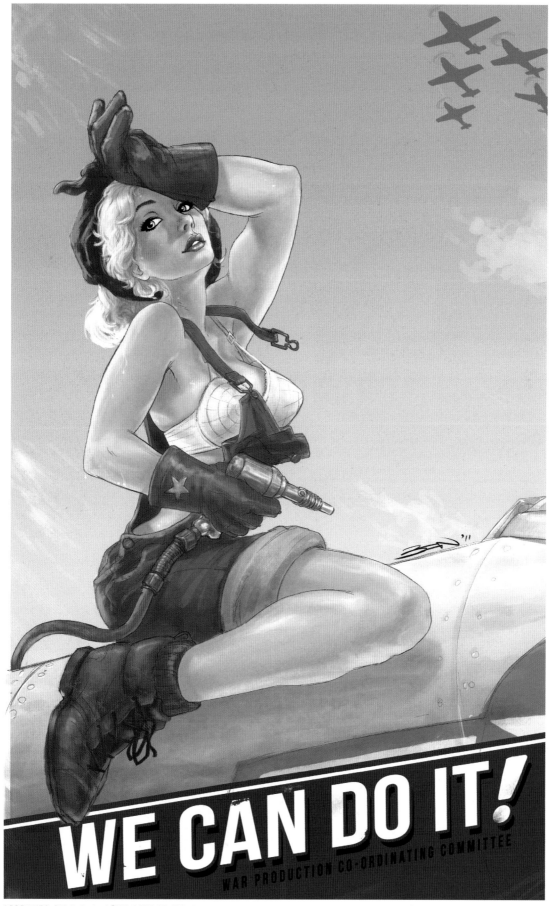

WE CAN DO IT!
WAR PRODUCTION CO-ORDINATING COMMITTEE

APPROVED BY U. S. A. ARMY CENSOR NO. 21

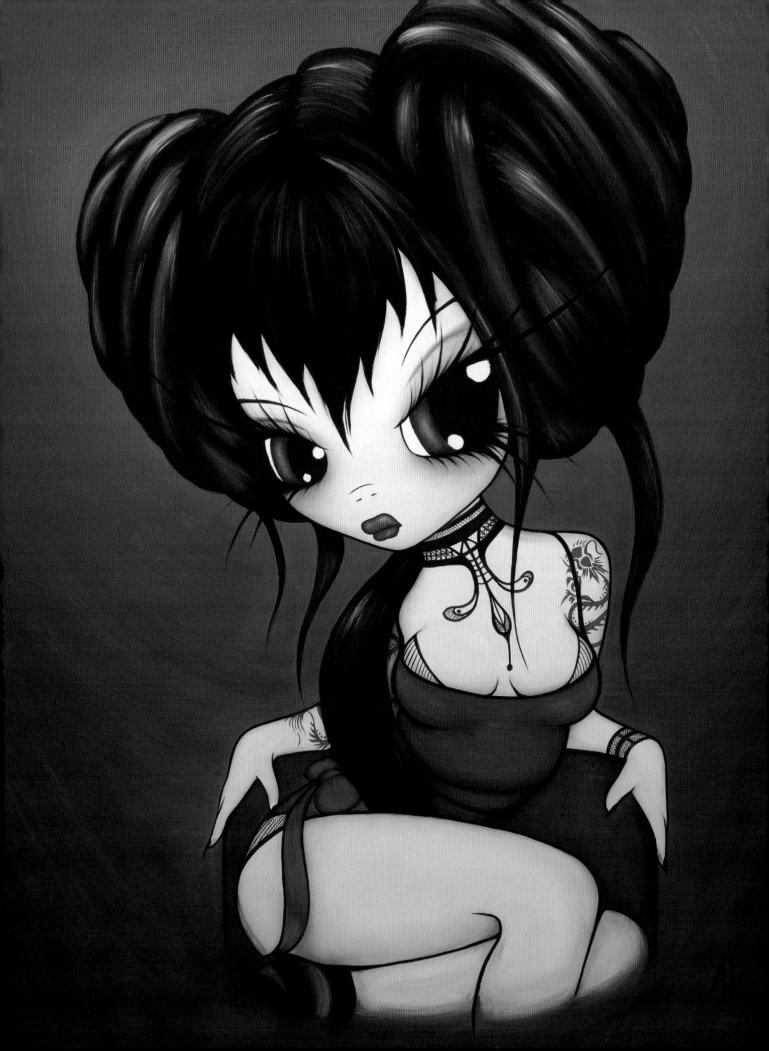

Cartoon & Comic

The original cartoon-style pinup was the lovely Betty Boop. Betty came along in sombre 1930, with her baby-like huge head and eyes and a sultry, mature body. She was totally radical, innocent but also sexy, and got the ball rolling as a cartoon coquette. The first leading female cartoon character to have more than just a bow and shapeless frock to show her gender, she was given fantastic cleavage, flapper dresses, stockings, garters and high heels.

Off the back of the widespread popularity of Betty, a new type of attractive comic-strip minx started to appear in 1930s newspapers. Popular examples were Milton Caniff's Dragon Lady and Burma in his comic strip *Terry and the Pirates* and Alex Raymond's girls in his comic strip *Flash Gordon*. These gave way to raunchier comic creations in the 1940s like Bill Ward's famous Torchy, and cartoon styles became used for illicit erotic underground comix like the *Tijuana Bibles* (which were certainly not subject to the restrictive and pious Comics Code in force at the time). 1950s *Playboy* artists like the great Jack Cole realised that the simplicity of a watercolour cartoon allowed for a humorous yet sexy image with a risqué subtext. By the 1970s and 1980s the need for censorship had gone, but a respect for the minimalism and clean lines of earlier eras – particularly the art deco years – inspired the simple, stylish pop art pinups of Patrick Nagel.

From these beginnings came the range of cartoon and comic pinup styles that are still evolving today. The archetypal big-eyed, suggestive-but-naïve Japanese anime girl has its roots in none other than American Betty Boop cartoons. Classic Disney cartoons of the 1930s onwards also paved the way for the much more recent, digital trend of 3D rendered pinups, in the style of Disney's later Pixar works. As the artist Andrew Hickinbottom explains, "Not many people do pinups in 3D, especially cartoony ones. I like to vary my styles and give my characters as much life, personality and appeal as I can. I try to capture the essence of 2D pinup illustration in a 3D form."

LEFT: Masuimi
Anarkitty

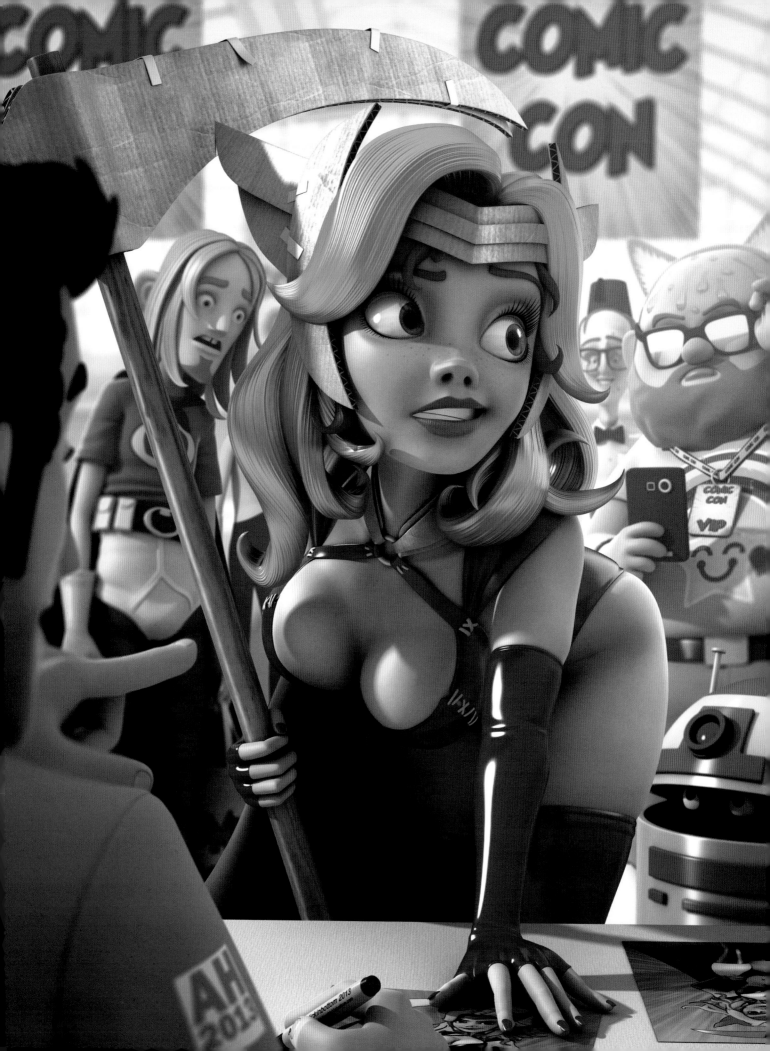

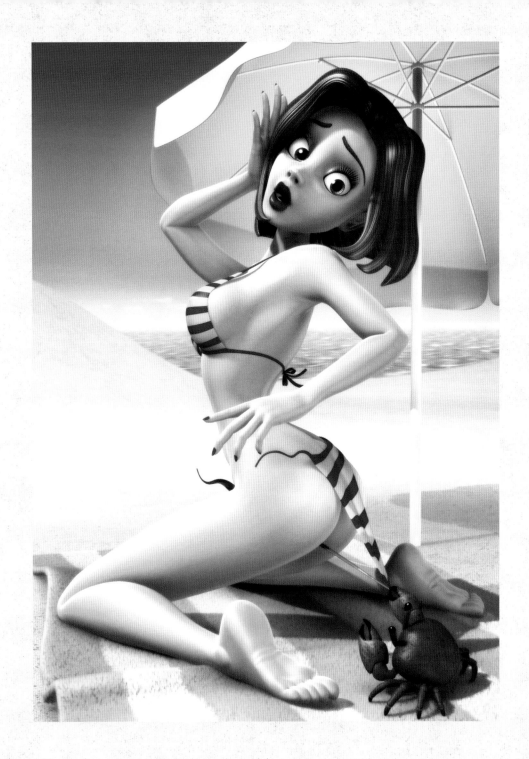

LEFT: Comic-Con Curves
Andrew Hickinbottom

ABOVE: Suzie and the Lil Nipper
Andrew Hickinbottom

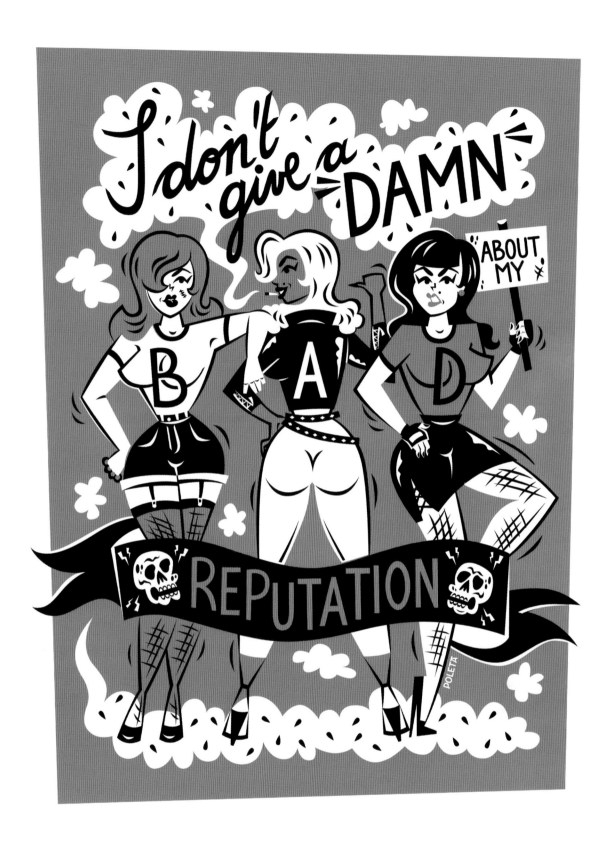

ABOVE: Bad Reputation
Poleta
RIGHT: Bang! You're Dead
Mike Mahle

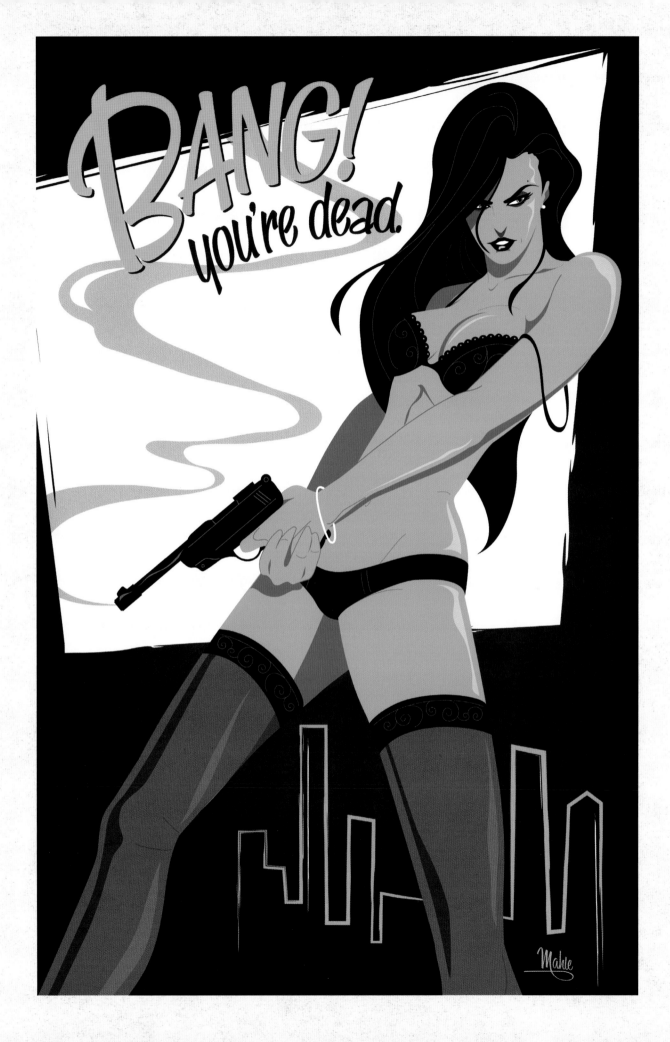

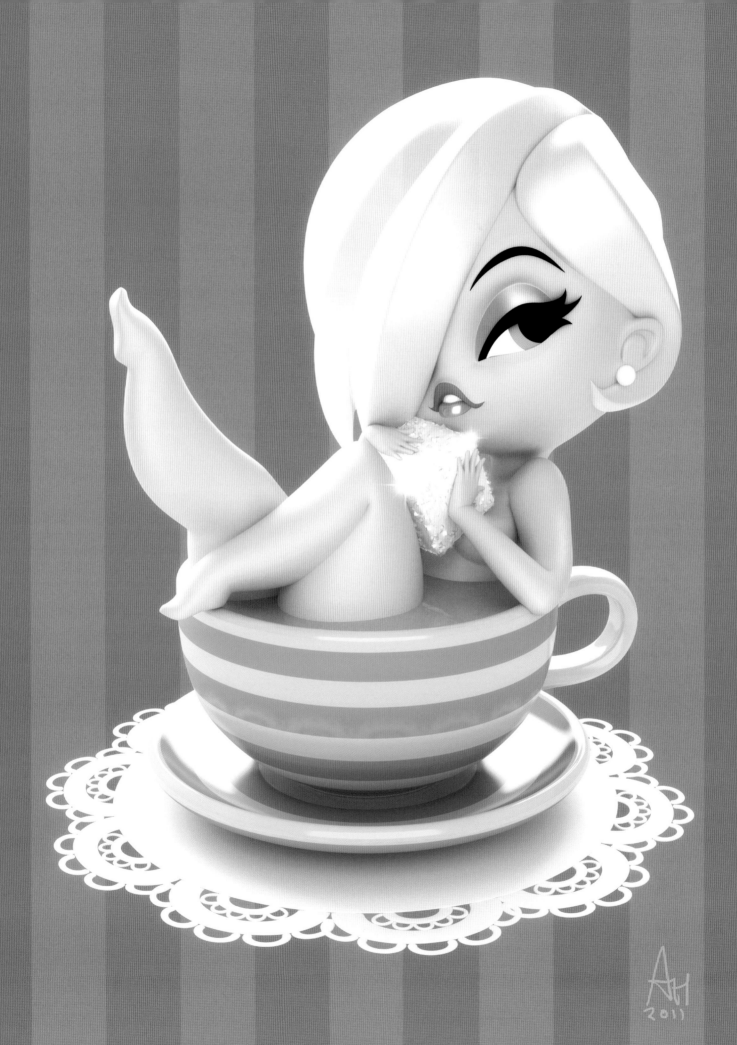

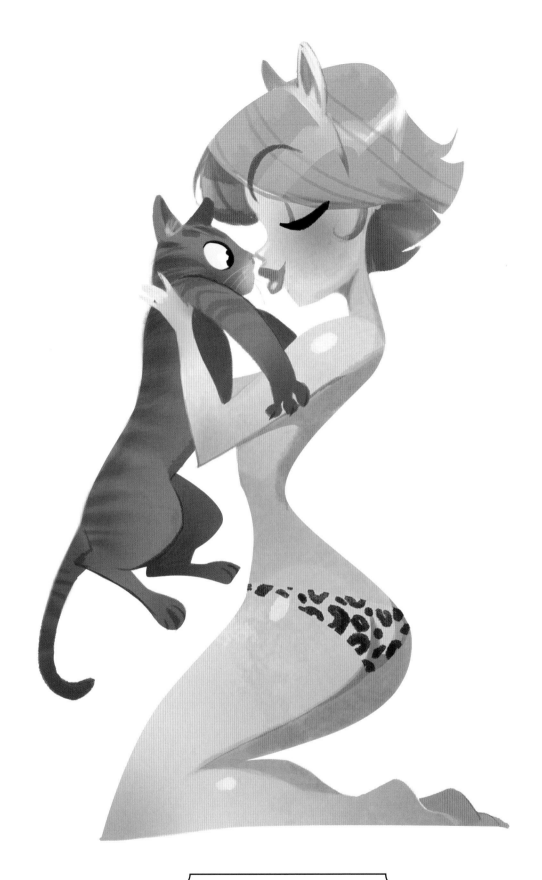

LEFT: One Lump or Two
Andrew Hickinbottom

ABOVE: Kitty Cat
Guillaume Poux

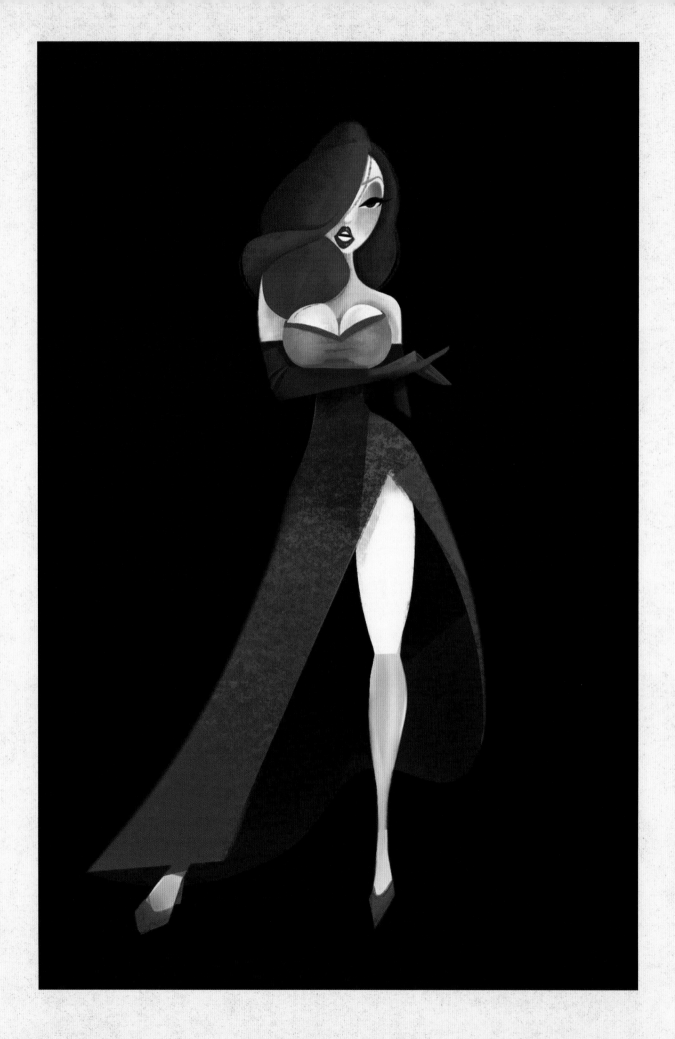

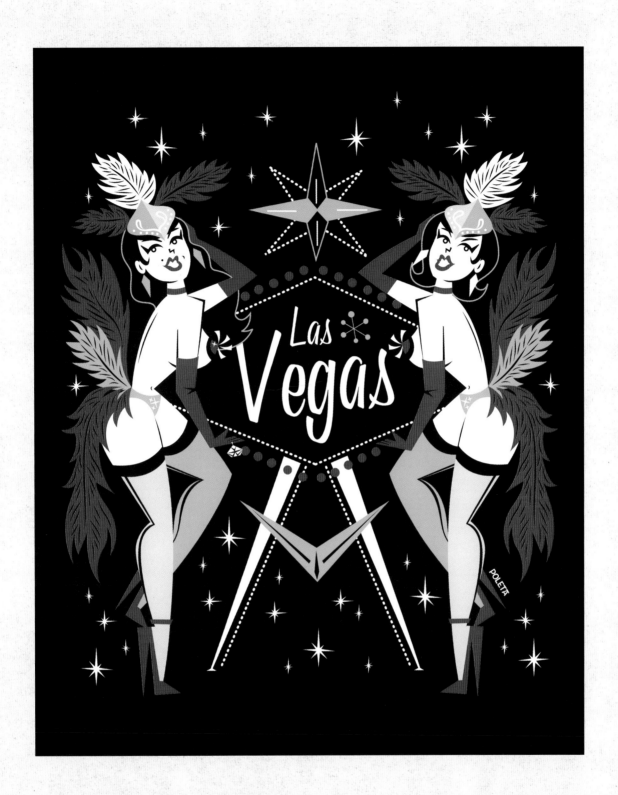

LEFT: Jessica
Zach Gracia

ABOVE: Showgirls
Poleta

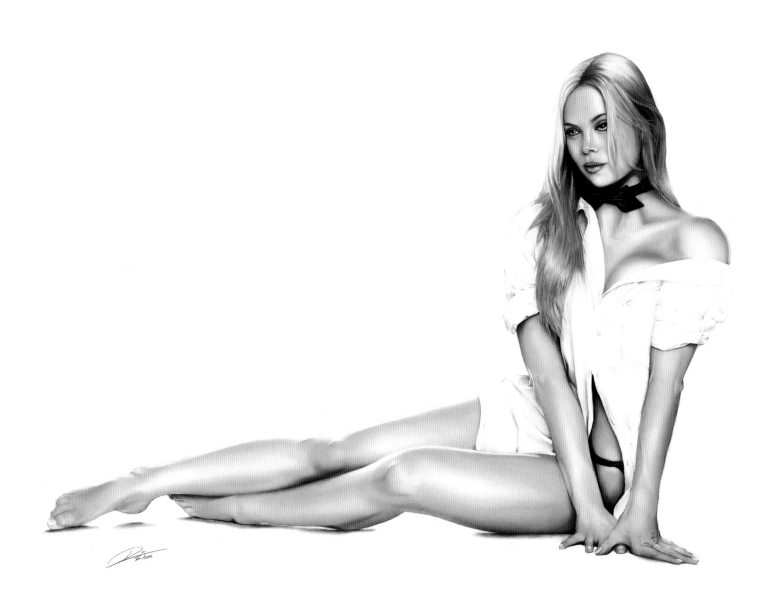

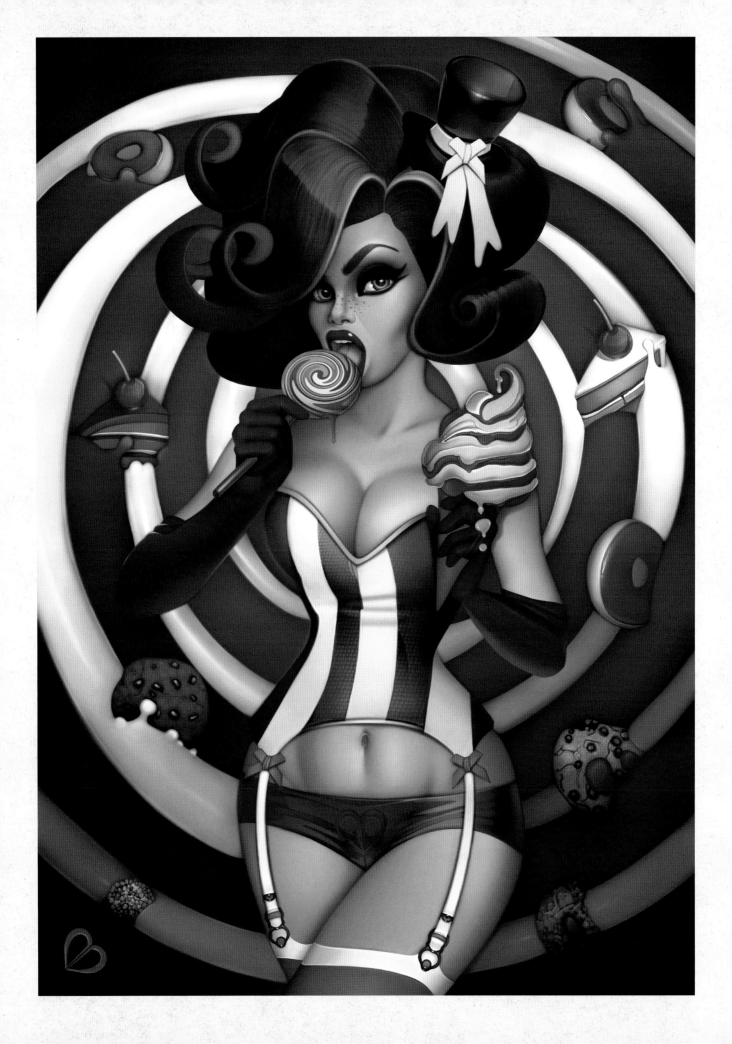

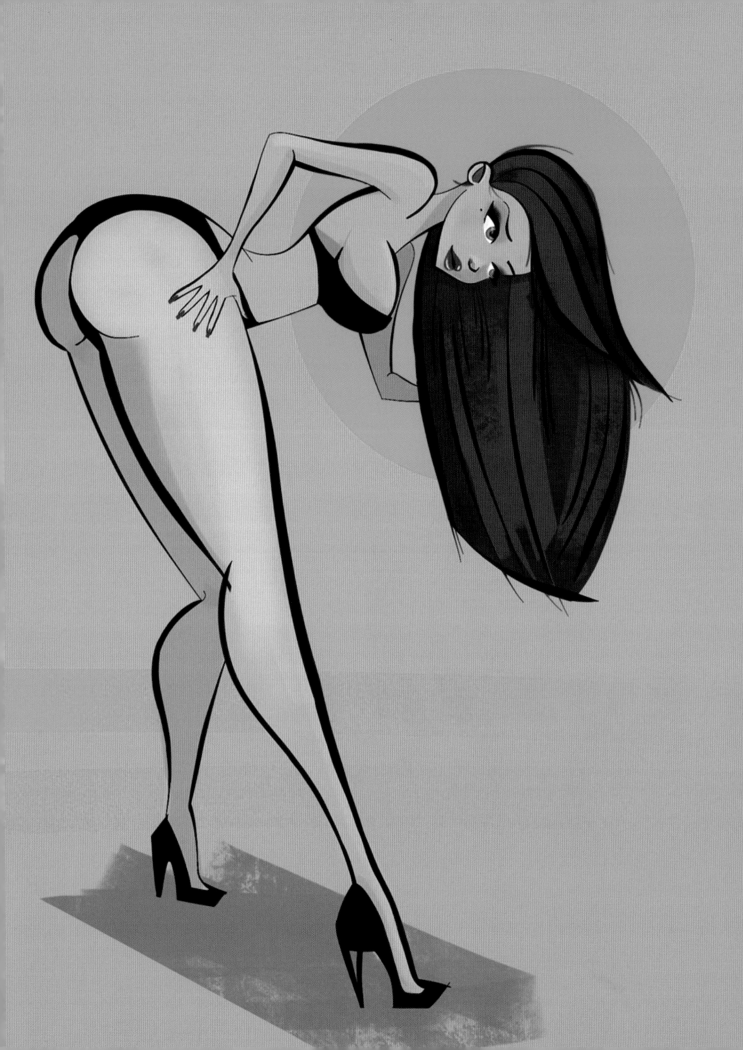

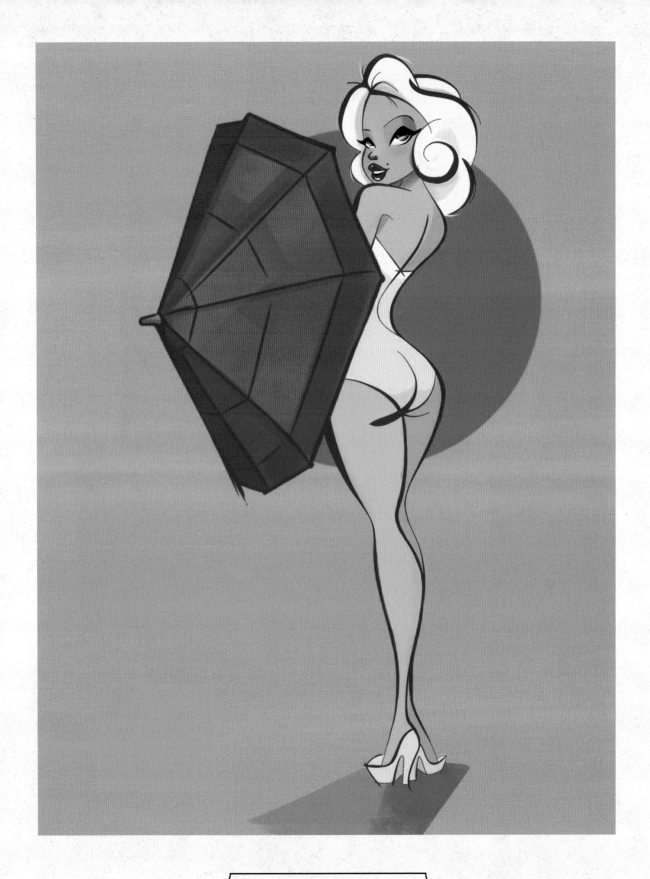

LEFT: Morning
Zach Gracia

ABOVE: Marilyn
Zach Gracia

49

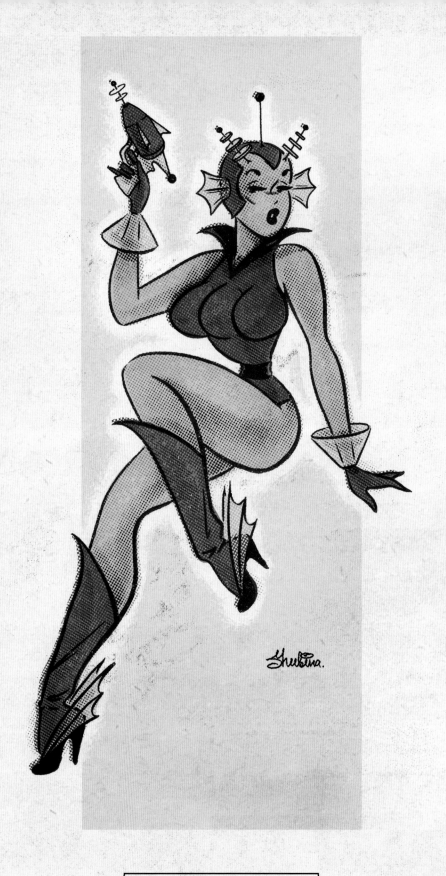

ABOVE: Alien
Sveta Shubina

RIGHT: Bewitched
Sveta Shubina

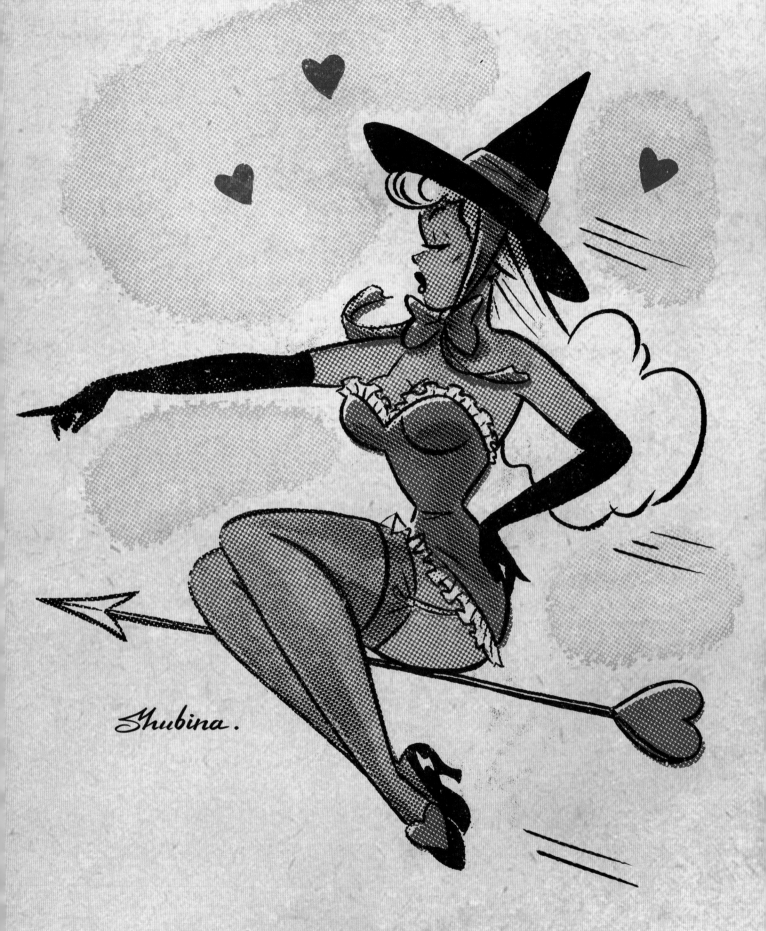

"I am bewitched by you!"

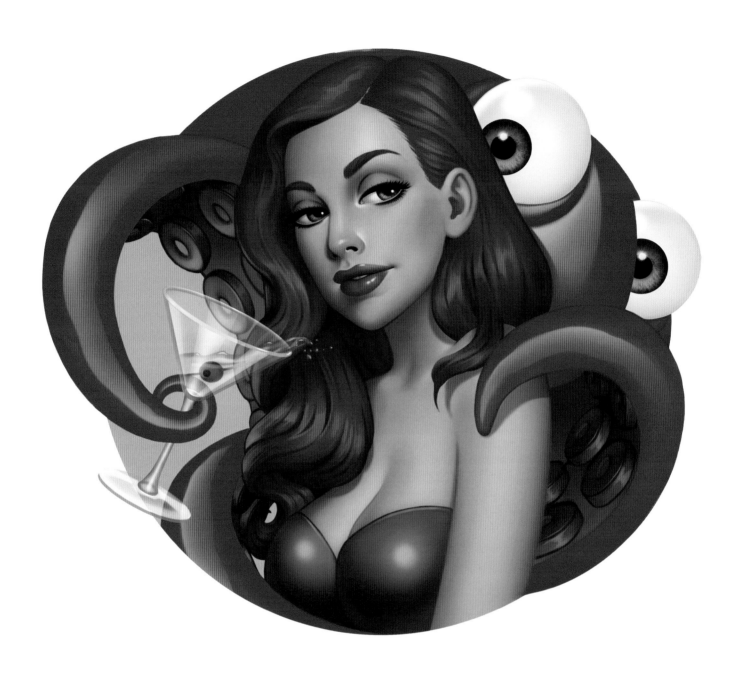

ABOVE: Party for Serge
Daniela Uhlig

RIGHT: Valentine's Day
Maly Siri

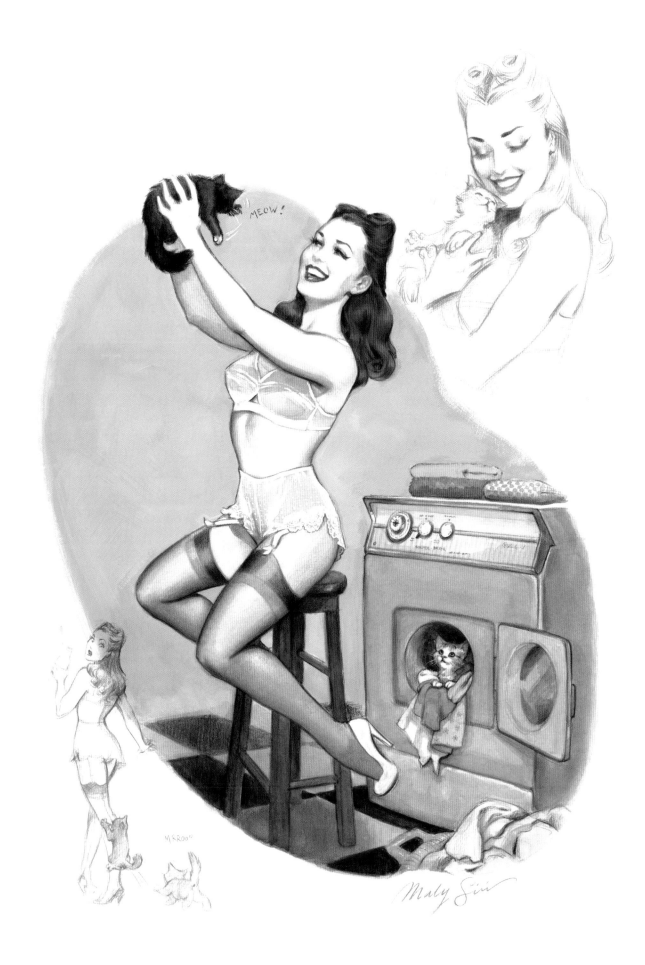

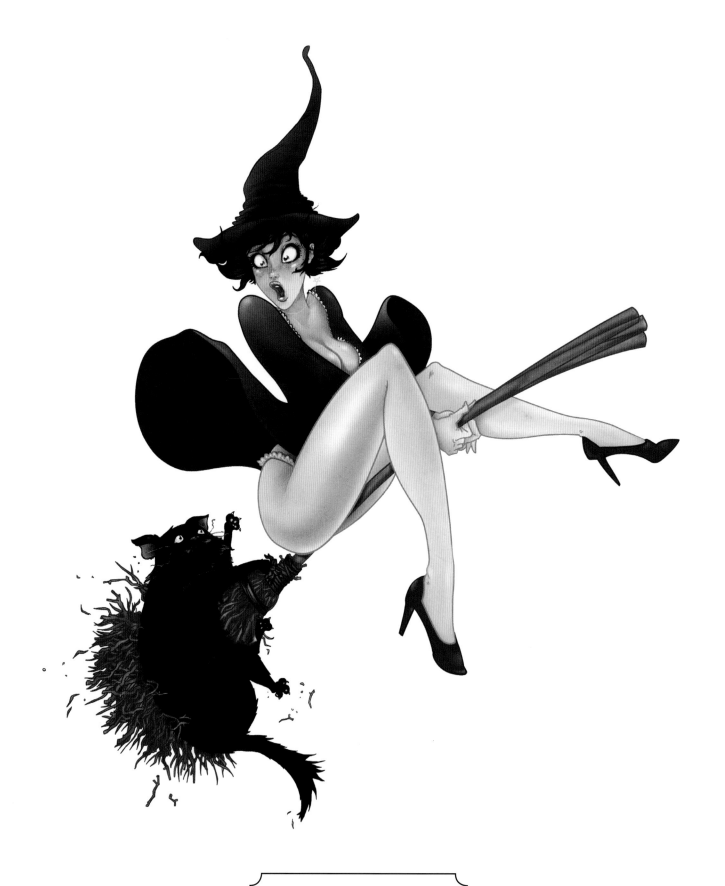

ABOVE: Witch
Matthew Britton

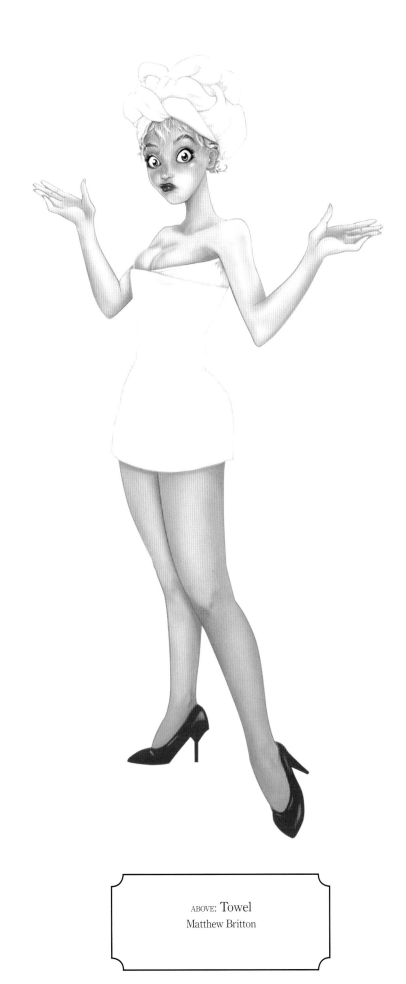

ABOVE: Towel
Matthew Britton

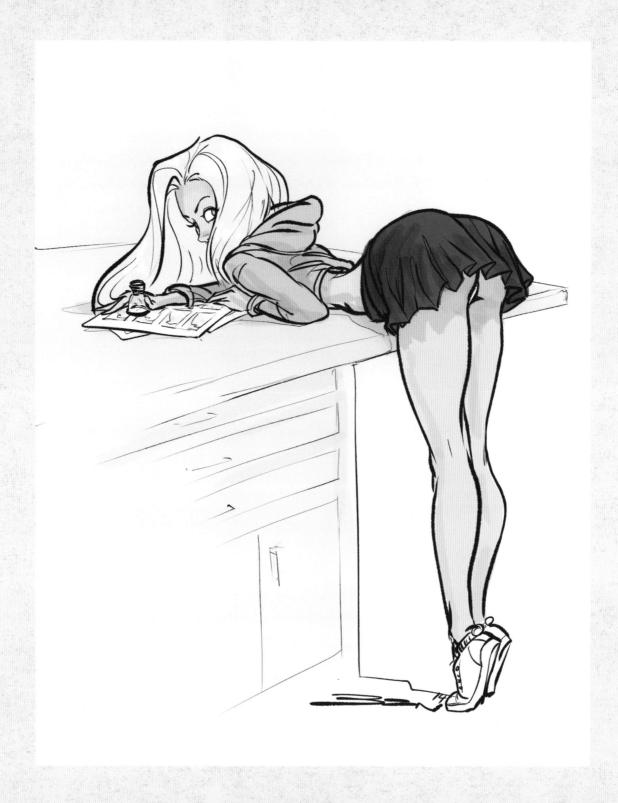

ABOVE: The Intern
Ben Tan

RIGHT: Senorita
Ben Tan

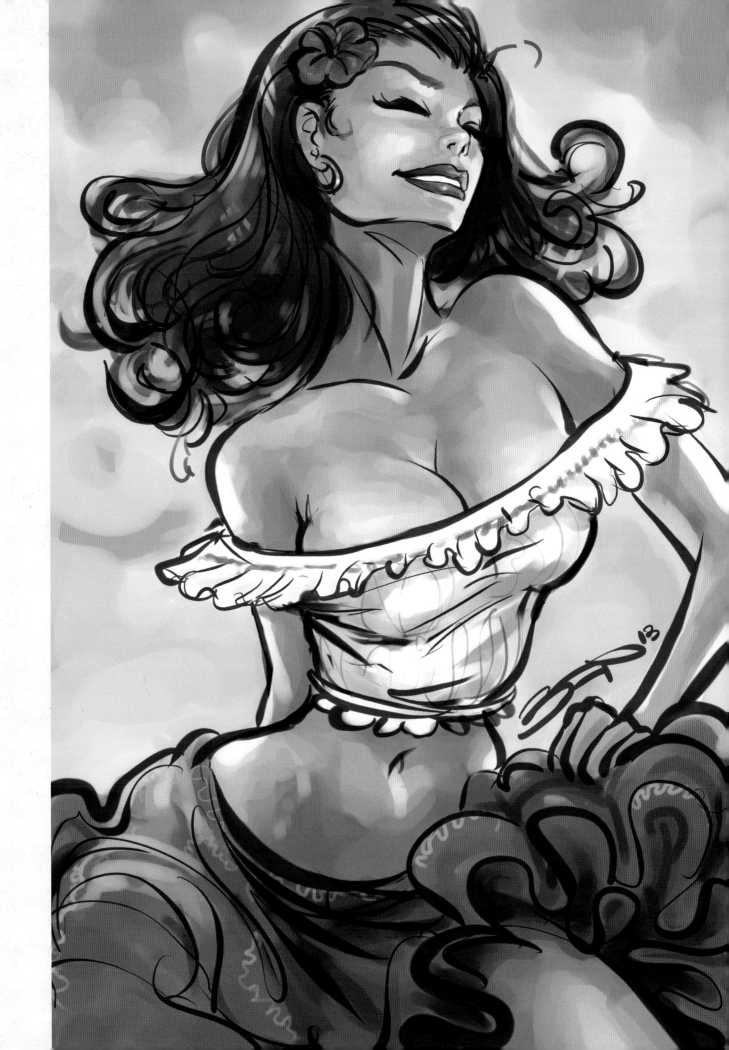

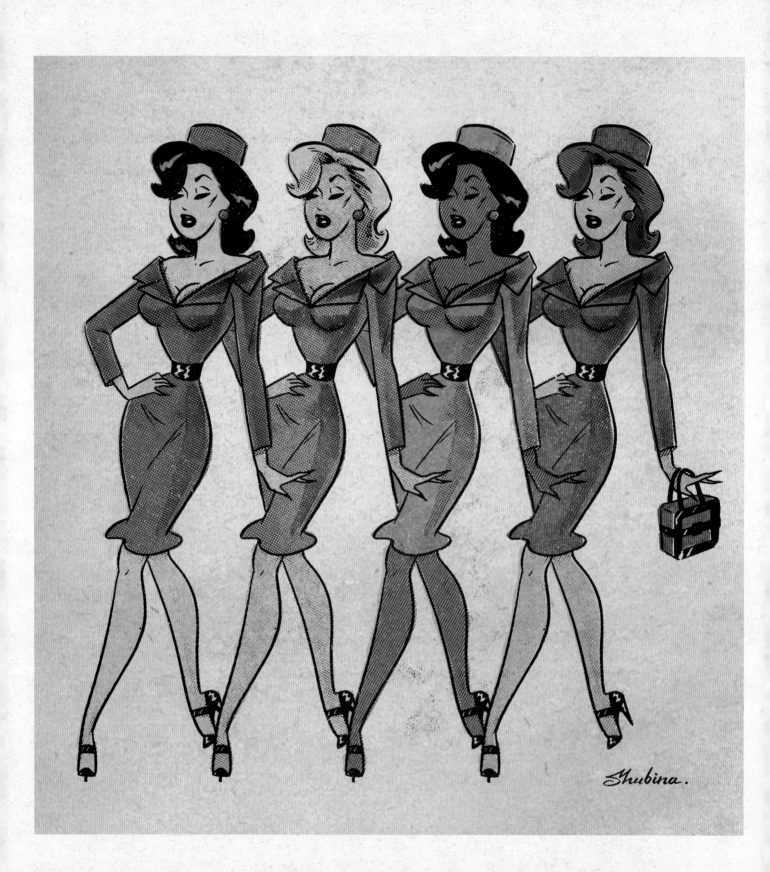

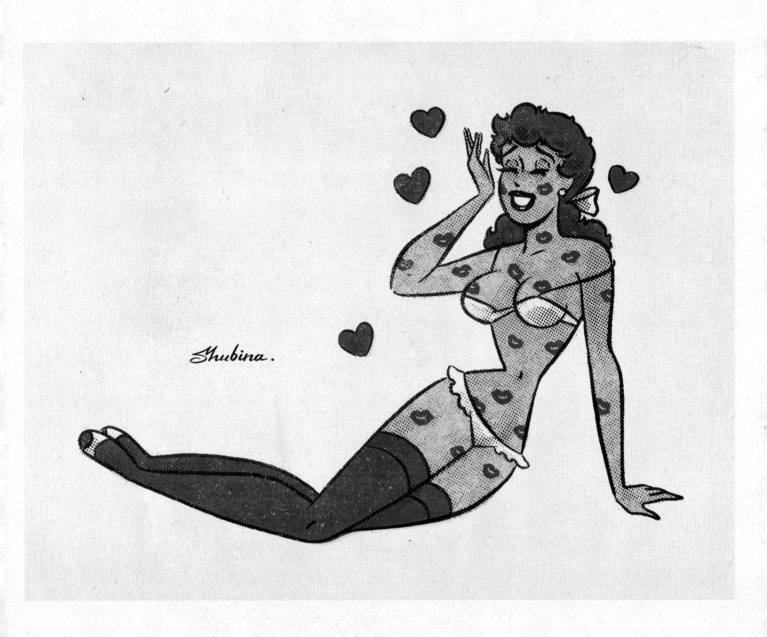

LEFT: Moschino
Sveta Shubina

ABOVE: Valentines Day
Sveta Shubina

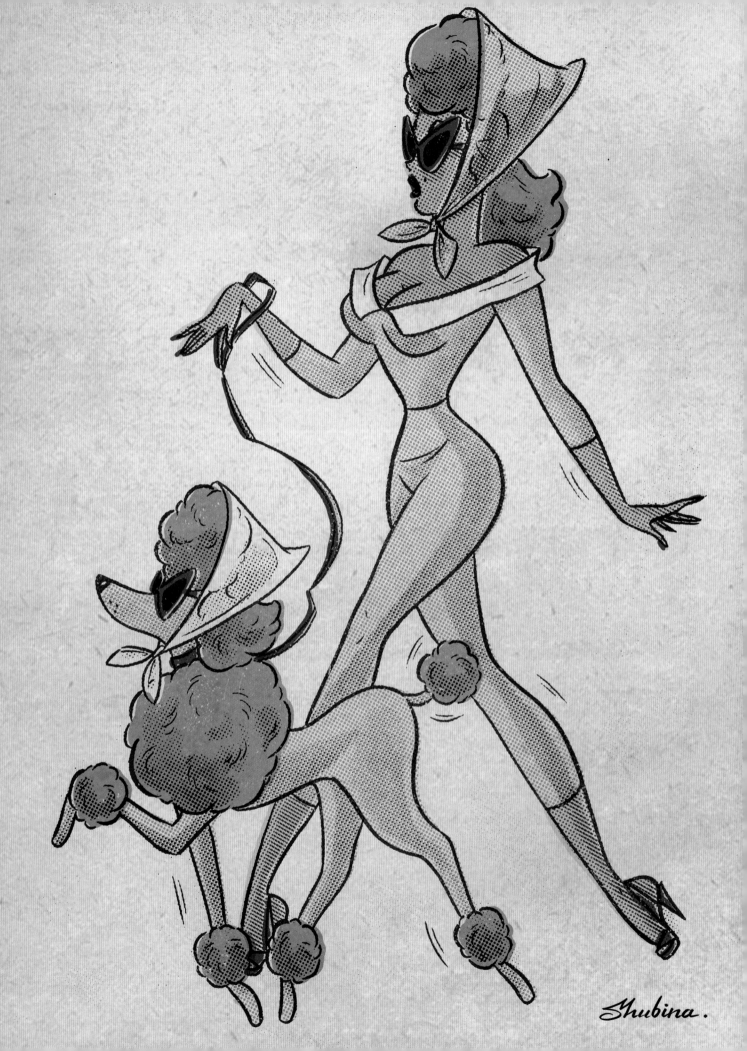

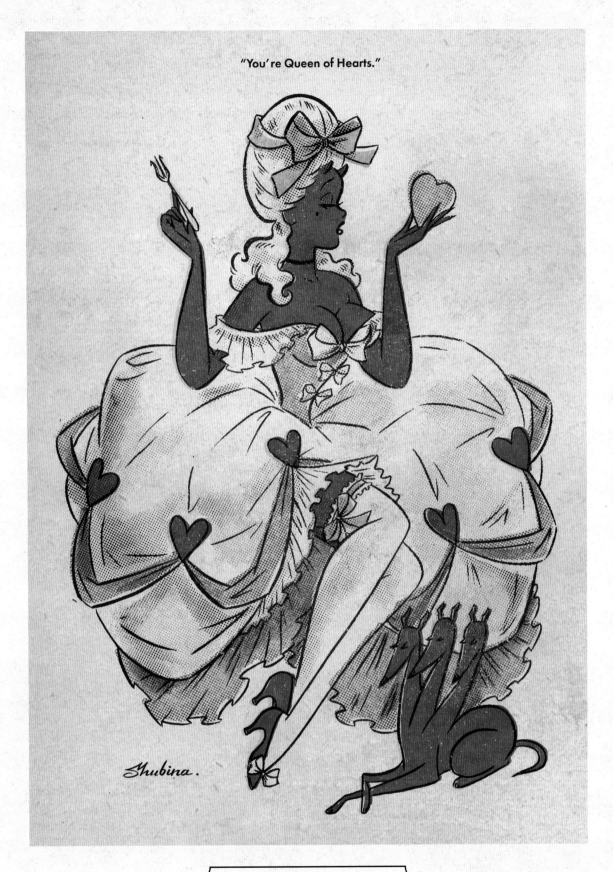

LEFT: Poodle
Sveta Shubina

ABOVE: Queen of Hearts
Sveta Shubina

Retro & Pulp Pinup

I f you want to find the roots of almost all pinup art, pick up some early-20th century pulp magazines. Pulps (so-called because their pages were printed on cheap wood pulp) were mostly American fiction factories that churned out formulaic tales of exotic adventure, crime, passion, violence and science fiction. Pretty soon after the first pulp, *Argosy*, came out in 1896, publishers realised they could get their sales to balloon by adding bright, sensationalist cover art. They drafted in illustrators like Norman Saunders, Walter M. Baumhofer and Earle K. Bergey, and had them create vivid painted covers that made full use of all available female assets. They would feature voluptuous damsels in distress, tied up by aliens, cornered by bad guys or gagged by kidnappers.

This gleefully sexualised cover art was new, and meant that pulp magazines sold up to a million copies an issue right through to the 1940s, when WWII paper shortages put paid to the much-loved format. But this early lowbrow form of art, with its smuttiness and garish melodrama, had helped create certain pinup archetypes that carried on, on the covers of books and movie posters, and that remain throughout the genre today. There was the helpless ingénue, strung up in her underwear, her hands tied behind her back, facing a leering baddie or monster; there was the seductive, scheming, Noir femme fatale that was hugely popular during the heyday of detective pulps in the 1930s; then there was the armed woman – who more often than not was painted with a meek expression on her face, as if she had picked the gun up by accident.

You might think these styles would grow tired, but more than ever, designers these days are looking to create pinups that look and feel retro. As the following pages demonstrate, this is a rich seam of creative inspiration, as the artists picked here show.

LEFT:
Fogerty
Leviathan

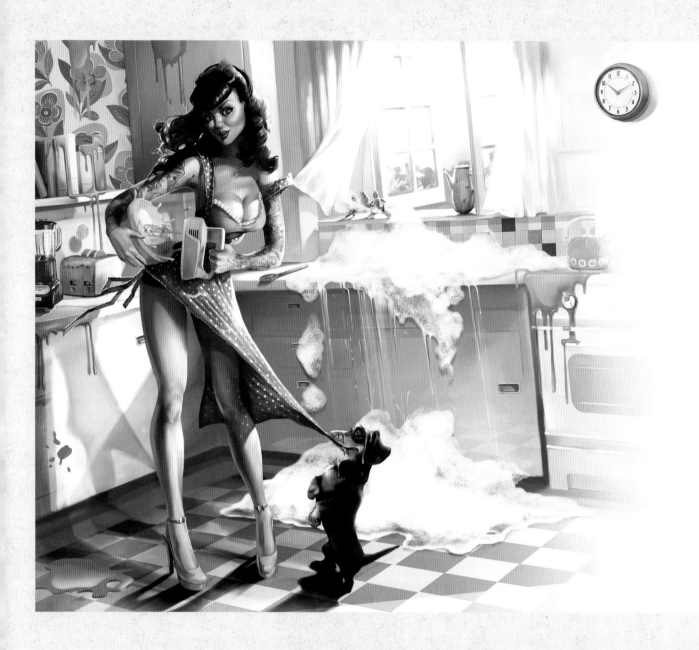

ABOVE: Kitchen Sink
Caroline Vos

RIGHT: Ludella
Andrew Hickinbottom

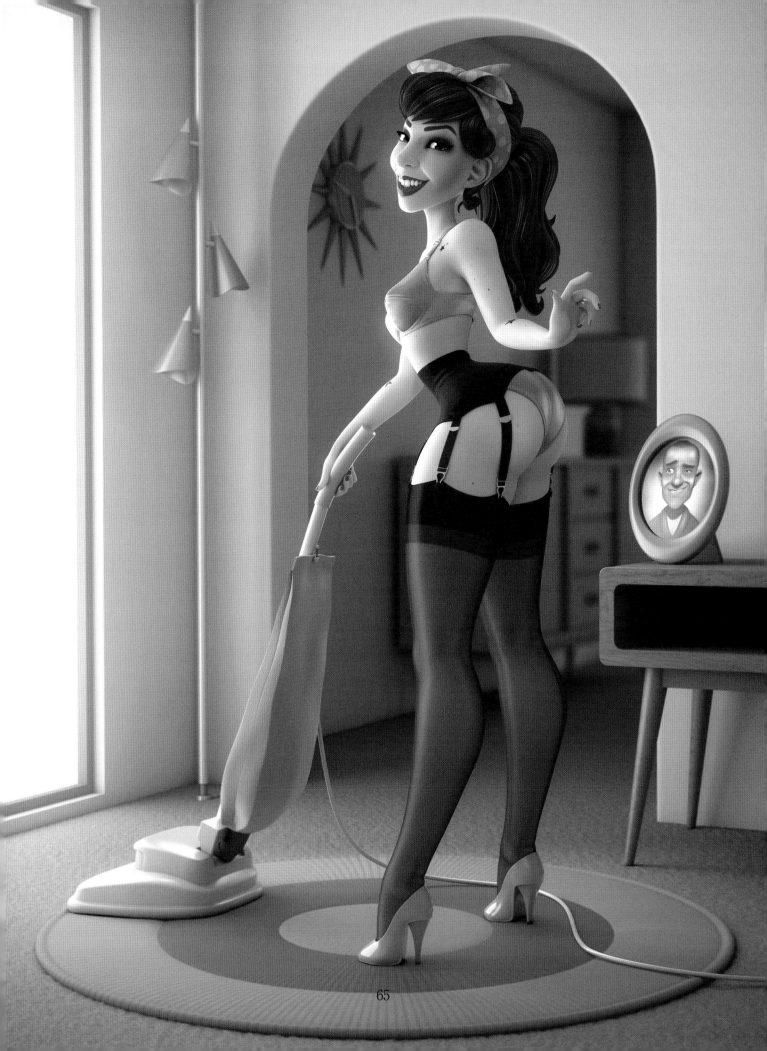

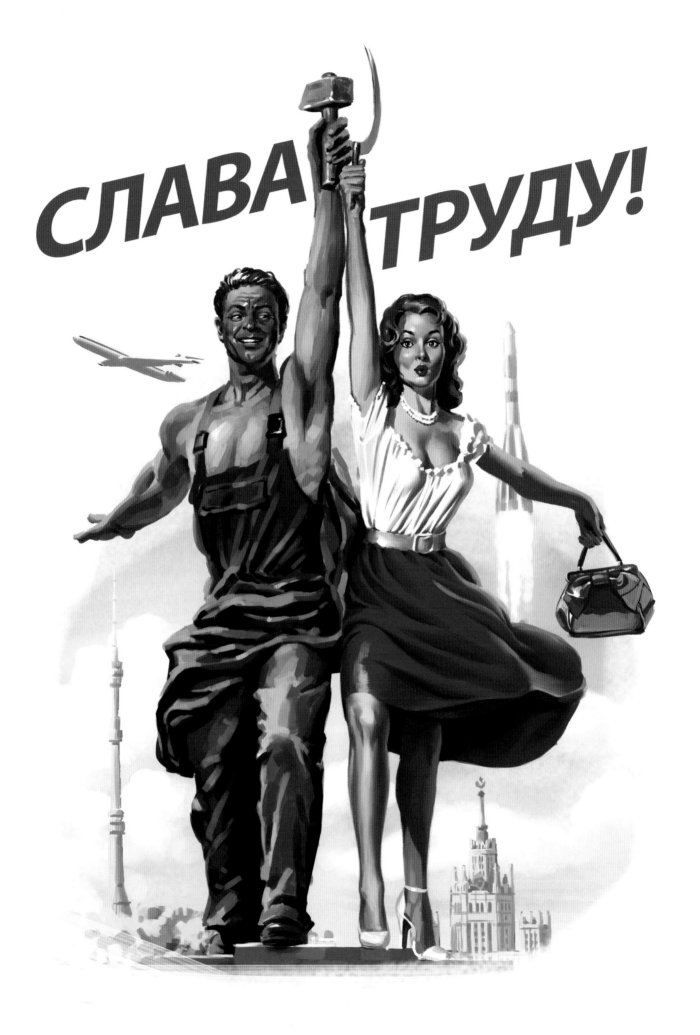

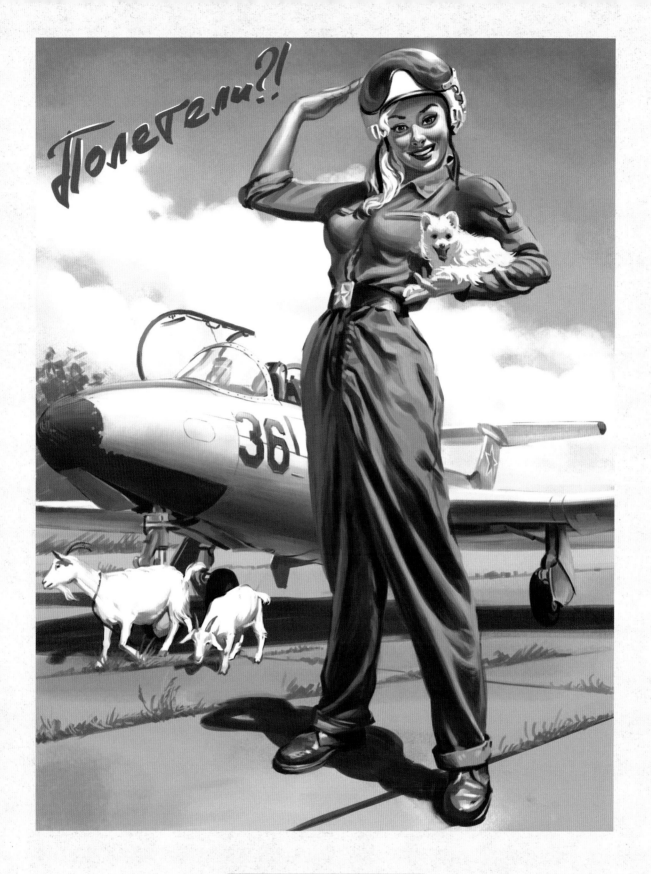

Полетели?!

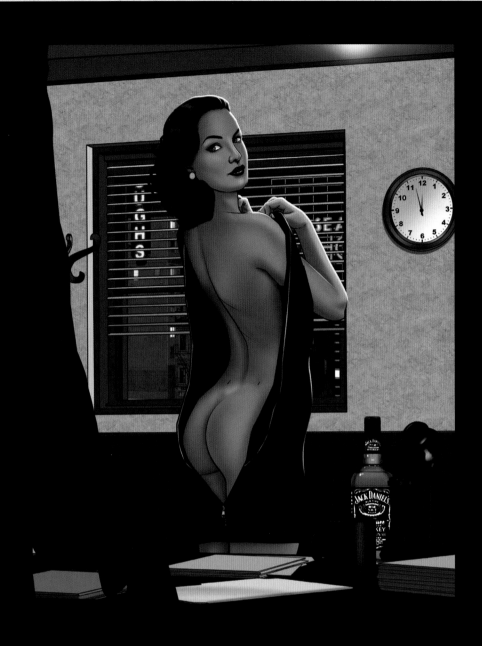

ABOVE: **Film Noir**
Ted Hammond

RIGHT: **Taxi Driver**
Sveta Shubina

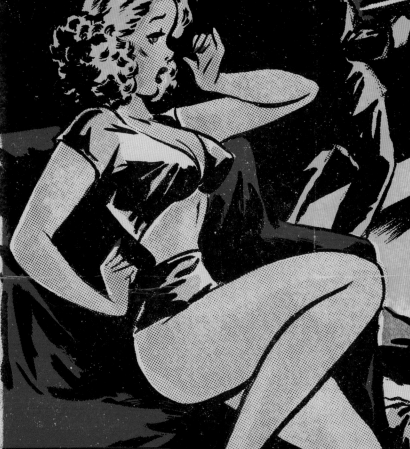

"ON EVERY STREET IN EVERY CITY, THERE'S A NOBODY WHO DREAMS OF BEING A SOMEBODY."

ROBERT DE NIRO

TAXI DRIVER

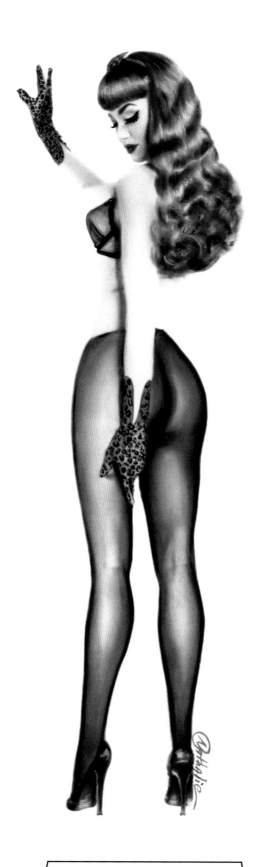

ABOVE: Lavender
Nathalie Rattner

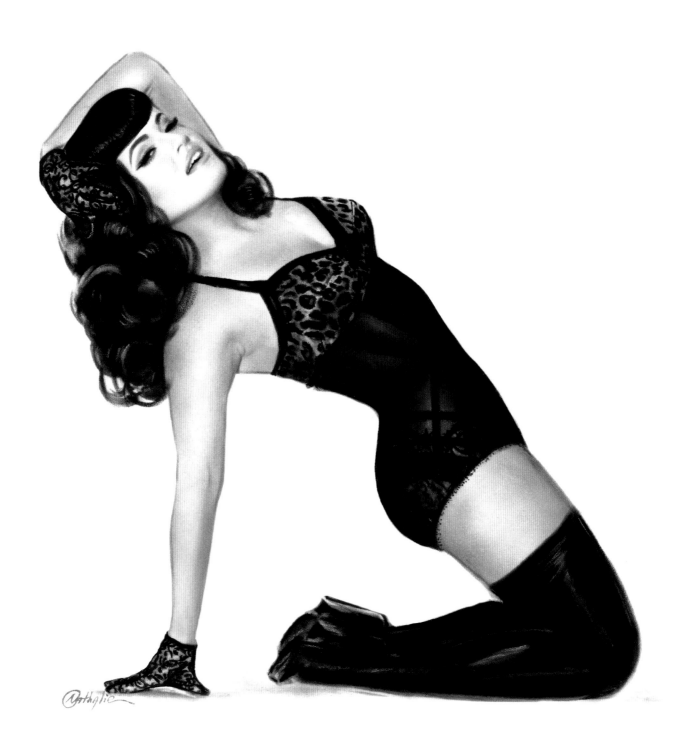

ABOVE: Miss May
Nathalie Rattner

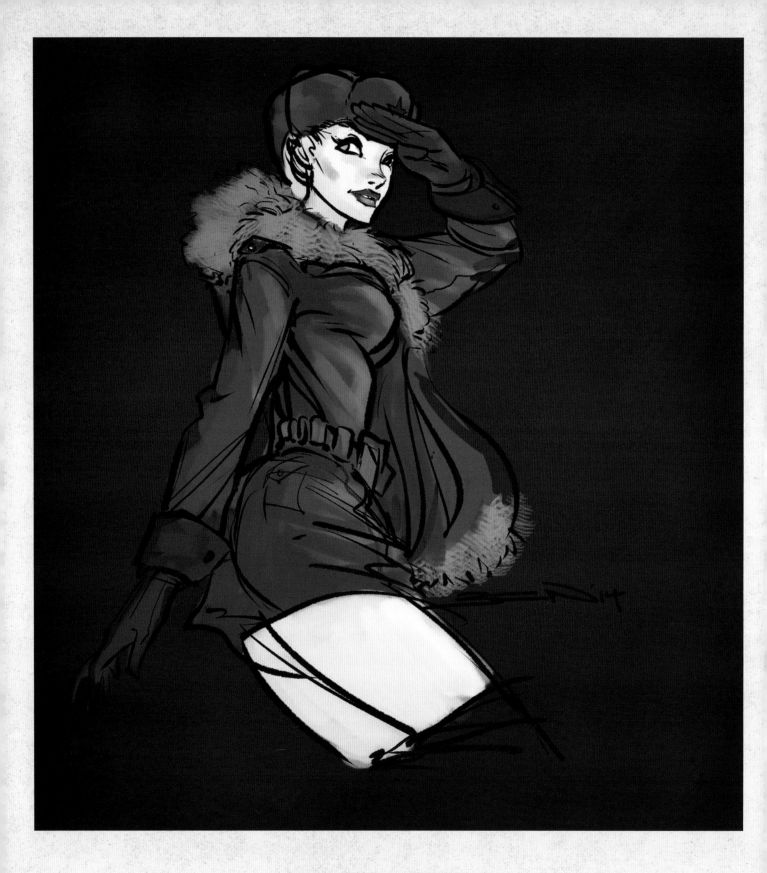

ABOVE: Russian
Ben Tan

RIGHT: Cathy Ray
Andrew Hickinbottom

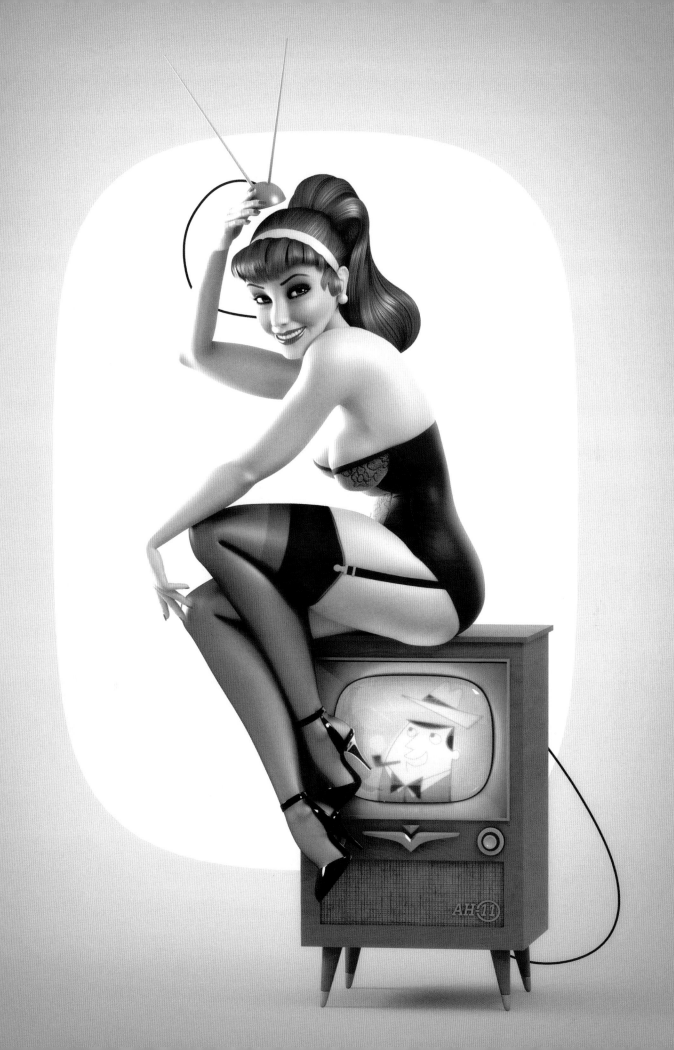

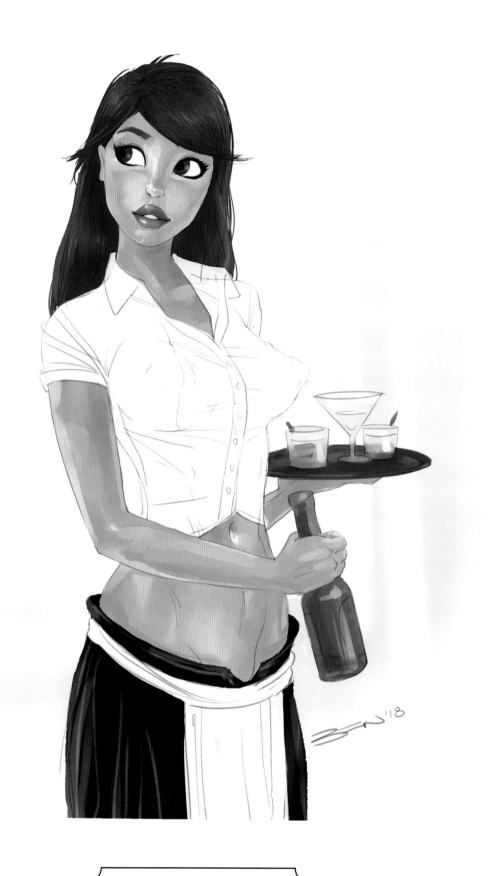

ABOVE: Waitress
Ben Tan

RIGHT: Hostess
Ben Tan

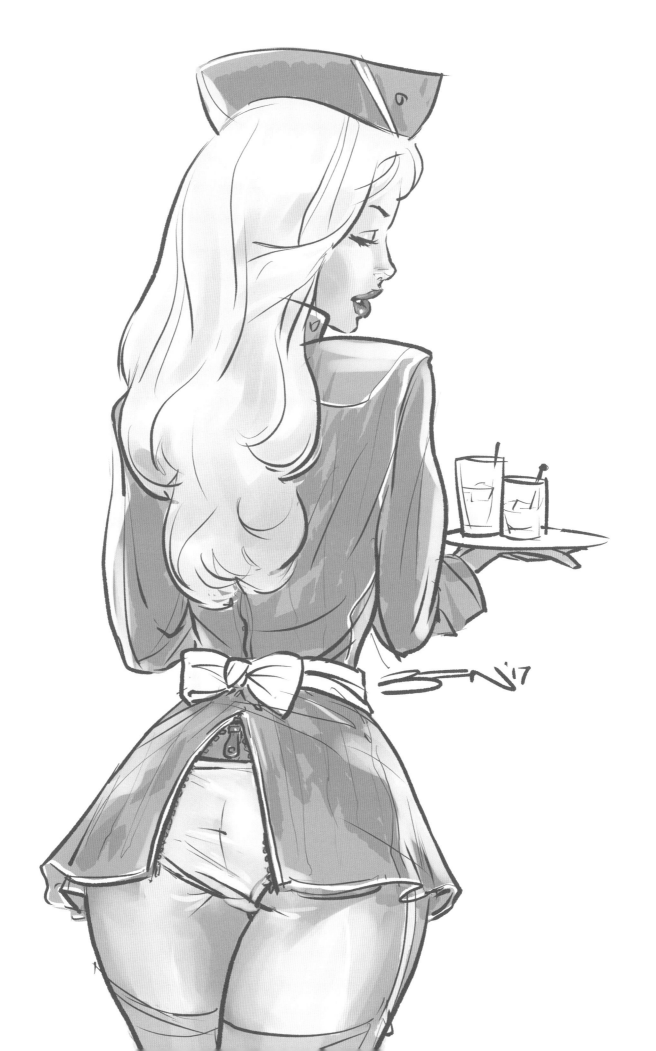

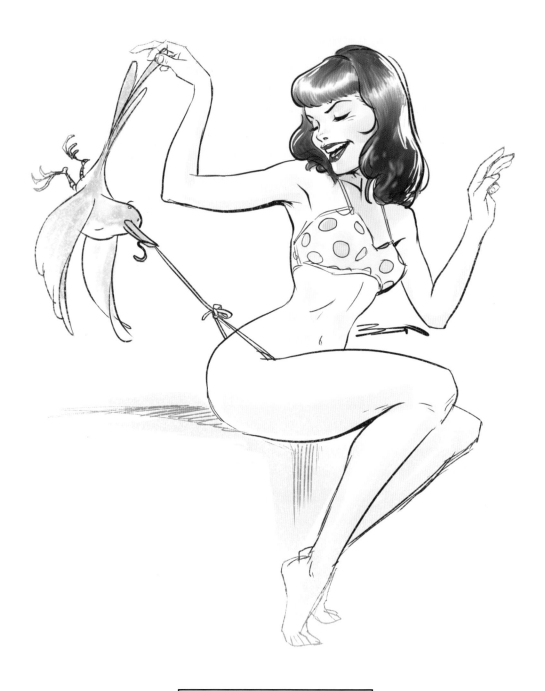

ABOVE: Betty
Ben Tan

RIGHT: Prehistory
Enric Badia Romero

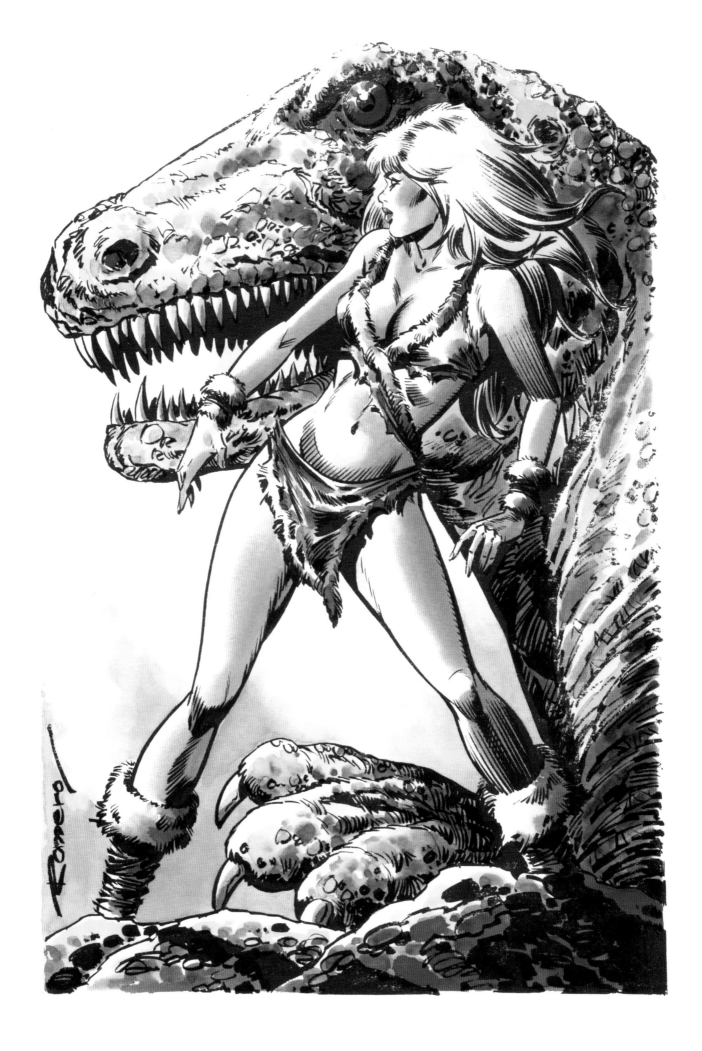

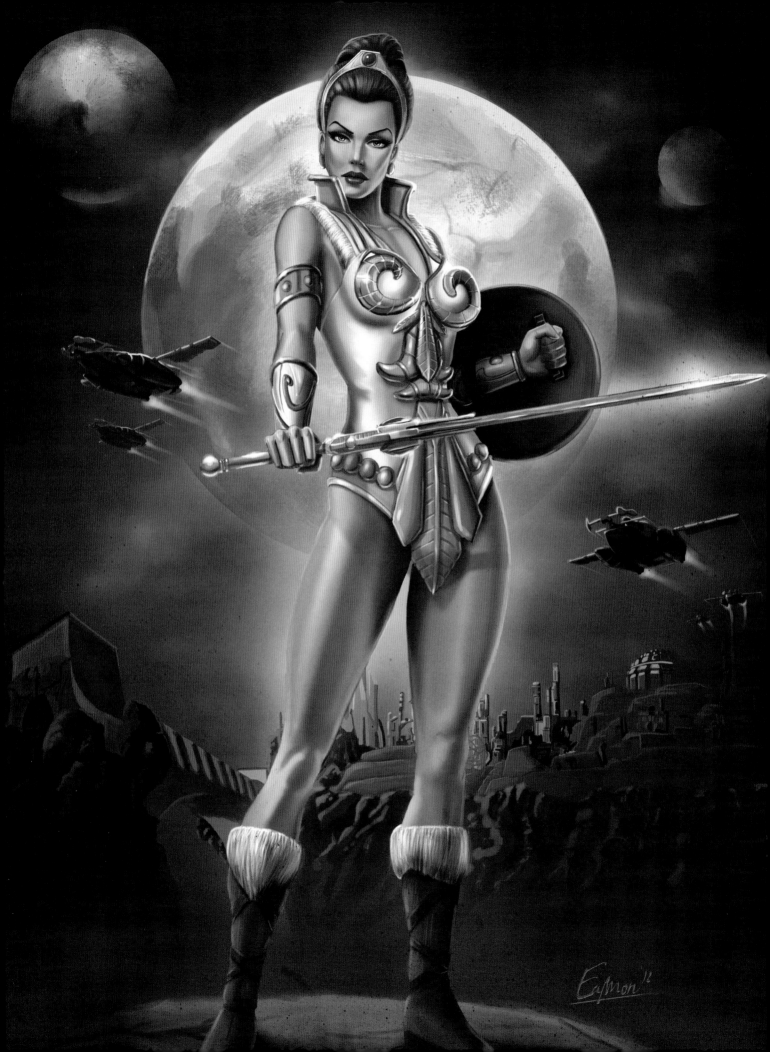

SCI-FI & FANTASY PIN UP

The fantasy and sci-fi pinup genre would not be where it is today without heroes Frank Frazetta and Boris Vallejo. Gaining widespread attention as film poster, magazine, book and comic book cover artists at similar times in the early 1960s, both artists showed how to depict a beautiful woman facing dangers of mythical proportions. Frazetta was the master of fantasy characters, as shown in his 1969 cover for the first Vampirella comic, whilst Vallejo's well-endowed goddesses show he ruled when it came to straight-up erotic fantasy art.

When newspapers' popular comic strips became their own separate entity in the 1930s, these new comic books needed cover art. Much of the material in comic books was sci-fi or fantasy-related, and artists drew on the melodramatic representations of females-in-fantastical-situations that had been used on the covers of hugely popular 1920s and 1930s sci-fi pulp magazines. Although the comic book covers started off being knocked up in the same cartoony style as the content inside – featuring popular saucepots like Buck Rogers' Col. Wilma Deering – by the 1960s, thanks to artists like Frazetta, Vallejo and the Brothers Hildebrandt, the cover pinups were also parts of epic painted scenes. The 1960s' Space Race, and popular notions of reaching and colonising Mars, gave way to a golden age of sci-fi cover illustrations for books, magazines and films – which married the cute Barbarella look for women with demonic space creatures and menacing UFOs.

The close relationship between sci-fi and fantasy writing and illustrations has created a number of recurring themes in pinup imagery that are still hugely popular today. Fantasy pinups in particular often hark back to ancient mythology, Medieval imagery or classic Lord of the Rings-style weapons and surroundings. The pinup will usually be fighting the forces of good or evil, or she will be an extraordinary but exotic creature herself – perhaps complete with wings or magical powers. Science fiction pinups are less often set in the past (apart from in highly popular throwback, steampunk, dieselpunk or pulp cover-style images) and frequently feature futuristic or dystopian robots, aliens, monsters, evil scientists, contraptions and dream technologies.

LEFT: Teela
Eamon O'Donoghue

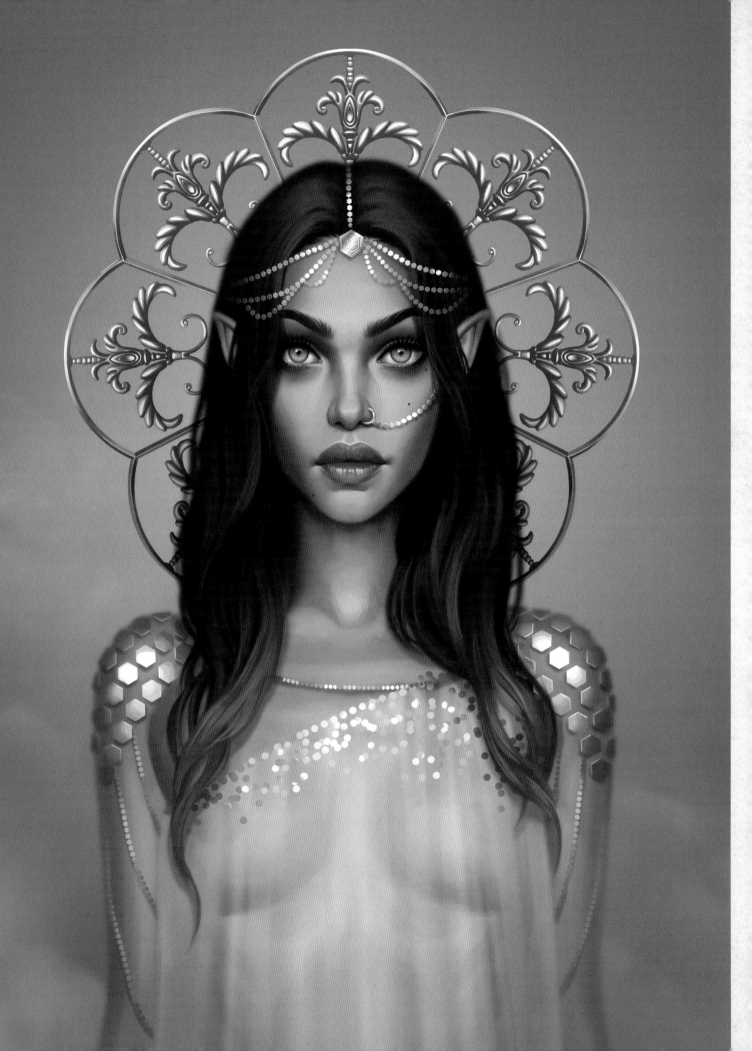

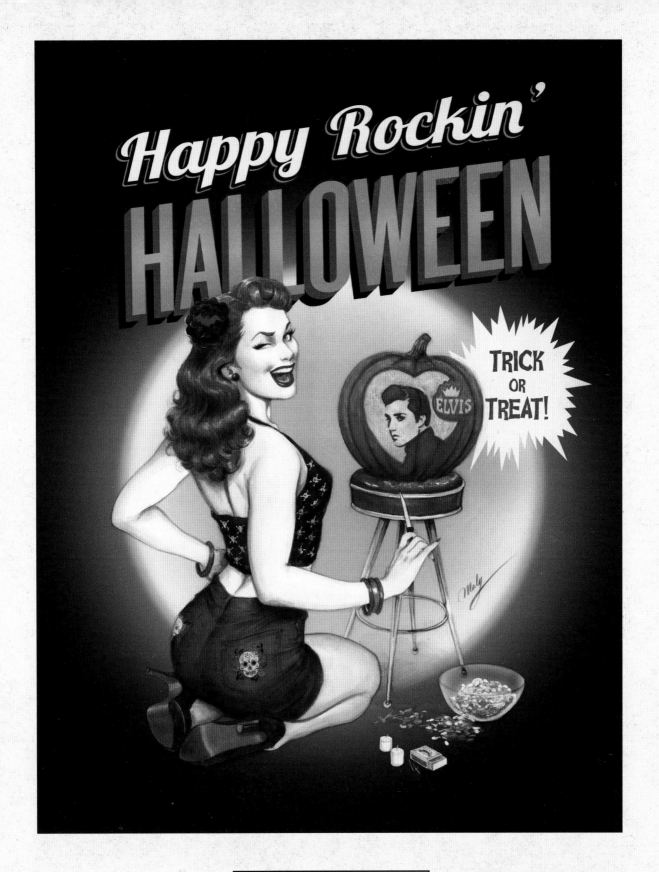

LEFT: Elf Queen
Daniela Uhlig

ABOVE: Halloween
Maly Siri

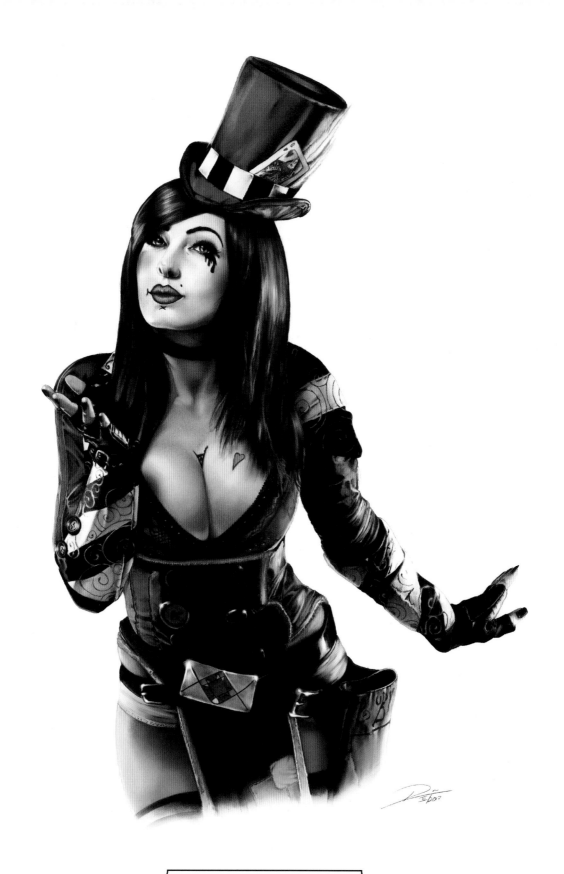

ABOVE: Moxxi
Dirk Richter

RIGHT: Spacegirl
Ben Tan

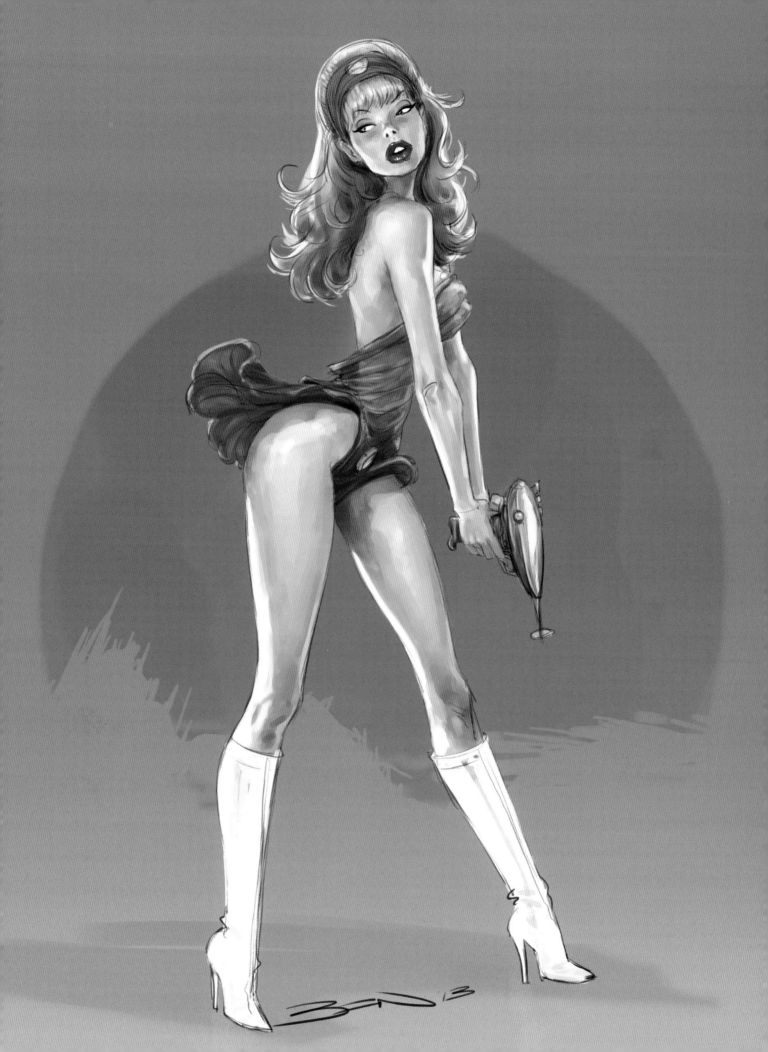

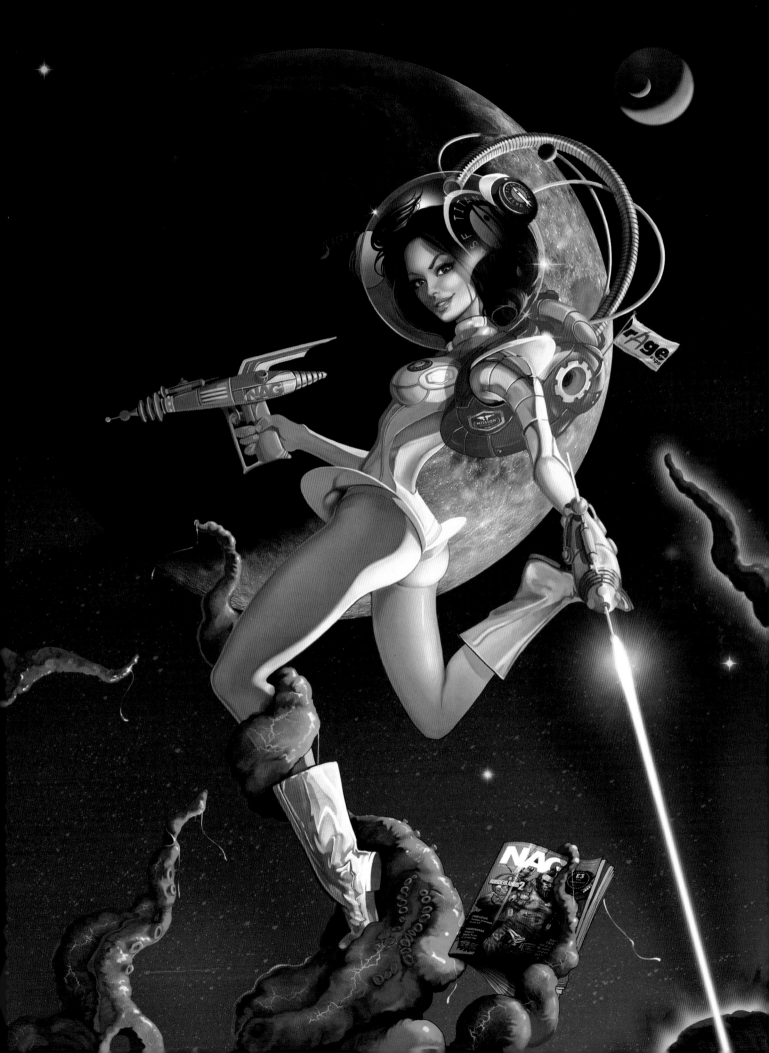

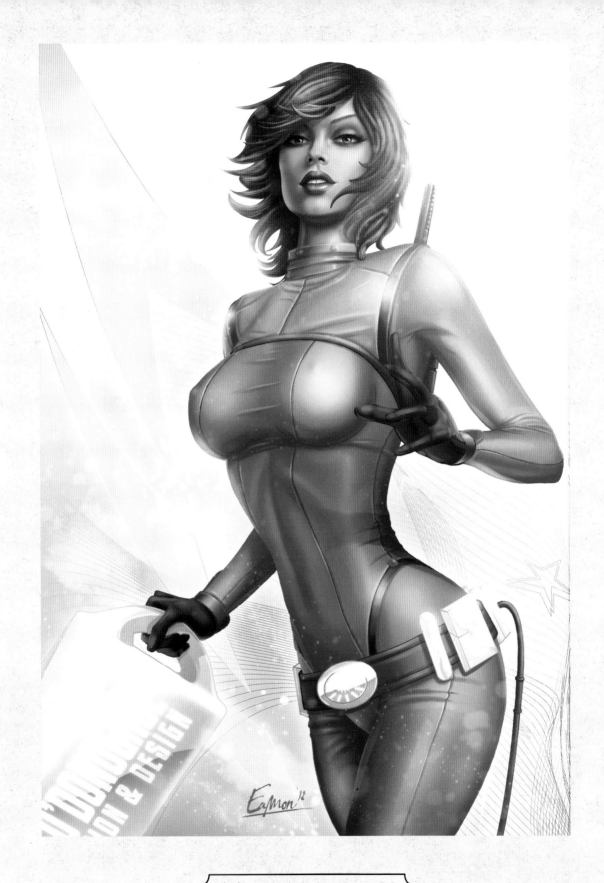

LEFT: Roxy
Caroline Vos

ABOVE: Space Girl Vera
Eamon O'Donoghue

85

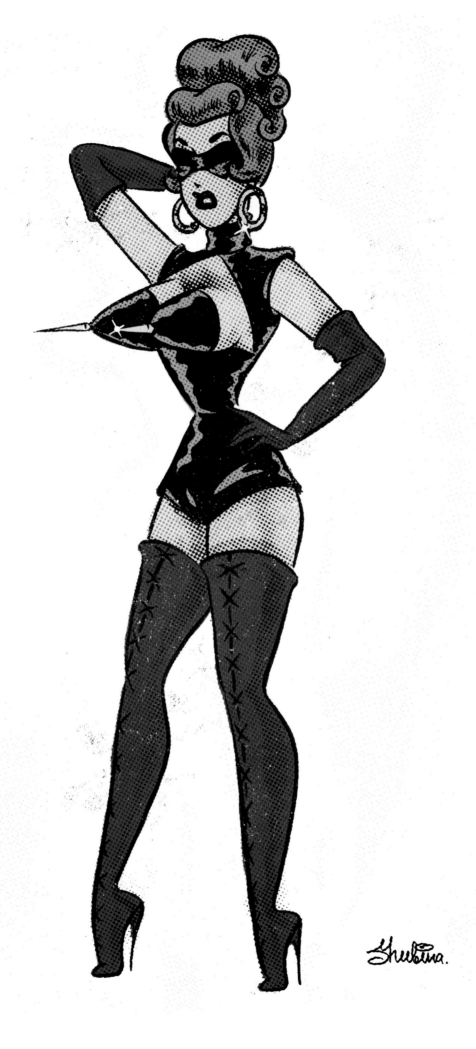

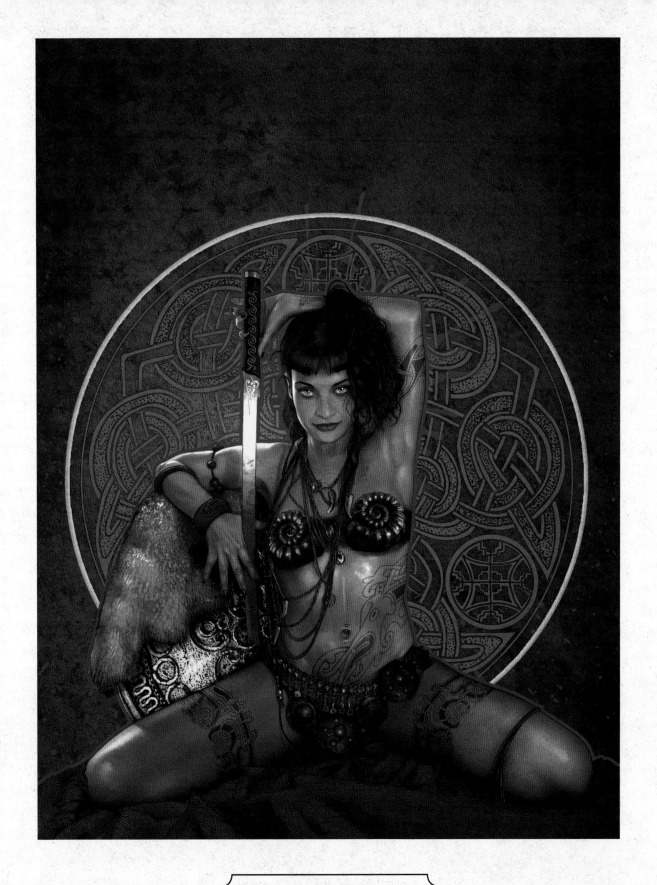

LEFT: **Eye Poker**
Sveta Shubina

ABOVE: **Brabarian**
Pinturero

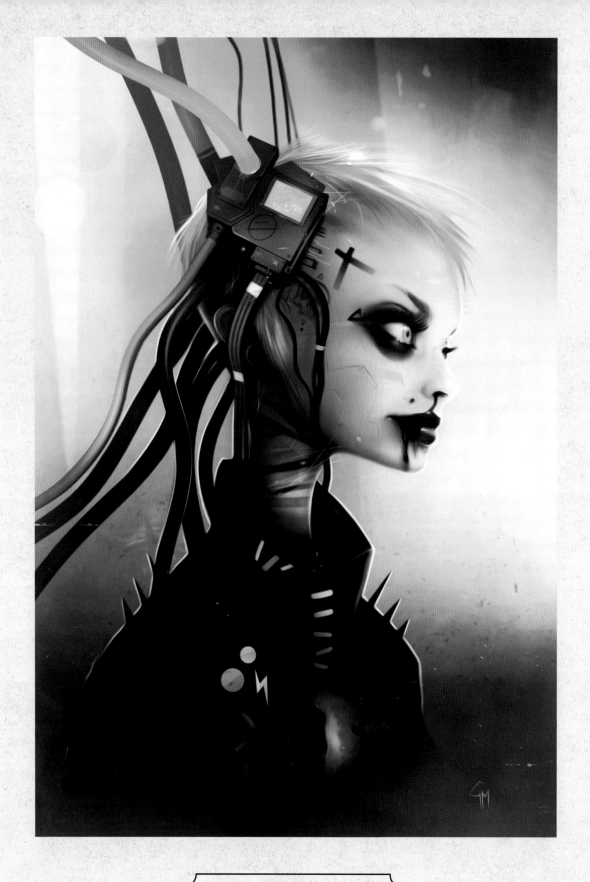

ABOVE: Beat
Gianluca Mattia

RIGHT: Prisma
Gianluca Mattia

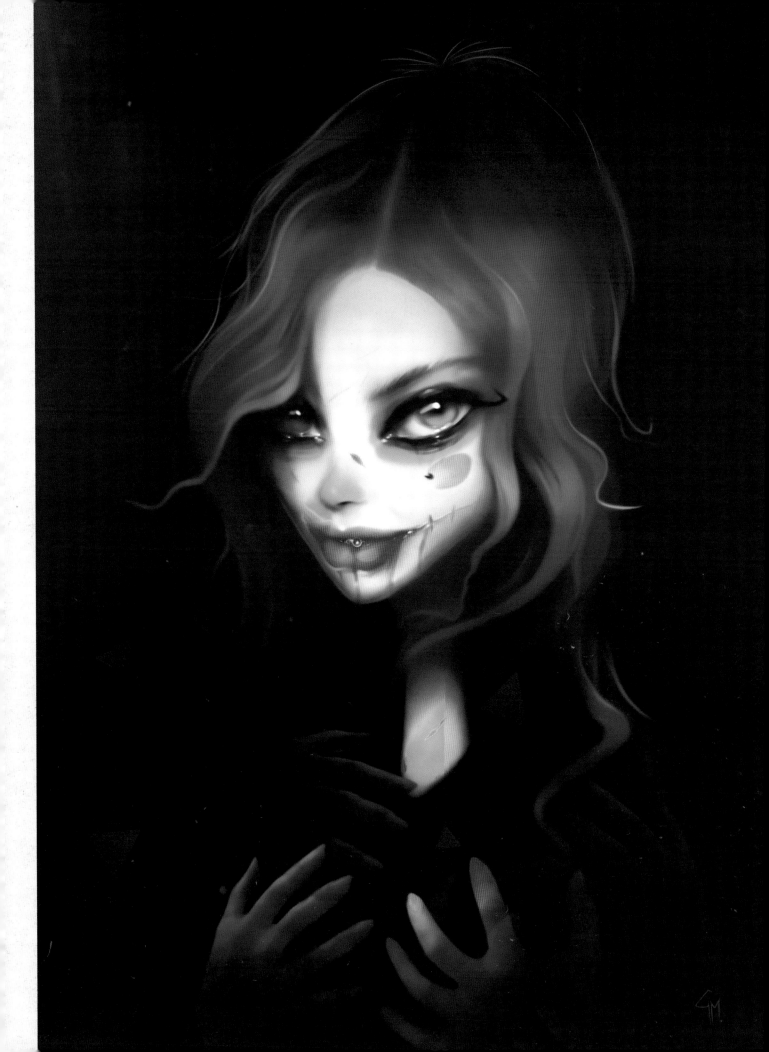

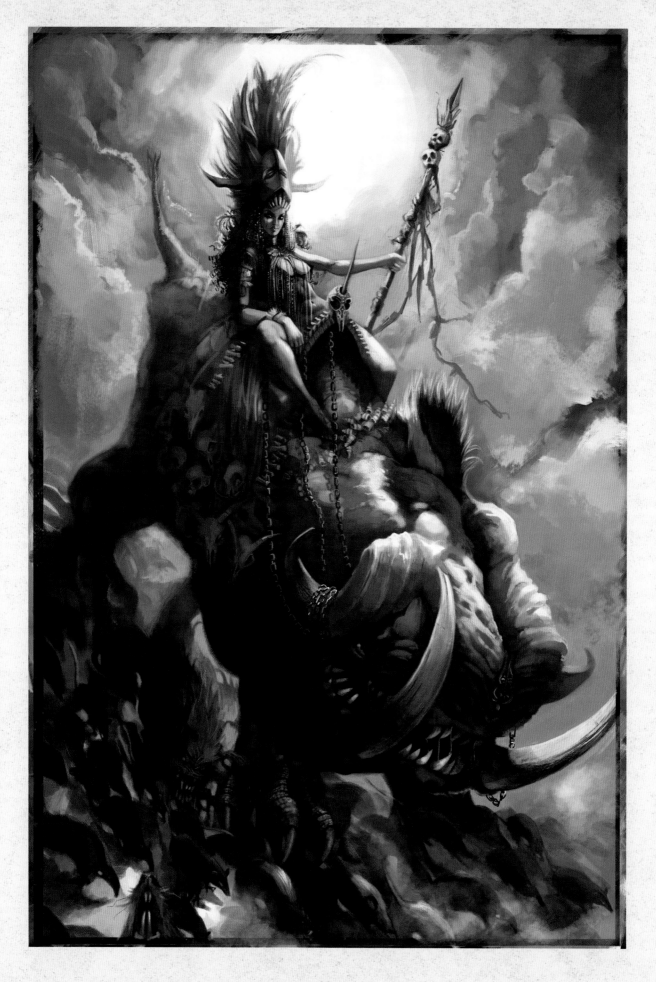

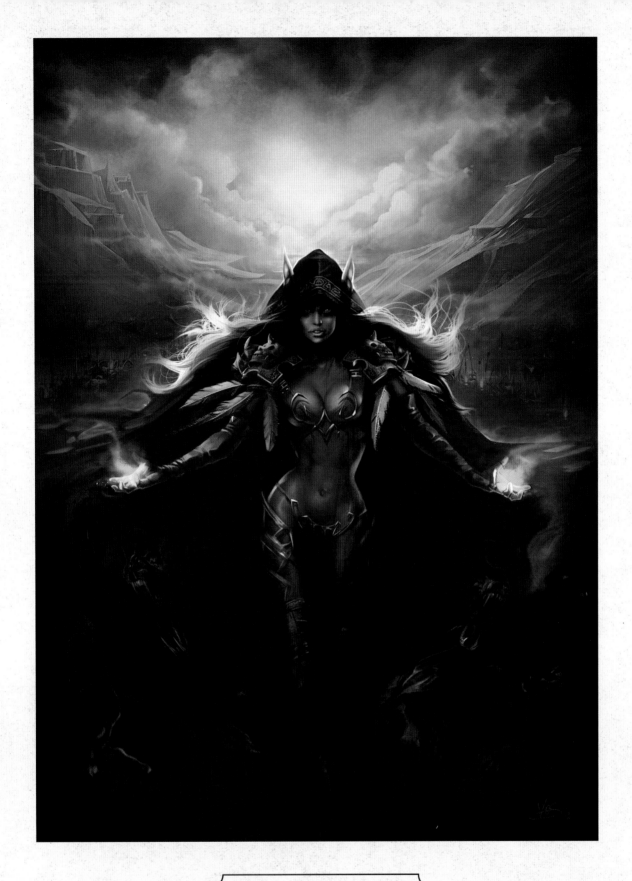

LEFT: Witchdoctor Gathering Her Army
Caroline Vos

ABOVE: Sylvanas Windrunner
Caroline Vos

91

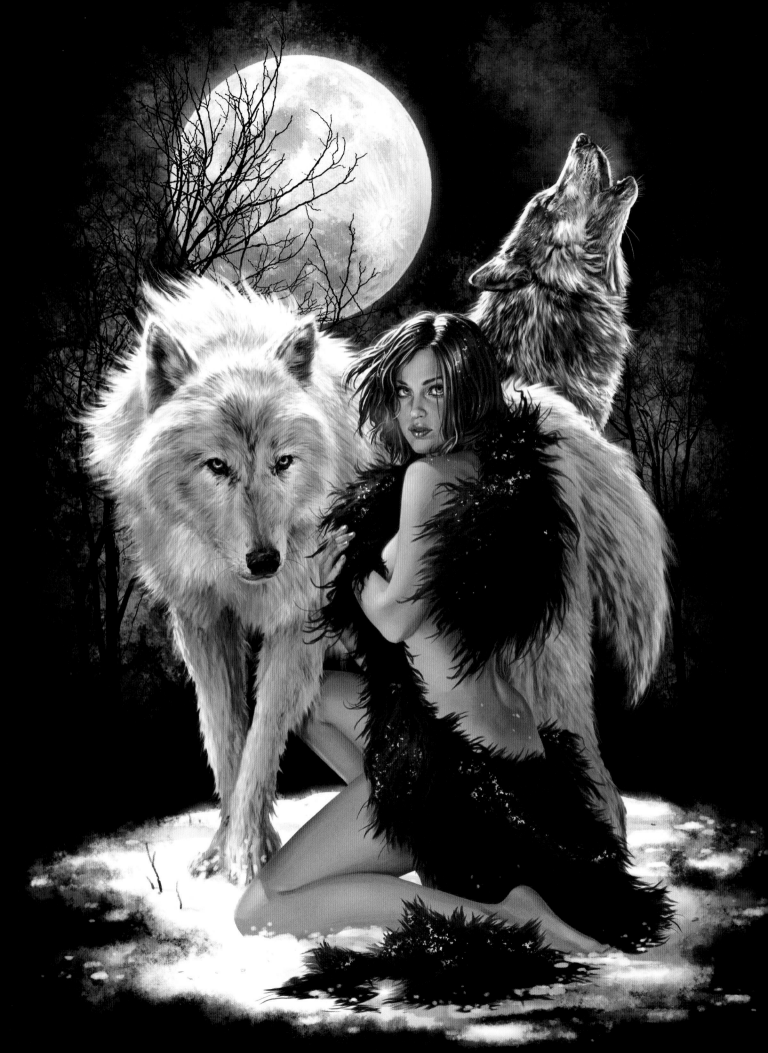

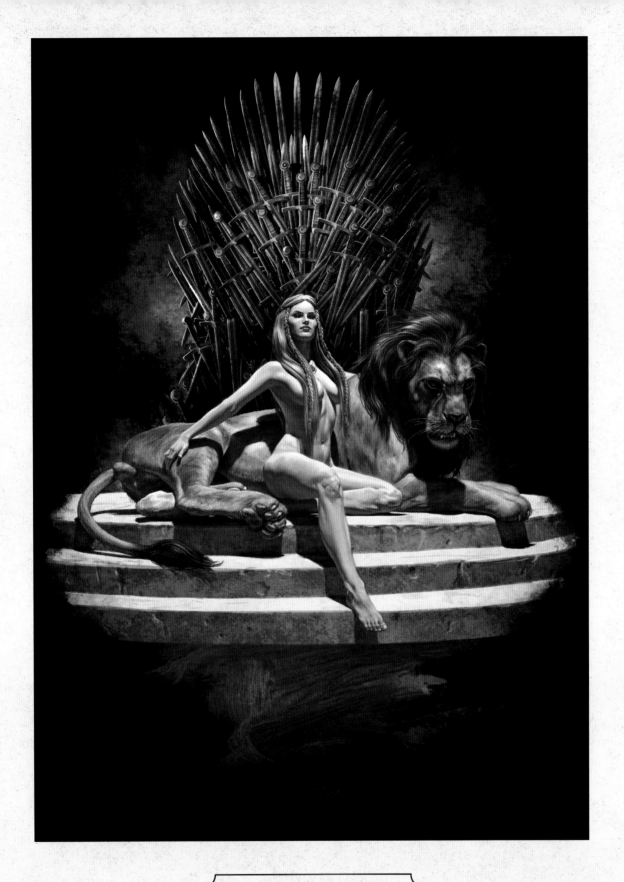

LEFT: The Wolf
Chris Wahl for Russal Beattie Presents
ABOVE: The Lion
Chris Wahl for Russal Beattie Presents

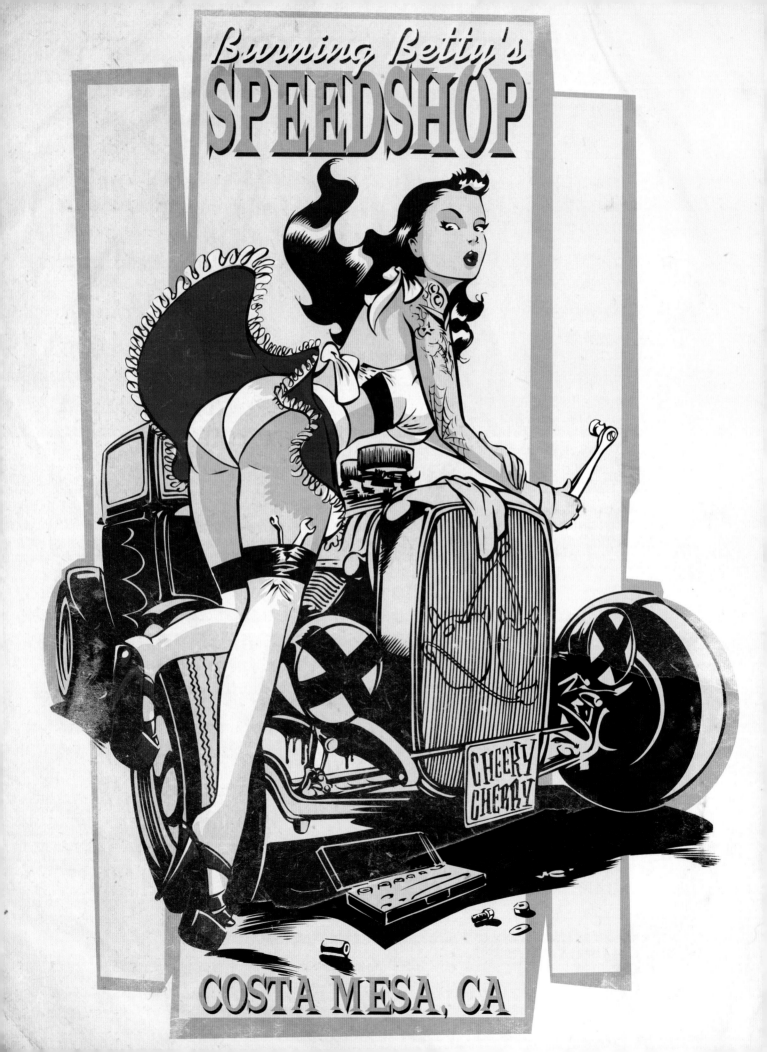

HOT ROD, KUSTOM & TATTOO PINUP

Hot rod culture emerged amongst demobbed World War II vets in Southern California, unwilling to conform to the anodyne consumer culture of much of late '40s and '50s mainstream USA. The movement worshipped classic 1940s and (later) 1950s automobiles, souped them up in speedshops, decorated them with pinstripes and raced them on dried-up salt lake beds. The '60s saw artists like Von Dutch, Ed Roth and Robert Williams define a whole new aesthetic that denoted this rebellious, anti-establishment attitude, and which celebrated individuality and independence. But it was still authentically all-American. It was logical that the classic American pinup would be appropriated into the aesthetic, particularly when hot rod fused with rock 'n' roll and, more specifically, rockabilly. Classic hot rod pinups are curvaceous – in true '50s style – they sport tattoos, wear skinny jeans and barely-there bikinis and polka dot bows in their hair. Their femininity contrasts sharply with the grease of the workshop. Kustom iconography is everywhere: 8-balls, Day of the Dead skulls or Lucky 13s. Where hot rod spills onto the beach, surfboards and skateboards will feature. They're brave, risk-taking and tough.

Tattoo pinups have a longer history. 19th century soldiers in the Spanish-American war had hot women tattooed on them to remind them what they were fighting for – just like the forces in the two world wars. Many of the tropes associated with today's pinup tattoos – scantily-clad hula, sailor, gypsy and pirate girls – started as cunning ways to get round the U.S. Navy's restrictions on increasingly popular nudey-girl tattoos at the turn of the century. During World War II pinup tattoos took on the Vargas/ Petty, cheesecake look, and Sailor Jerry created his monumentally successful line-art pinup tattoos – which have influenced the likes of Claudia Hek today. Lastly, there's the lurid 'new-school' pinup tattoo. Influenced by comic art and neo-surrealist girls, these often have big eyes, big curves and bags of attitude.

LEFT: Betty's Speedshop
Jan Meininghaus

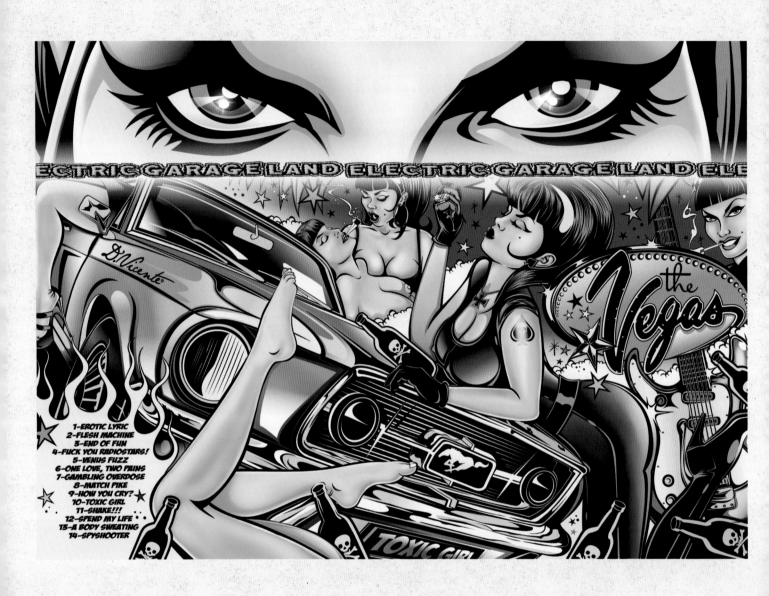

ABOVE: Electric Garage Land
David Vicente

RIGHT: Kliko Poster
Leviathan

PATRONAAT PRESENTS:

THE JON SPENCER
BLUES EXPLOSION
THE JIM JONES REVUE [UK]
LITTLE BARRIE [UK]
TRAUMAHELIKOPTER [NL]
THE PHANTOM FOUR [NL]
THE CAEZARS [UK] THE CUBICAL [UK]

- THE DRIP DRY MAN
 & THE BEAT REVOLVER BAND [UK]
- THE SATELLITERS [D]
- THE PIGNOSE WILLY'S [NL]
- BULLERSLUG [NL]
- BAZOOKA [GR]
- CHEAP THRILLS [NL]
- DE SP ATIES [NL]

KLITKO
FEST

LEVIATHAN

HOSTS: BONE & MR WEIRD BEARD OF THE IRRATIONAL LIBRARY.
DJ'S: CRAZY CRUDESJEV, 13 & POTLOOD, DE ROOIE NEGER,
WESTBANK & GAZA, BARRY STILETTO

SATURDAY 20 APRIL 2013

PATRONAAT
ZIJLSINGEL 2 HAARLEM
Saturday 20 april € 15,- Presale
From 21.00 till 06.00 € 20,- Door

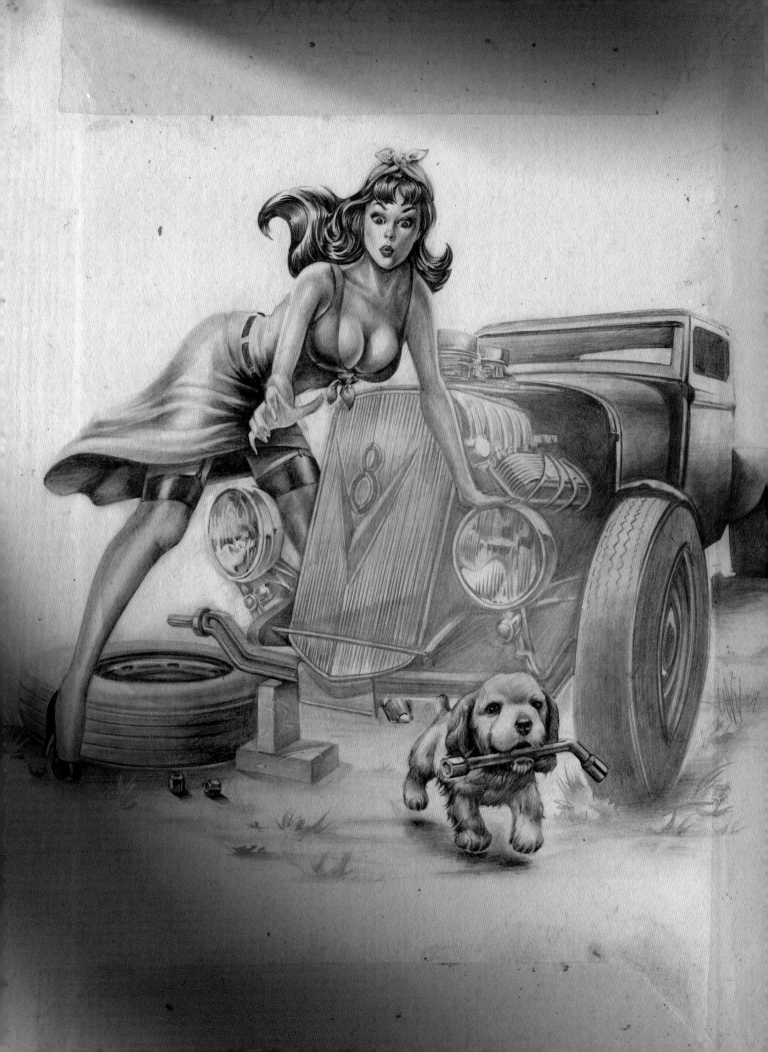

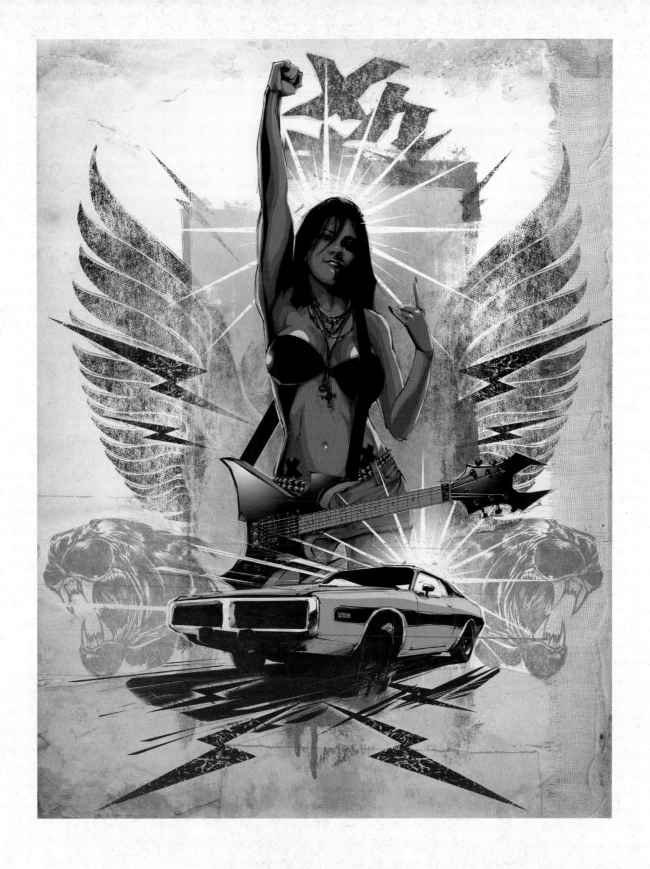

LEFT: Don't Play With My Tools
Jan Meininghaus

ABOVE: Charger Chick
Jan Meininghaus

99

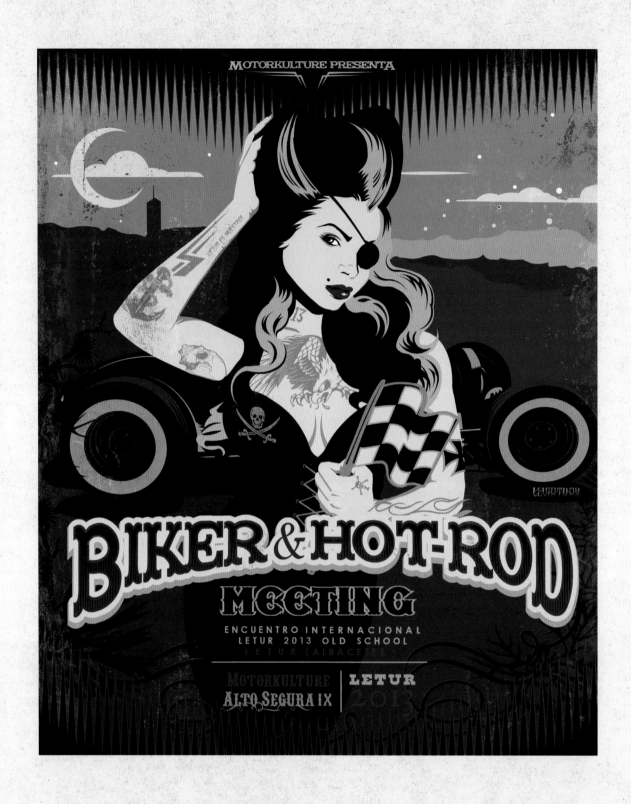

ABOVE: Letur 2013
Leviathan

RIGHT: Las Vegas
Leviathan

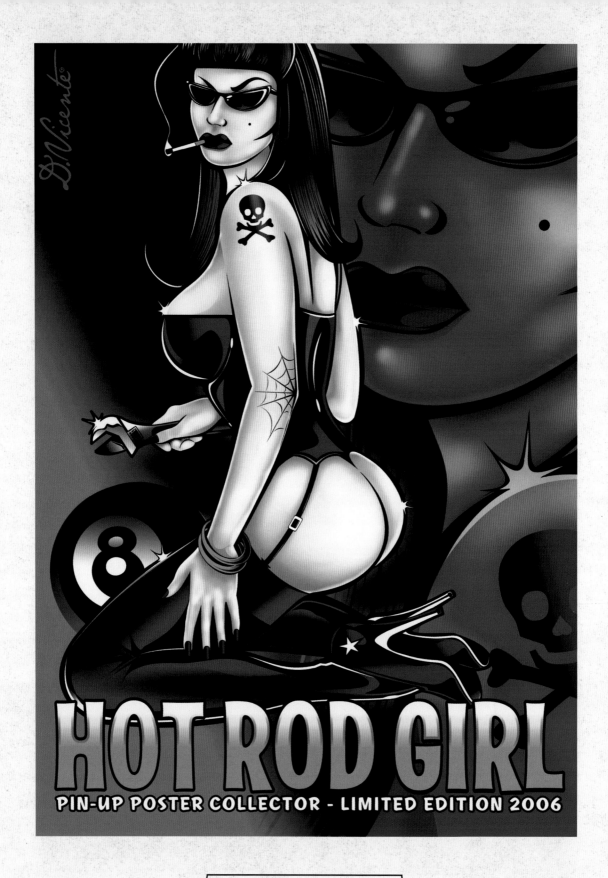

ABOVE: Hot Rod Girl
David Vicente

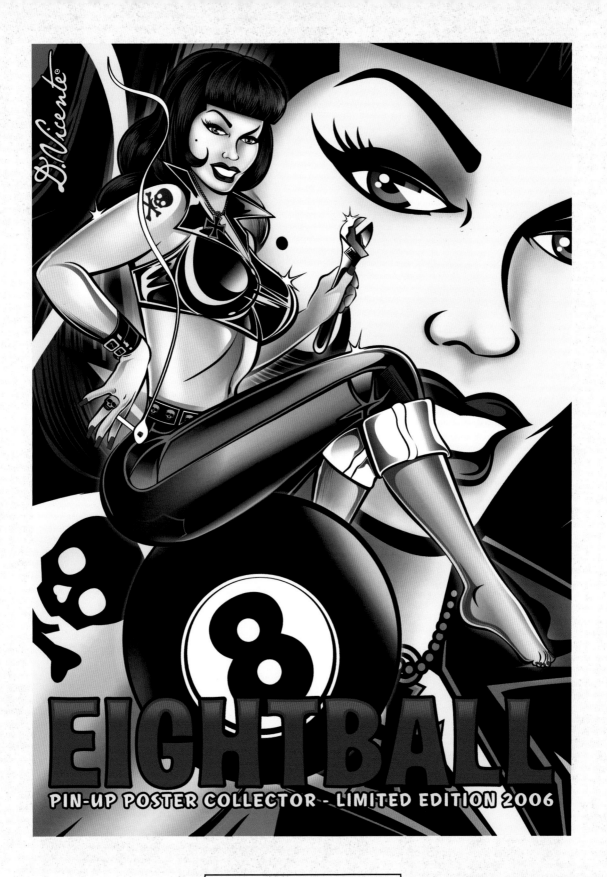

ABOVE: Eightball Girl
David Vicente

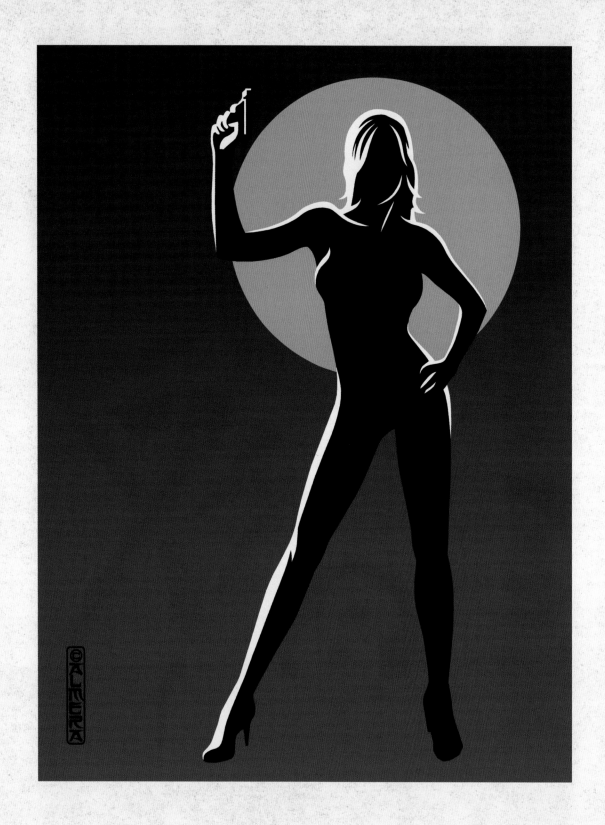

ABOVE: Blondie
Marco Almera

RIGHT: Muscle Car Girl
Marco Almera

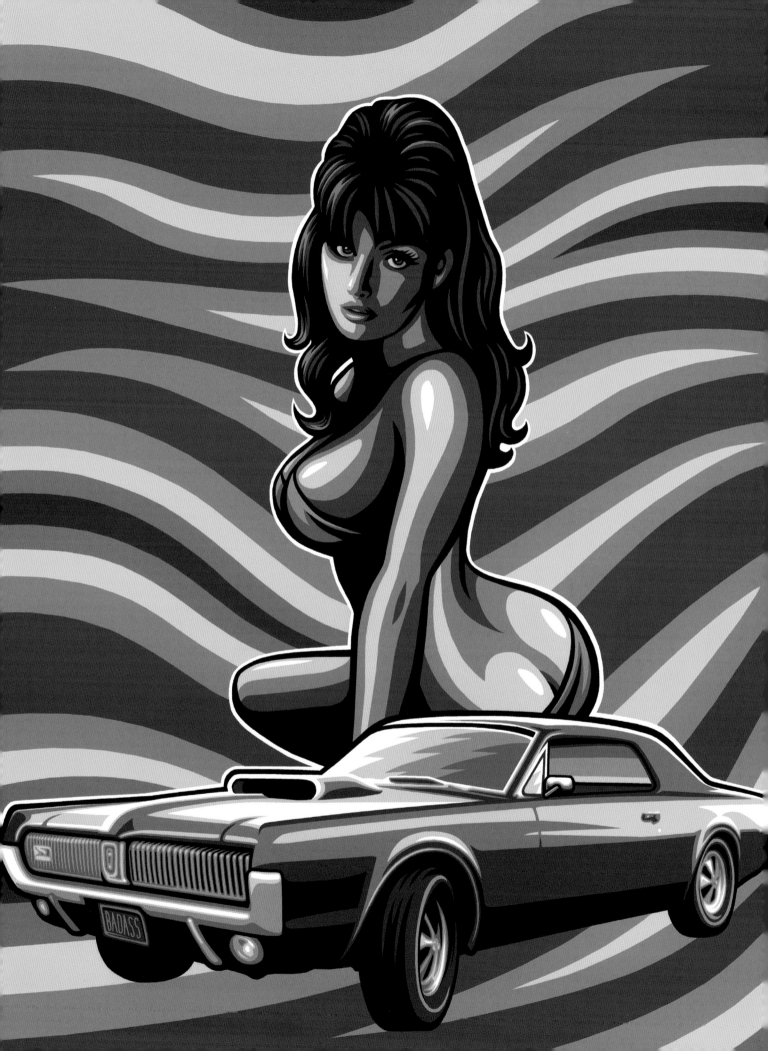

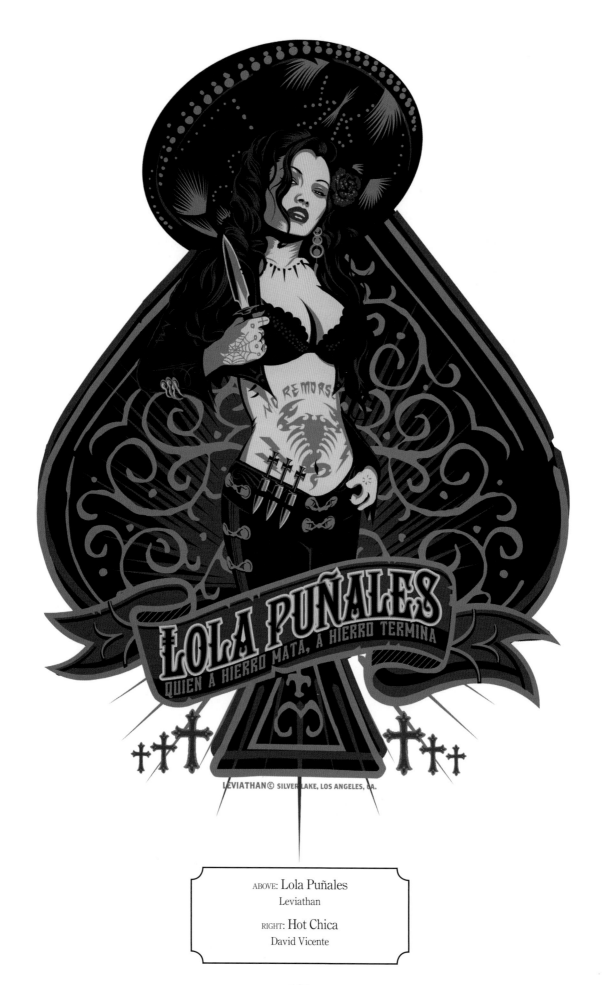

ABOVE: Lola Puñales
Leviathan

RIGHT: Hot Chica
David Vicente

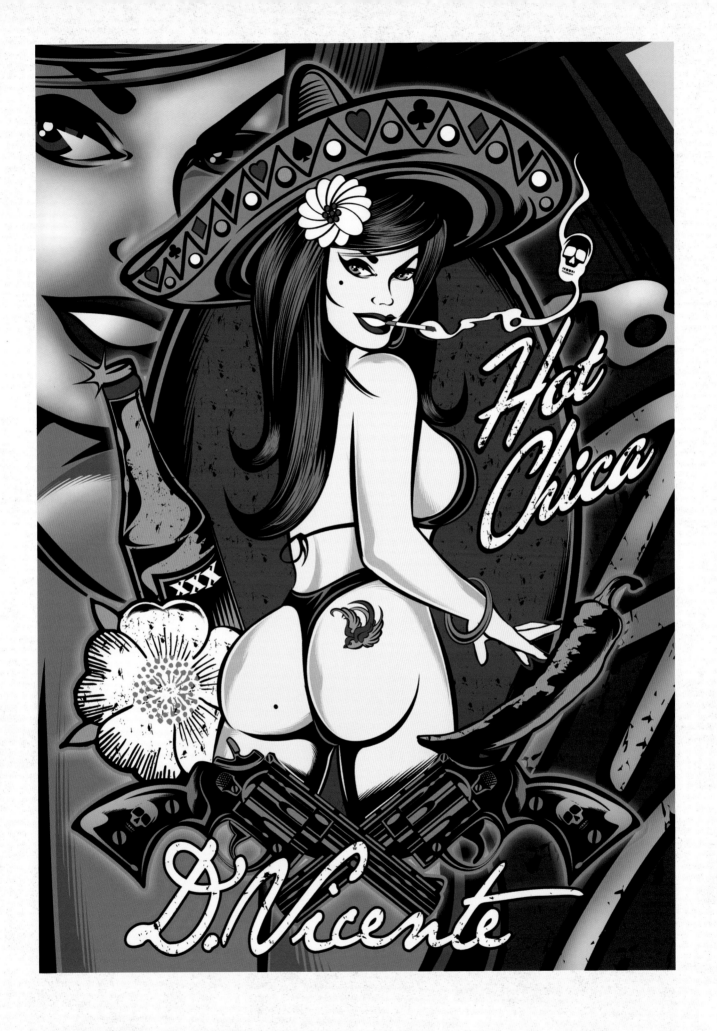

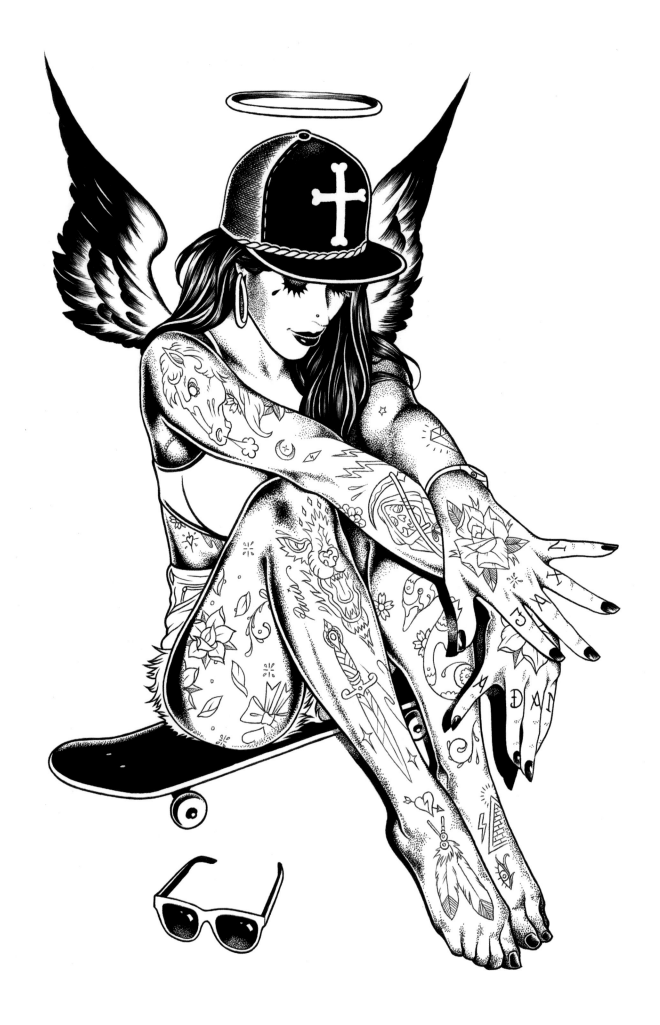

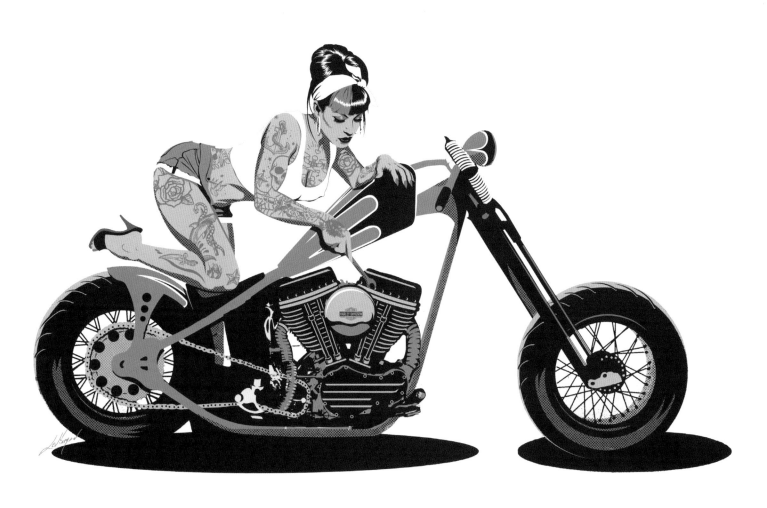

LEFT: Saint
Adam Isaac Jackson

ABOVE: Mecanica
Leviathan

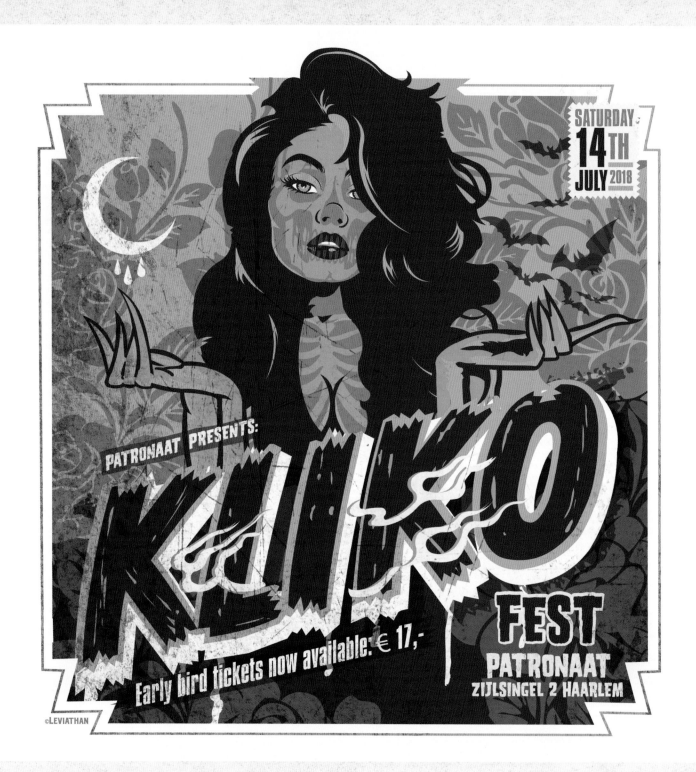

ABOVE: Kilko Flyers
Leviathan

RIGHT: Cienfuegos
Leviathan

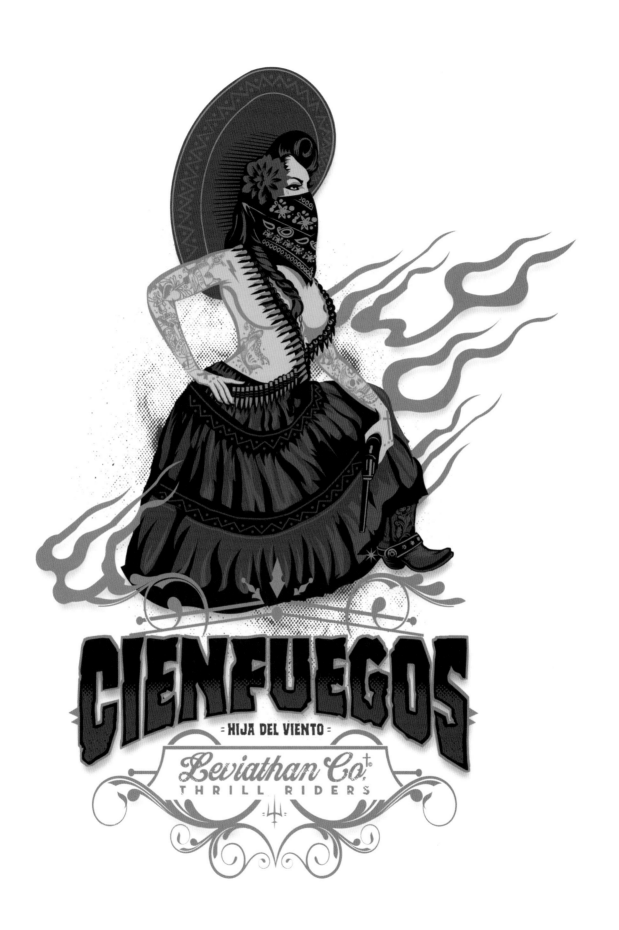

CIENFUEGOS

= HIJA DEL VIENTO =

Leviathan Co.
THRILL RIDERS

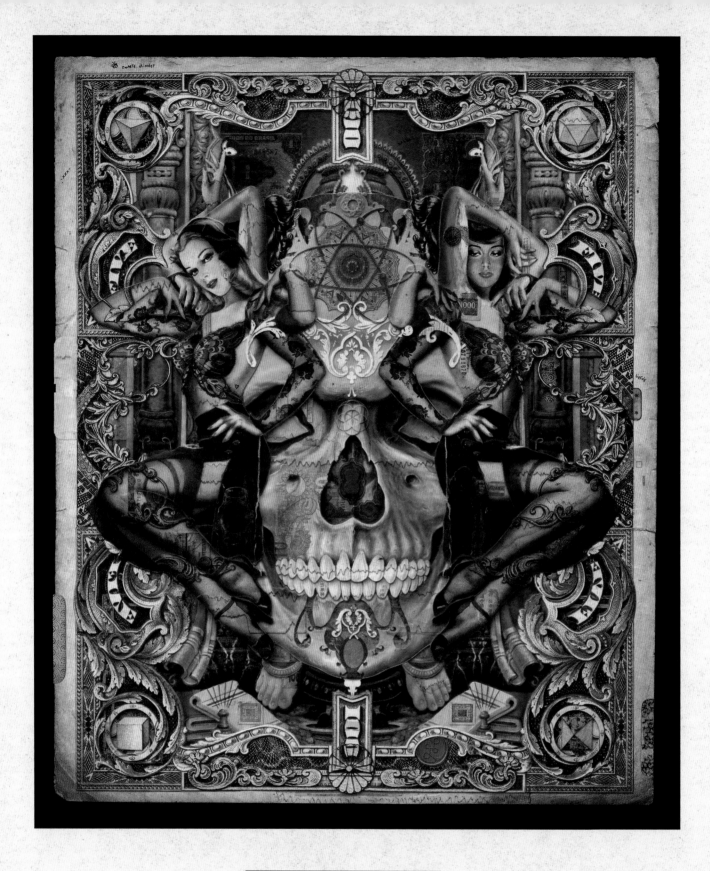

ABOVE: Zwarte Vlinder
Handiedan

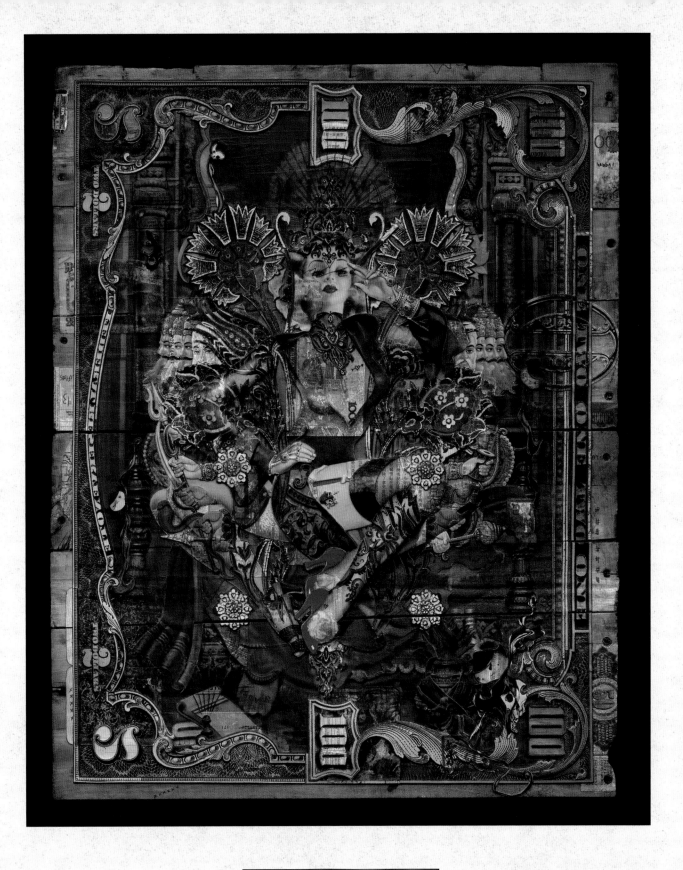

ABOVE: Bollywood Sugar
Handiedan

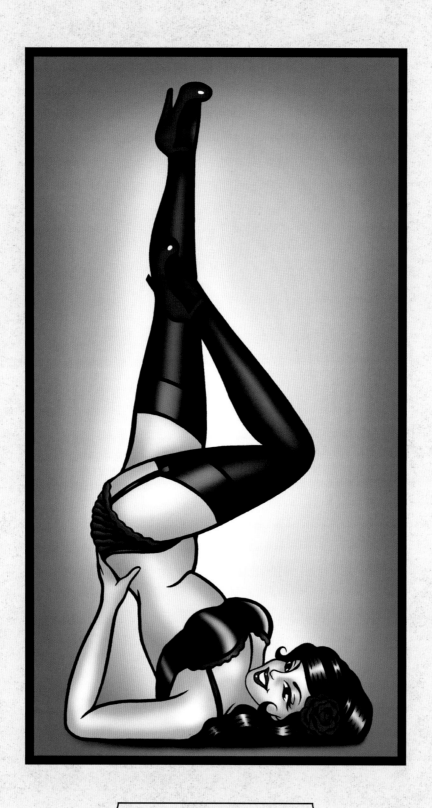

ABOVE: Clair
Claudia Hek

RIGHT: Tattooed Lady
Claudia Hek

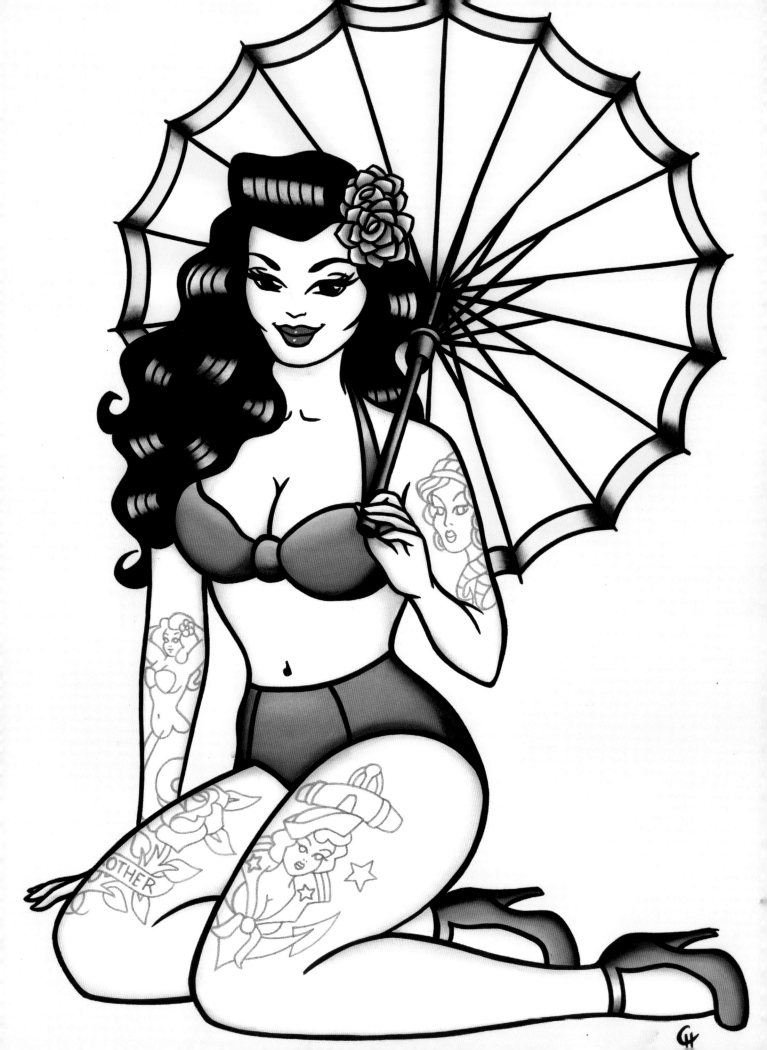

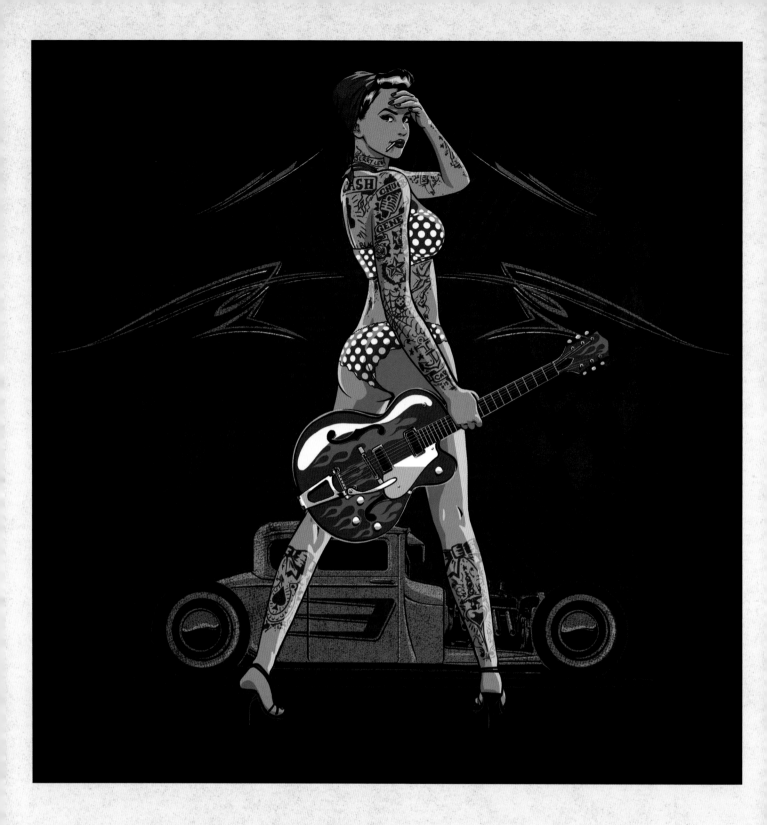

ABOVE: Rockabilly Babe
Jan Meininghaus

RIGHT: Kamikaze
Jan Meininghaus

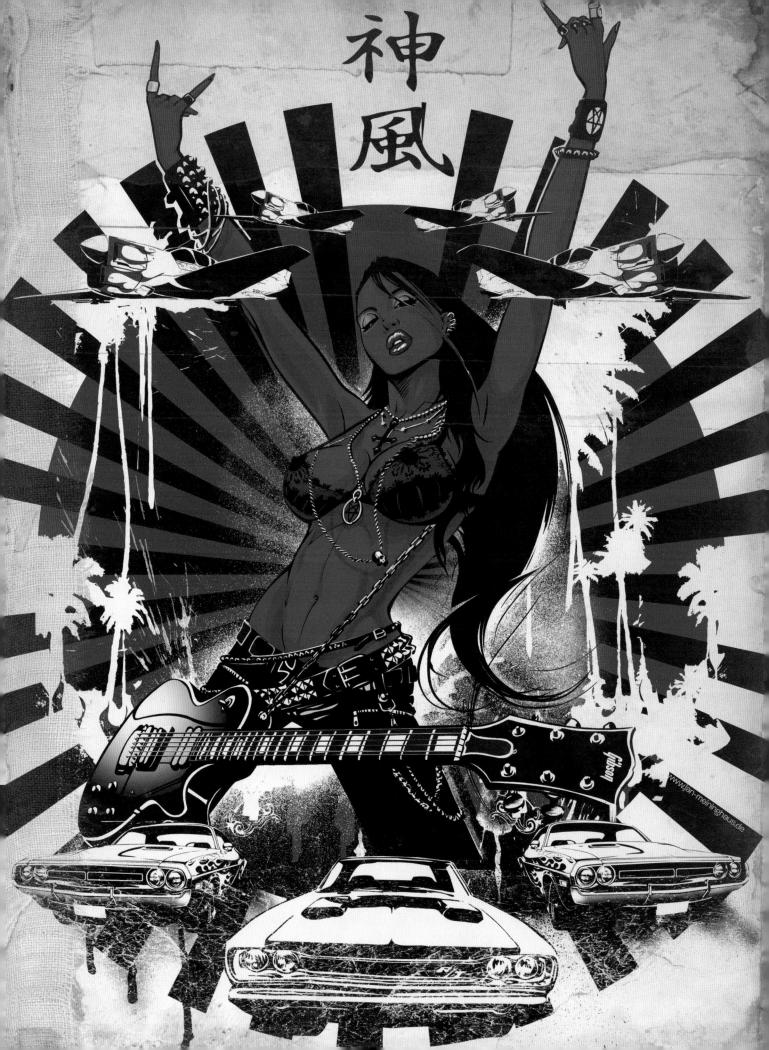

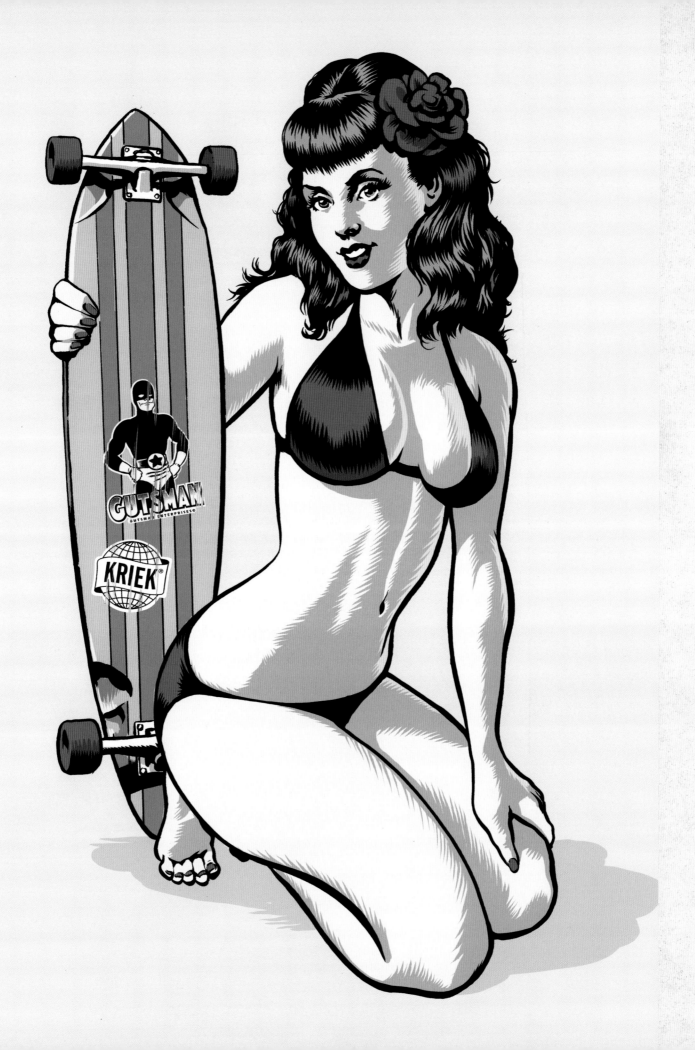

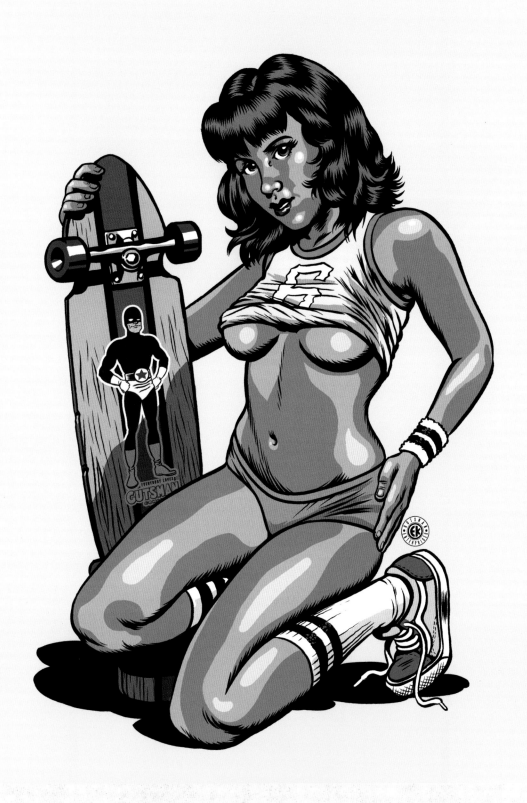

LEFT: Longboard Baby
Erik Kriek

ABOVE: Vintage Skate Chick
Erik Kriek

119

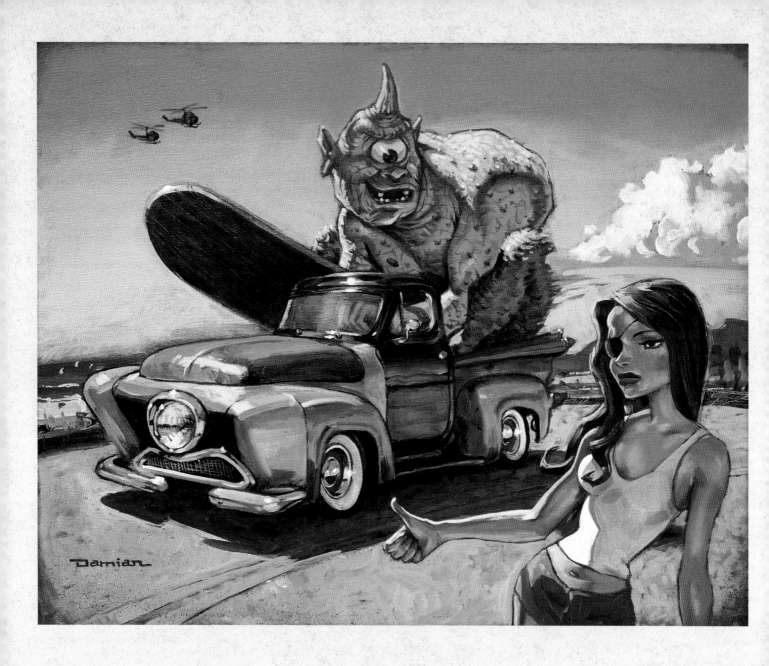

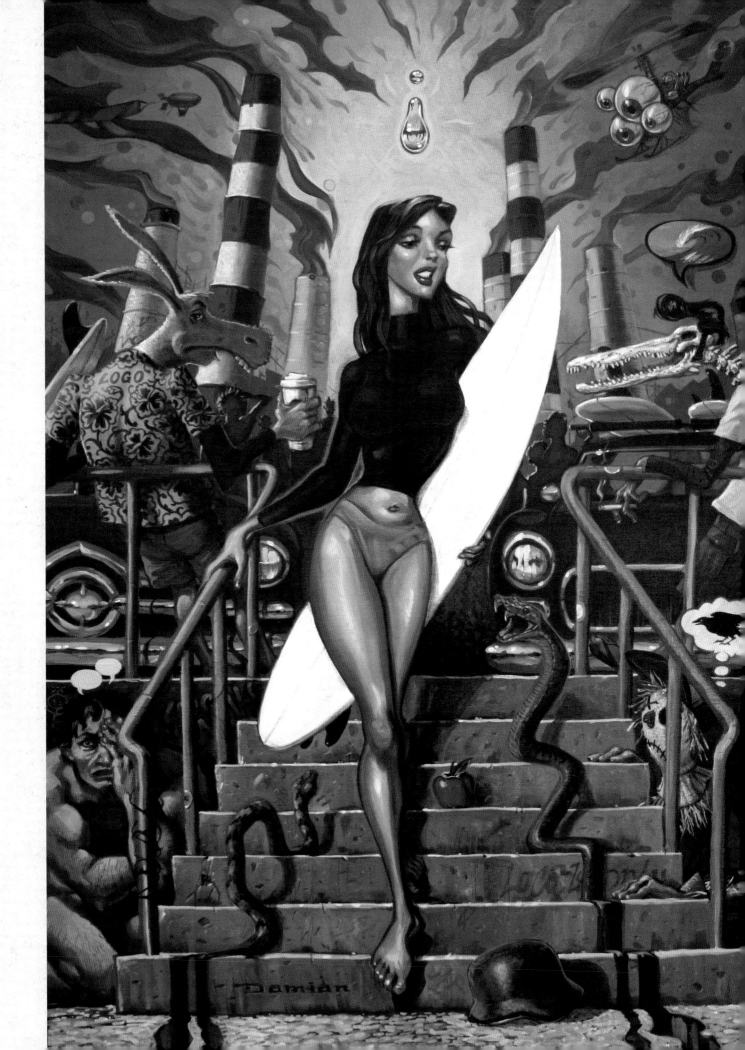

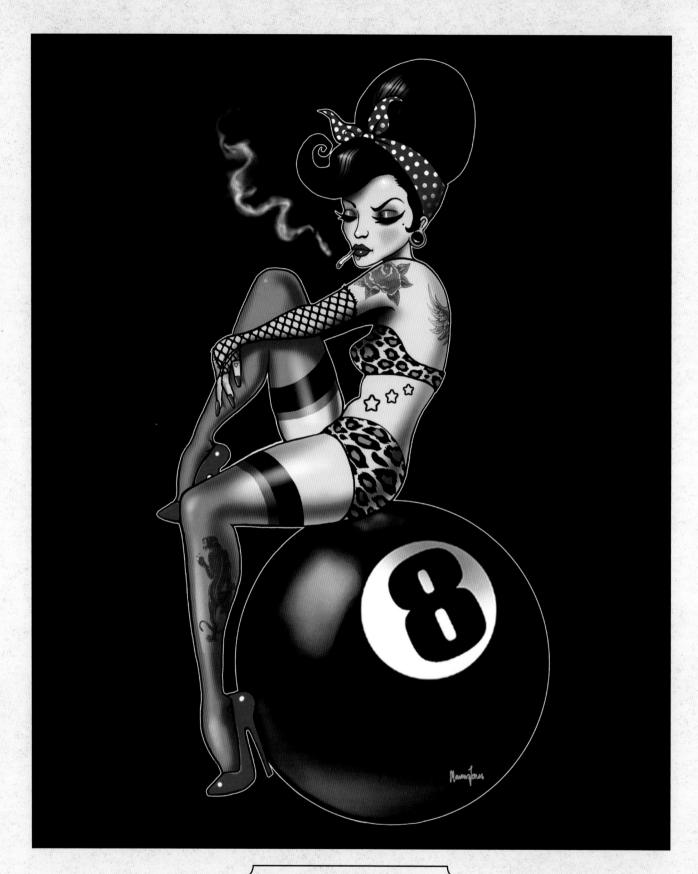

ABOVE: Eightball Pinup
Screaming Demons

RIGHT: Reverend Horton
Leviathan

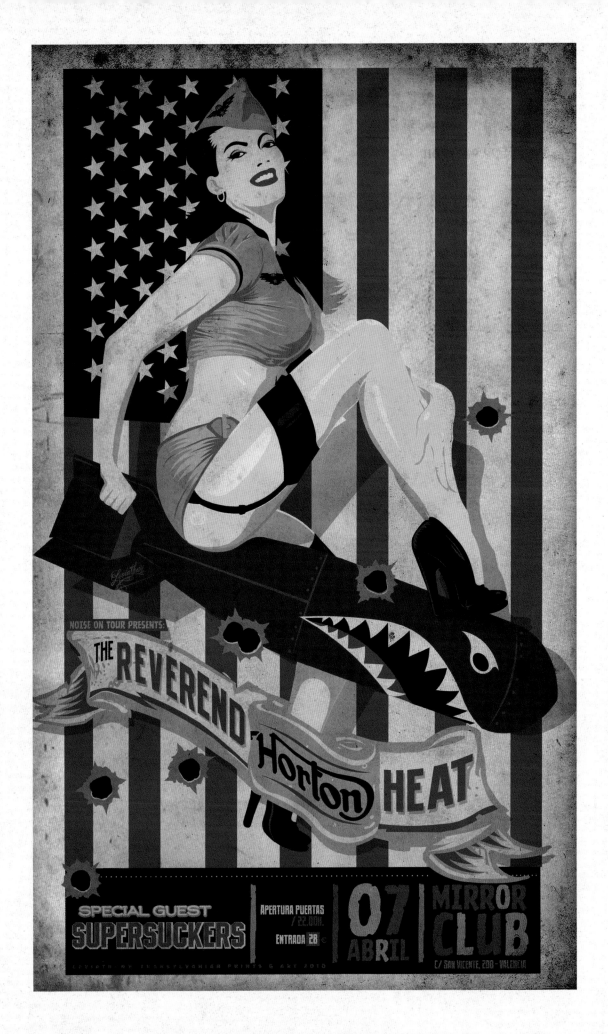

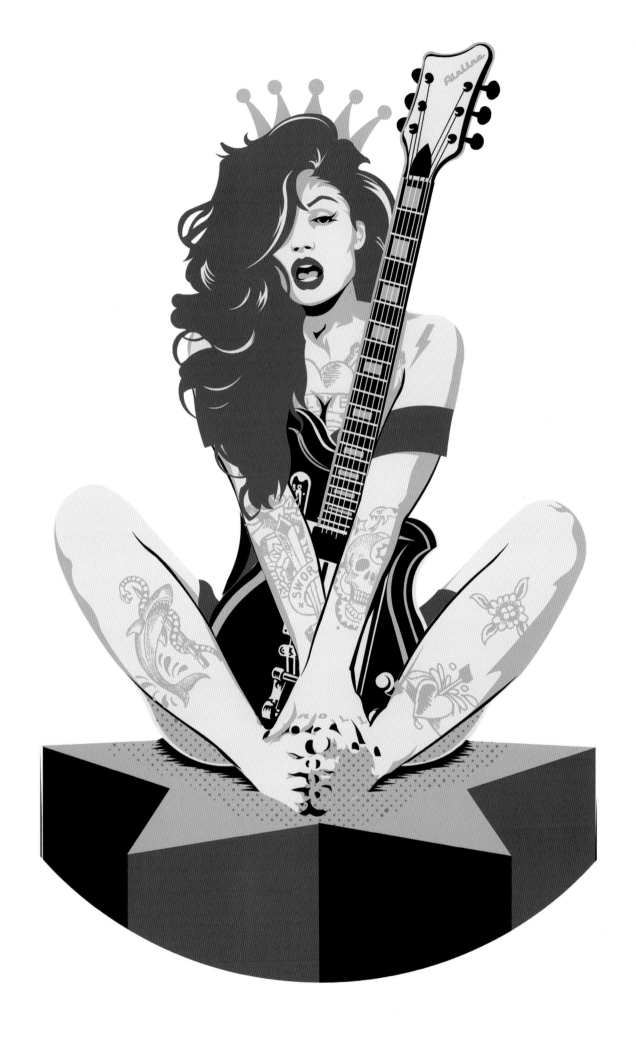

BADASS GIRLS

The tradition of a more out-and-out bad-girl pinup goes back to prohibition-era America. Artists like Enoch Bolles would use an art deco style to paint a sultry cover girl, often in an unapologetically sexualised position. Whilst depictions of good-girls-in-compromising-positions went on to reign during World War II, Hollywood's Film Noir inspired a range of loudly-coloured, explosive detective novel covers, with 1940s and 1950s artists like Howell Dodd and George Gross giving us smoking gun molls and femme fatales in stockings and impossibly tight dresses. With the 1970s advent of VHS – and a tsunami of porn – the flirty innocence of classic American pinup suddenly seemed old hat, and this paved the way for Dave Stevens' exquisite dominatrices and Patrick Nagel's 1980s power-stance women.

A classic of badass pinups has long been the GWG (Girl With Gun). Established as a genre of its own with Asian GWG movies in the '50s and '60s (which then influenced manga and anime pinups), these armed females were dangerous. Often GWGs fought to do good, but '80s and '90s comics became filled with deadly antiheroines, complete with weapons and hypersexual bodies of exaggerated proportions – like the villainous, leather-bikinied Lady Death from the '90s horror series by Chaos! Comics. Whilst weapons feature heavily across badass pinups – in fantasy and science-fiction and otherwise – bottles of booze and cigarettes (as with rock 'n' roll pinups), whips (dominatrix), motorcycles (Hot Rod), and even briefcases – are used to show a gutsy dominance in pinup art (the last accessorising 80s-influenced, men-trampling businesswomen). The 1980s punk movement also spawned a surge in screw-you attitude in pinup images, where an irresistibly spunky, spiky-haired subject might be flipping you off.

LEFT: Rock n Roll
Leviathan

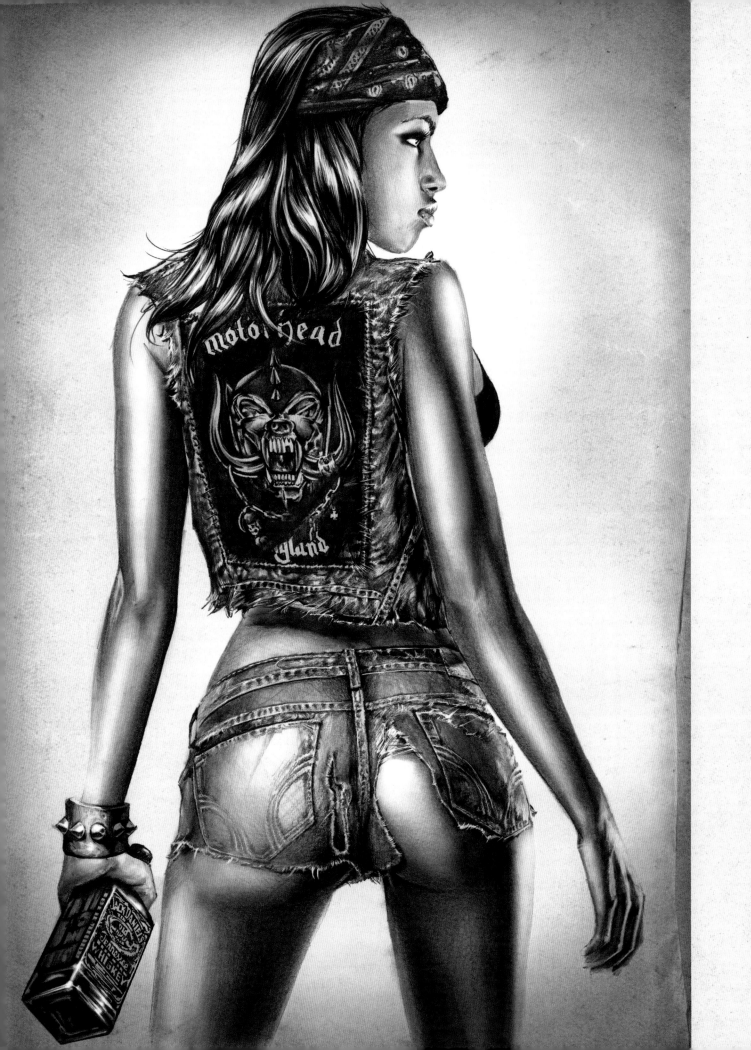

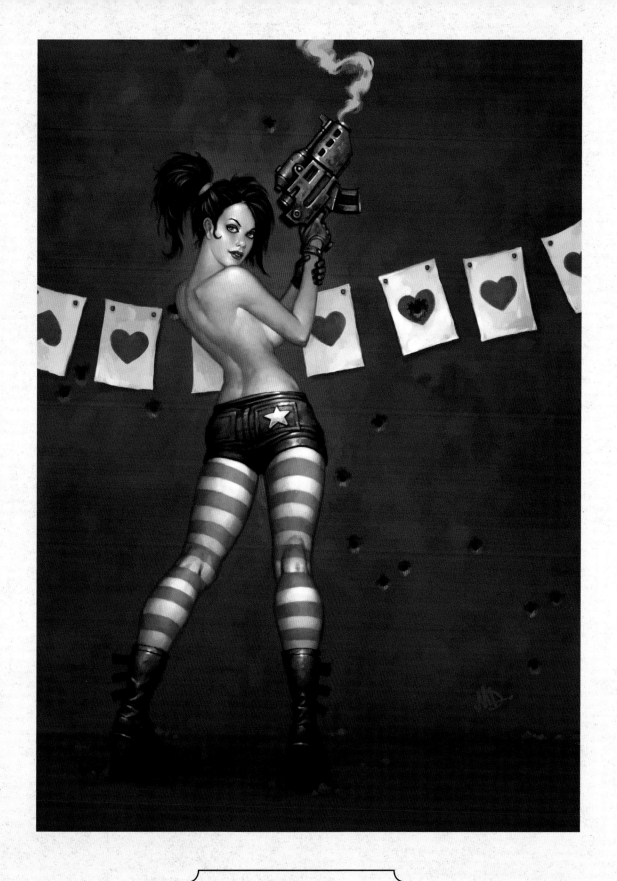

LEFT: Motorhead
Jan Meininghaus

ABOVE: Sharpshooter
Matt Dixon

FUEL DURDEN
FULL IMPACT

THE LAST HOPE FOR HUMANITY... RESTS ON A HIGH-POWER MACHINE GUN!

PIN-UP TERROR

A D. VICENTE INTERNATIONAL PICTURES RELEASE STARRING FUEL DURDEN. FANART BY DAVID VICENTE
WEBSITE WWW.DVICENTE-ART.COM & WWW.MYSPACE.COM/FUEL__DURDEN

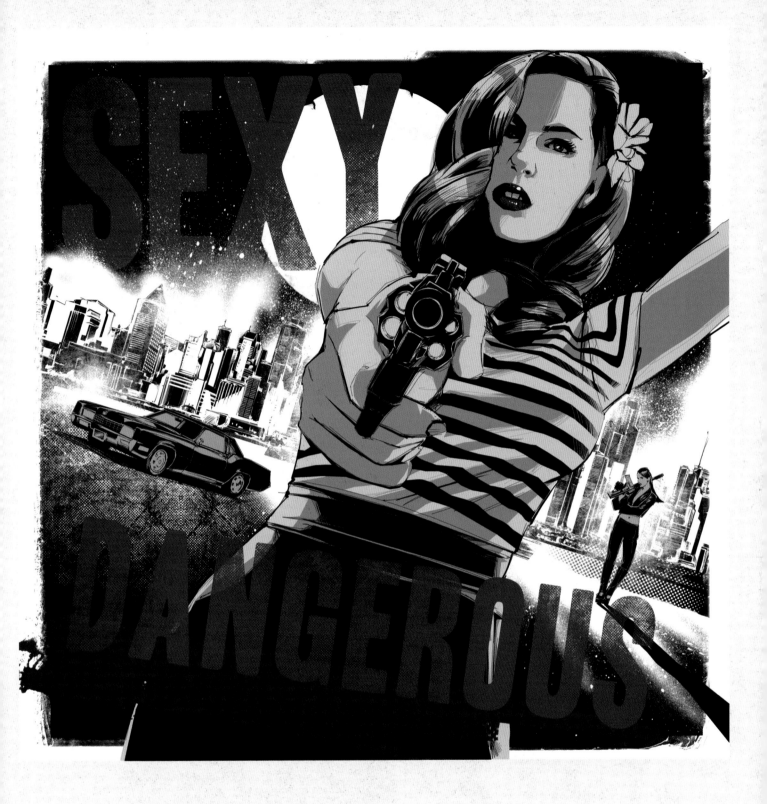

LEFT: Pin-Up Terror
David Vicente

ABOVE: Sexy Dangerous
Jan Meininghaus

129

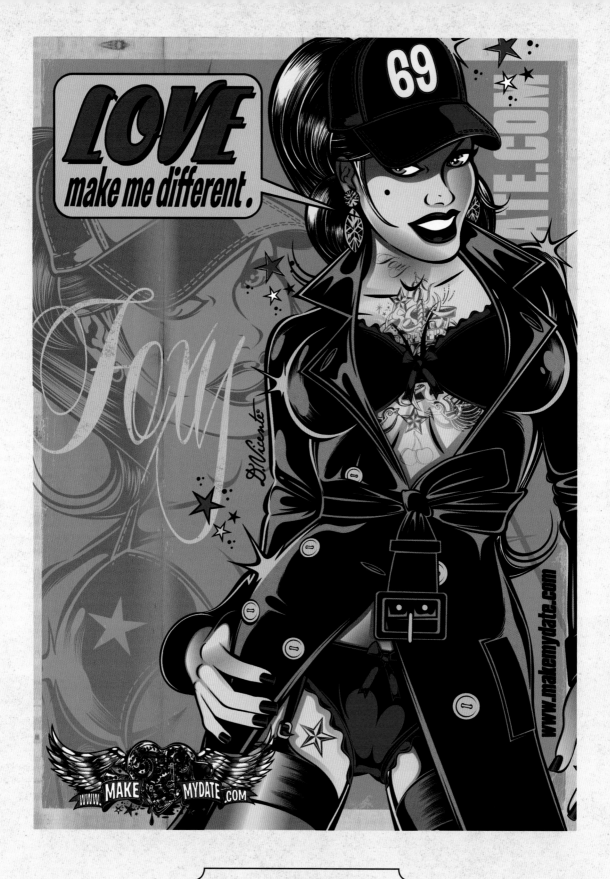

ABOVE: Foxy Poster
David Vicente

RIGHT: The Bride
Ted Hammond

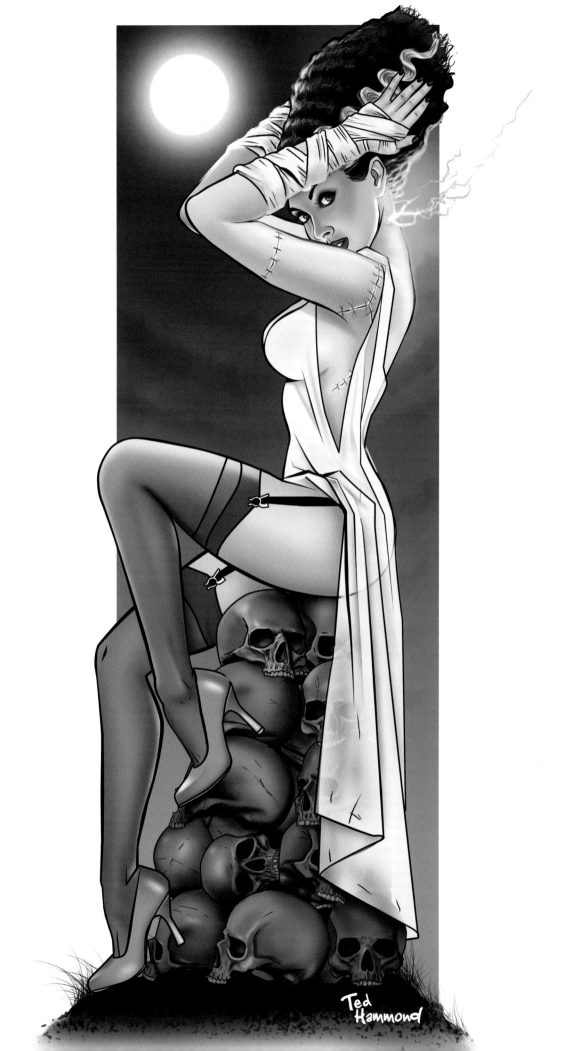

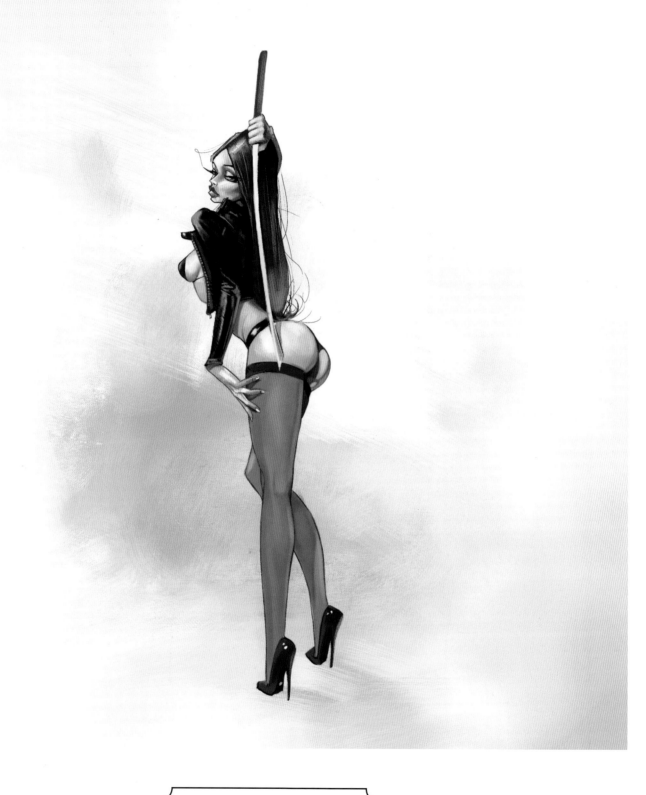

ABOVE: Bond Girl No 2
Caroline Vos

RIGHT: Bond Girl No 3
Caroline Vos

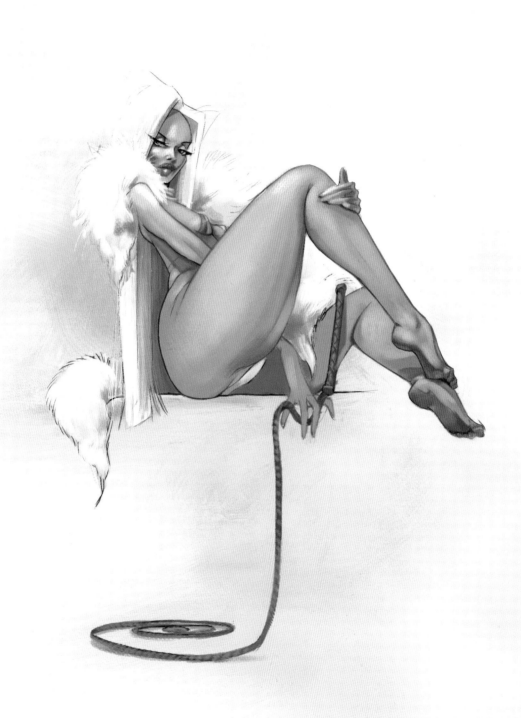

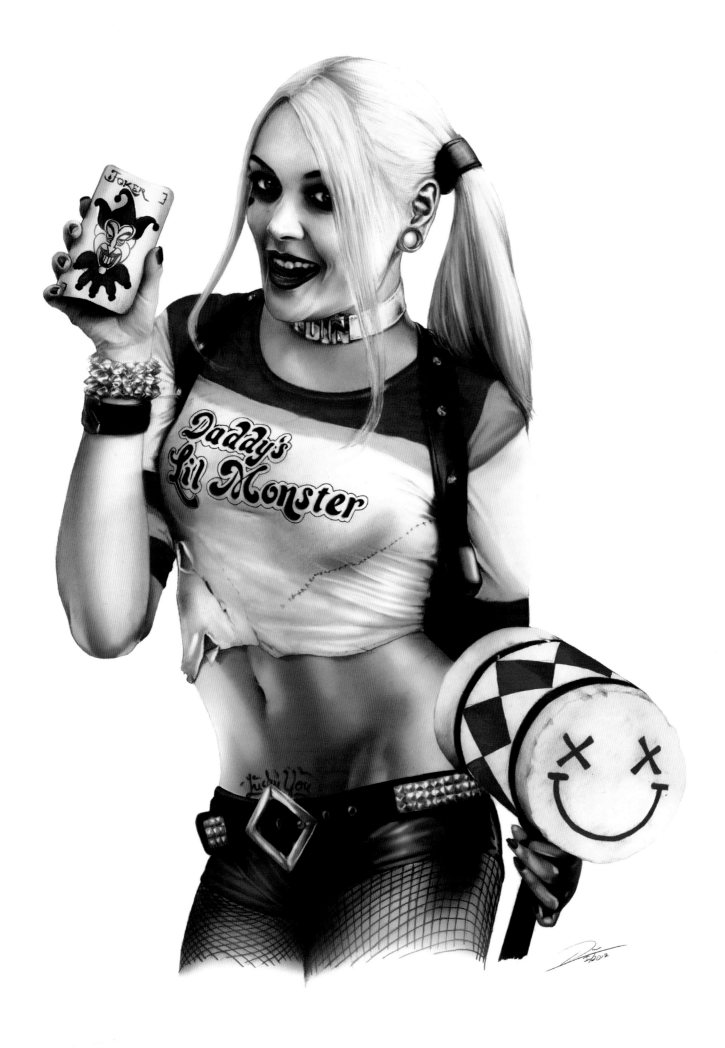

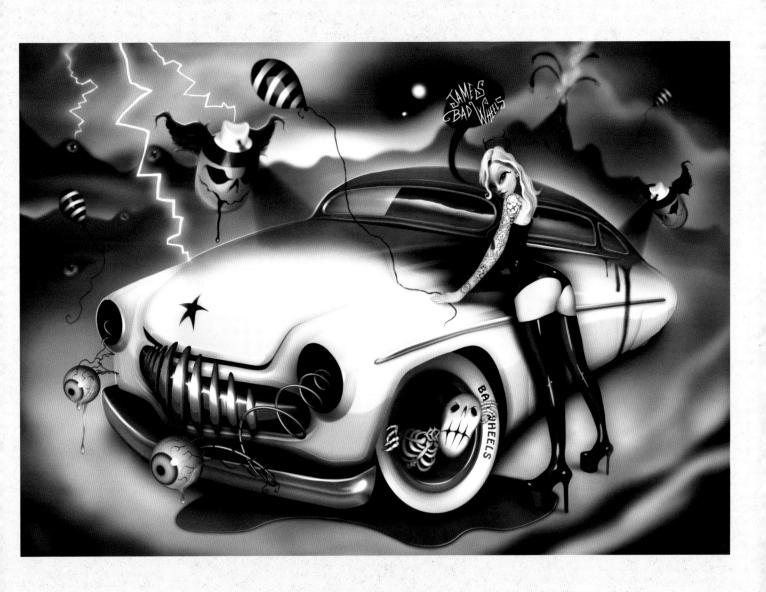

LEFT: Lucky You
Dirk Richter

ABOVE: Bad Wheels
Gianluca Mattia

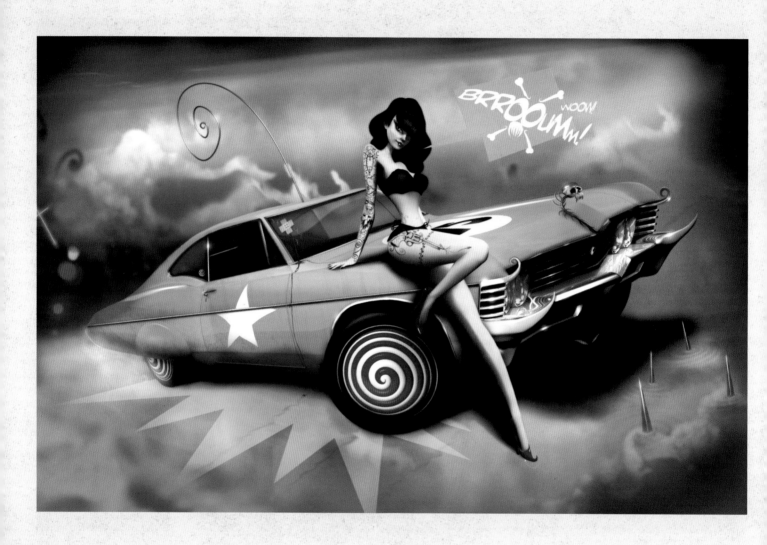

ABOVE: Juanita
Gianluca Mattia

RIGHT: Jumping Teds, Shrunken Heads
and Punk Co-Eds
Chris Wahl

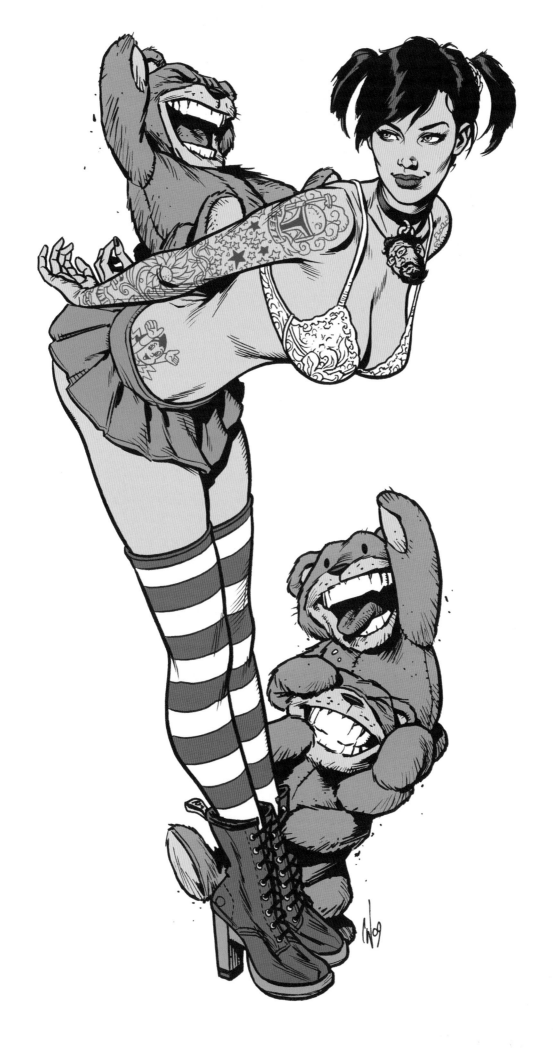

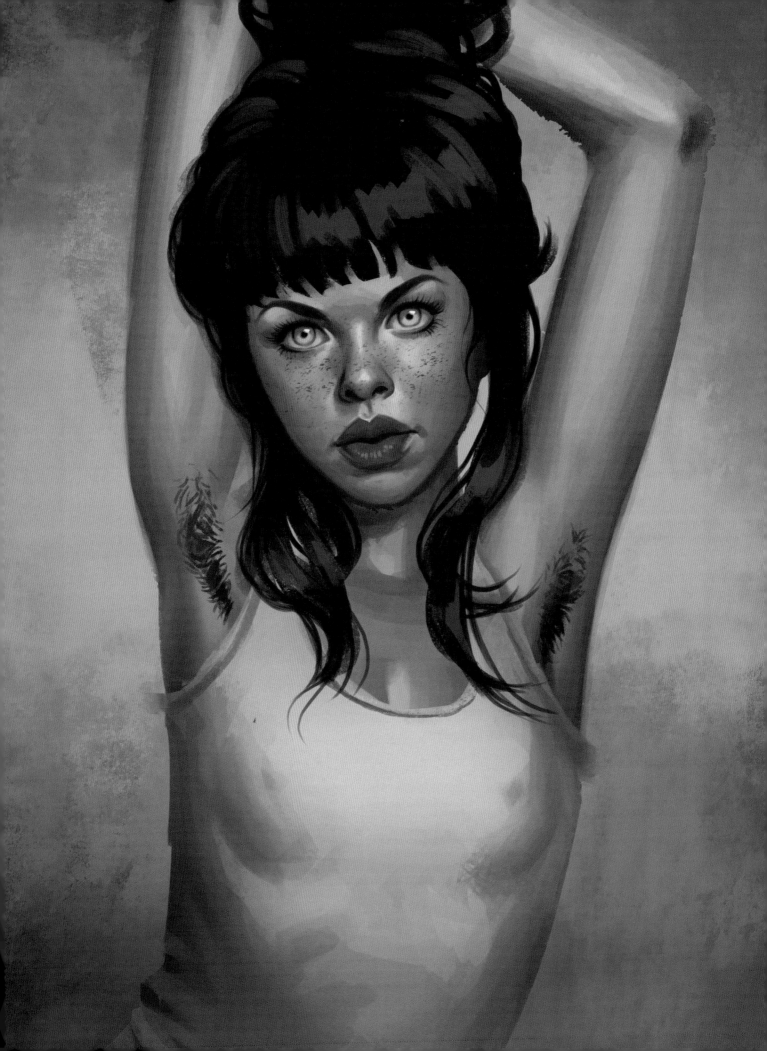

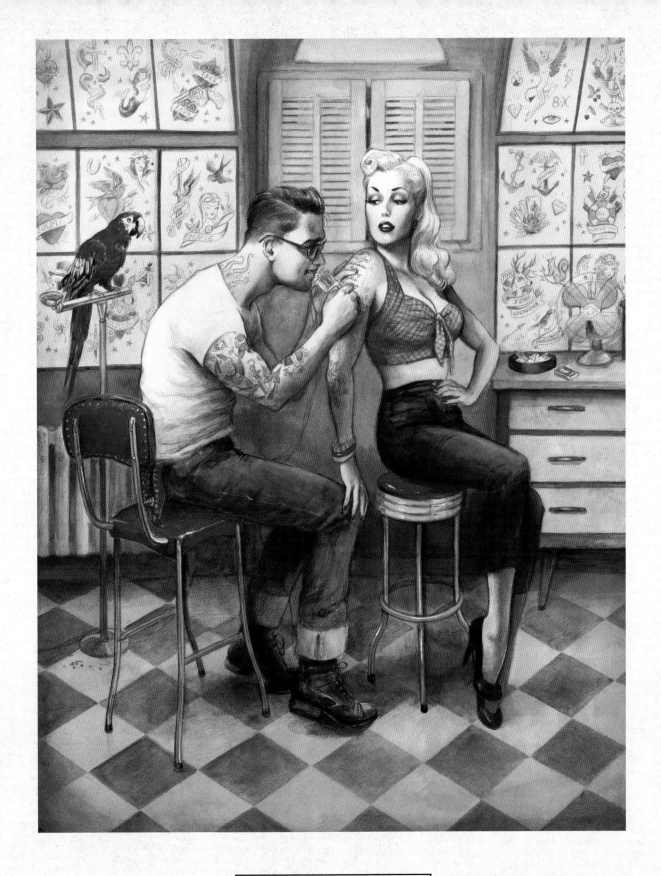

LEFT: Freedom
Daniela Uhlig

ABOVE: At the Tattoo Shop
Maly Siri

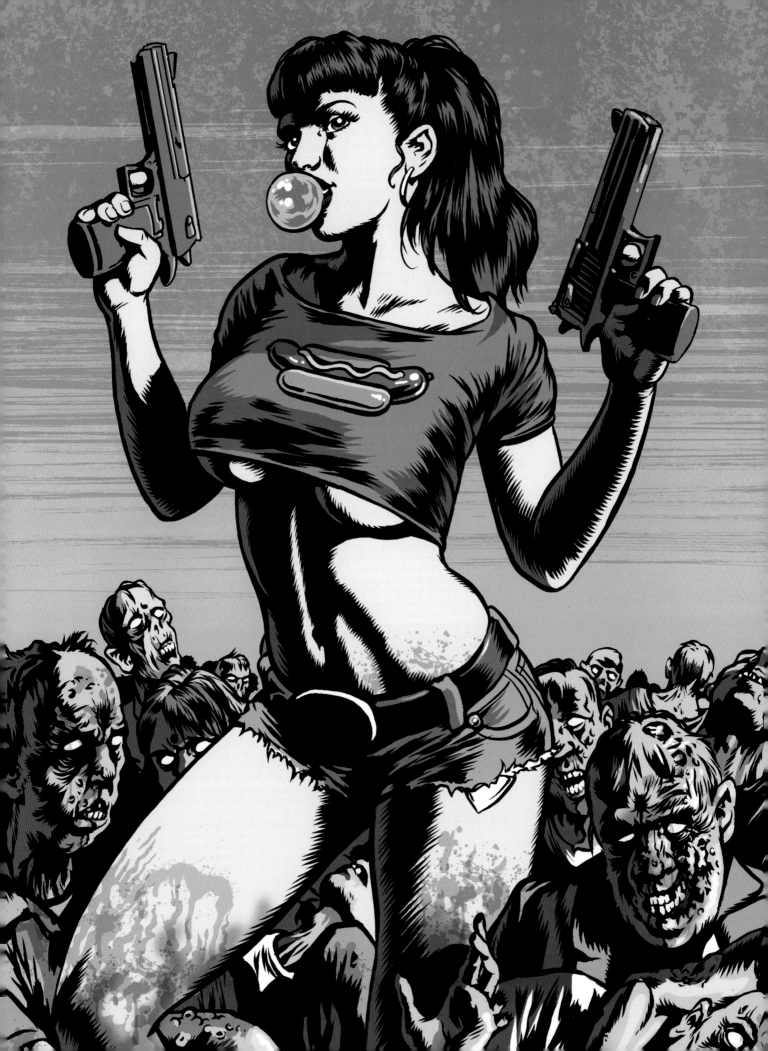

HORROR, ZOMBIE & HALLOWEEN PINUP

It seems the marriage of sexy pinups and spooky stuff goes back to the end of the 19th century, once the western world had shaken off its terror of the occult and attractive witches started to appear on adverts for products like soap. Come October, during the first three decades of the century, the United States was awash with illustrated Halloween postcards, party invitations and tally cards for Halloween games – often adorned with lascivious sorceresses in slightly suggestive poses. This trope persisted in the '40s and '50s, with Hollywood studios like MGM sending out publicity shots of starlet Ava Gardner in witchy garb, and classic cheesecake artists Gil Elvgren and George Petty creating broomstick-riding broads.

Meanwhile, the likes of '30s horror pulp cover artist Margaret Brundage (check out her amazing *Weird Tales* artwork) and '60s fantasy pinup legend Frank Frazetta were helping to broaden the scary-meets-sexy pinup genre into genuinely darker territories. Then came the brilliant George A. Romero, who lifted the zombie out of the B-movie zone with his 1968 smash hit *Night of the Living Dead*. This movie introduced the idea of recently deceased zombies being ravenous for human flesh – rather than the voodoo-animated, human-controlled corpses of previous motion pictures.

The birth of in-your-face guts and gore in horror movies in the '70s spawned a more twisted style of pinup – the flesh-eating zombie babe. By the '80s, certain rules for the portrayal of zombies had been set, which have remained staples of the genre. Zombies are less than cunning - they have simple, bloodthirsty motives and the only way to kill one is with a very strong blow to the head. The popularity of both the zombie movie and zombie pinup boomed in the following decades, with artists giving a nod to the trend with cannibalistic originals and tongue-in-cheek subversions of classic pinups – turning Vargas' girls green!

LEFT: Zombie Killer
Erik Kriek

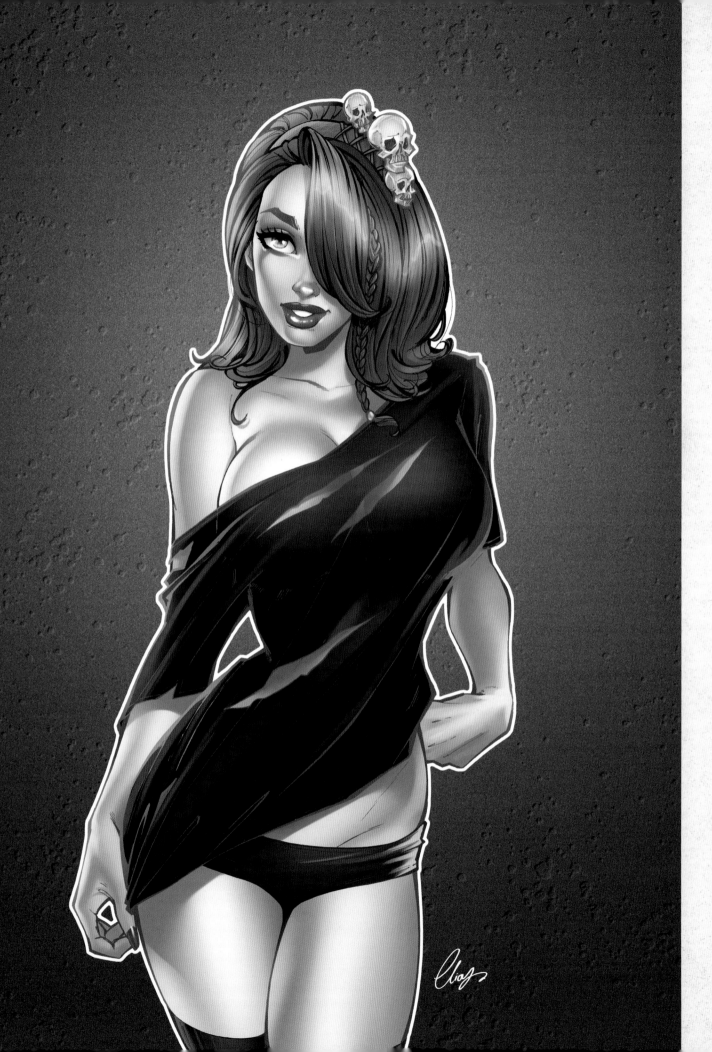

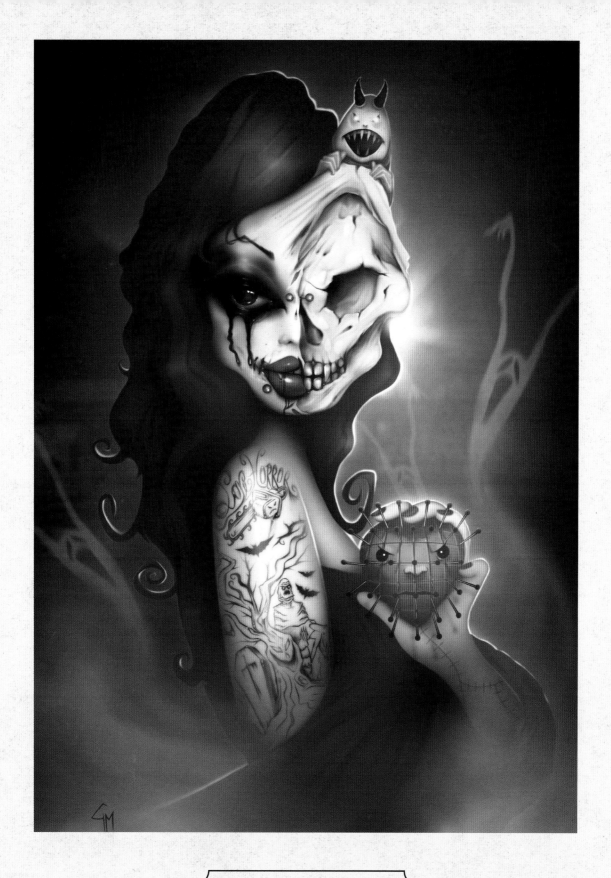

LEFT: Debora
Elias Chatzoudis

ABOVE: Sacramento Horror Festival
Gianluca Mattia

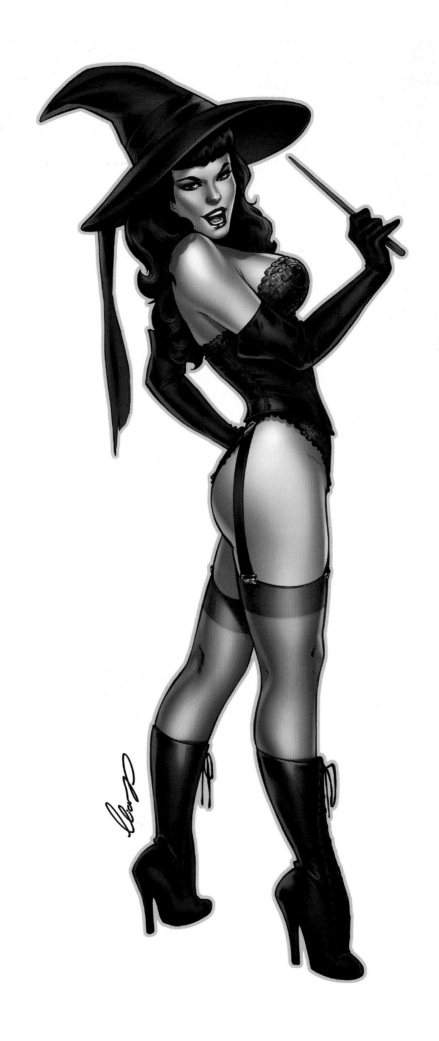

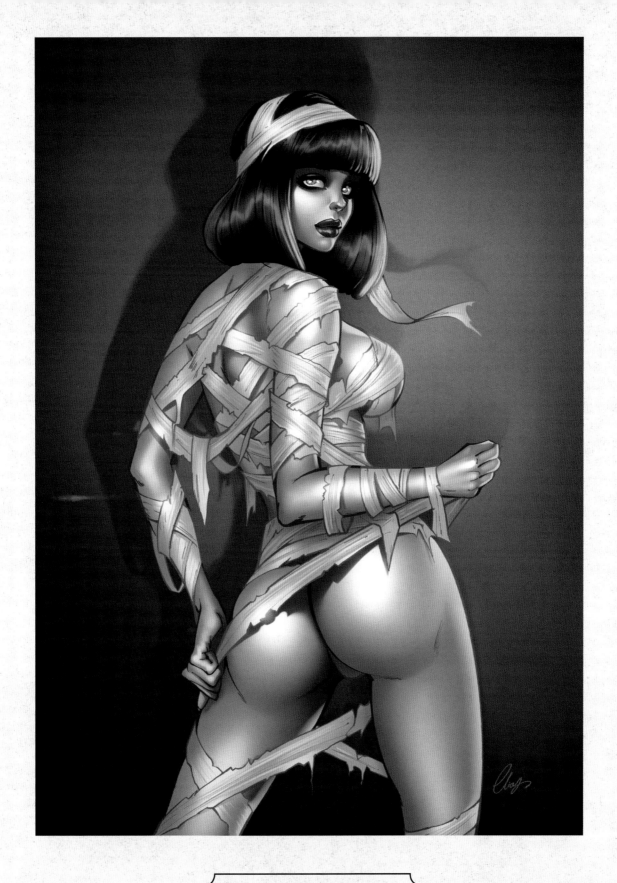

LEFT: Bettie Witch

Elias Chatzoudis

ABOVE: Mummy Chick

Elias Chatzoudis

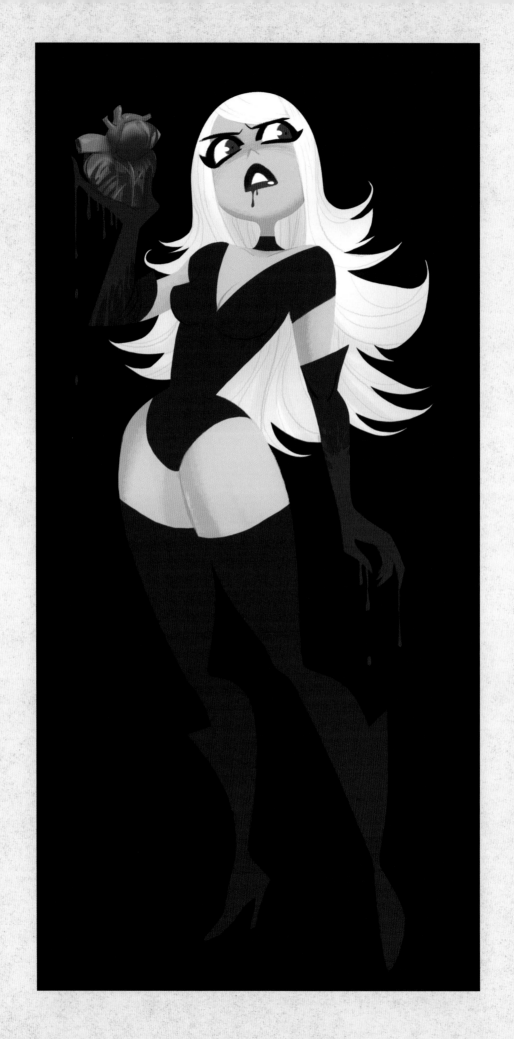

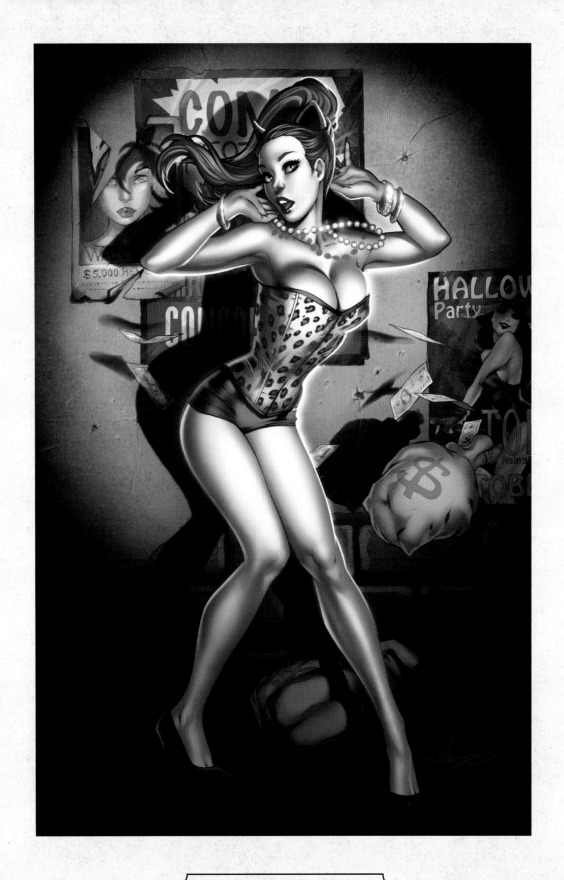

LEFT: Bloody Mary
Guillaume Poux

ABOVE: Red Cat
Elias Chatzoudis

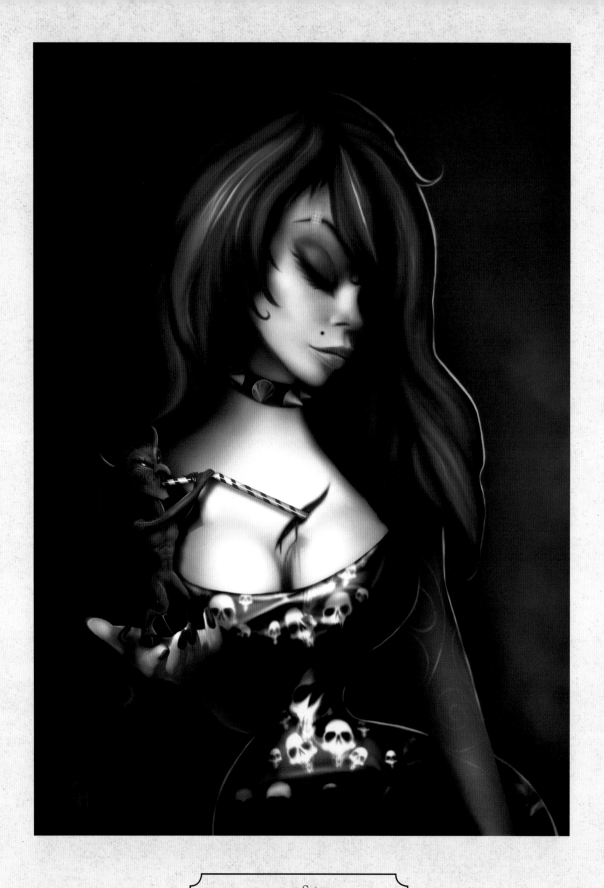

ABOVE: Sete
Gianluca Mattia

RIGHT: Vampire Girl
Mike Hoffman

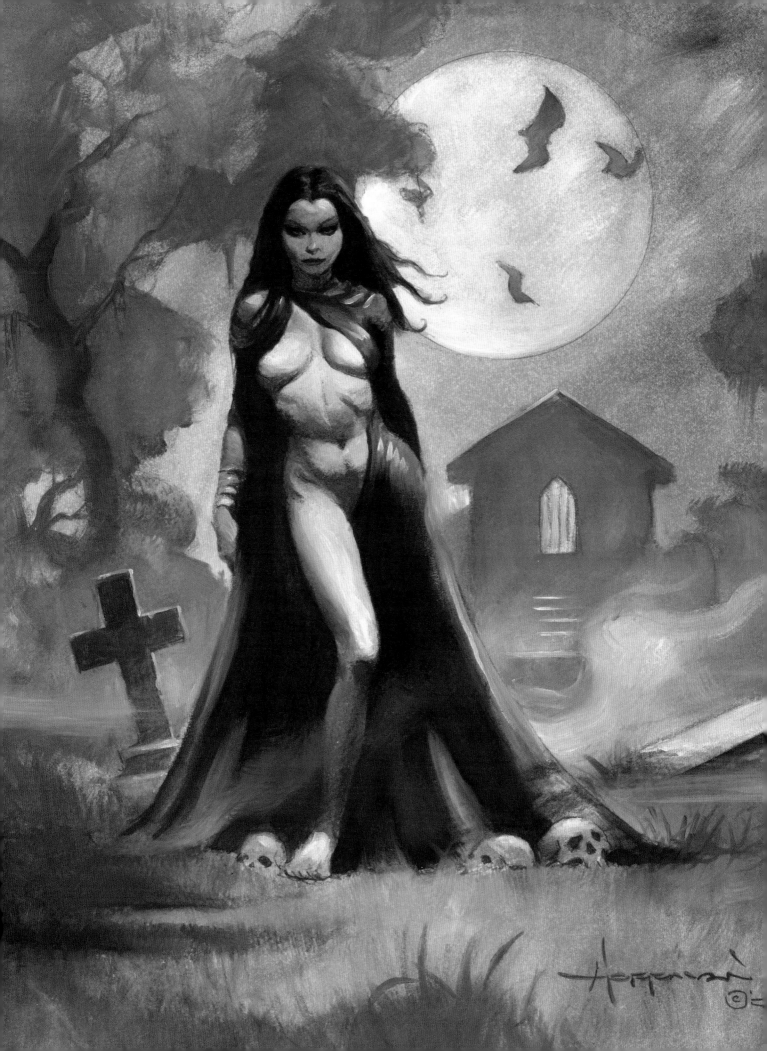

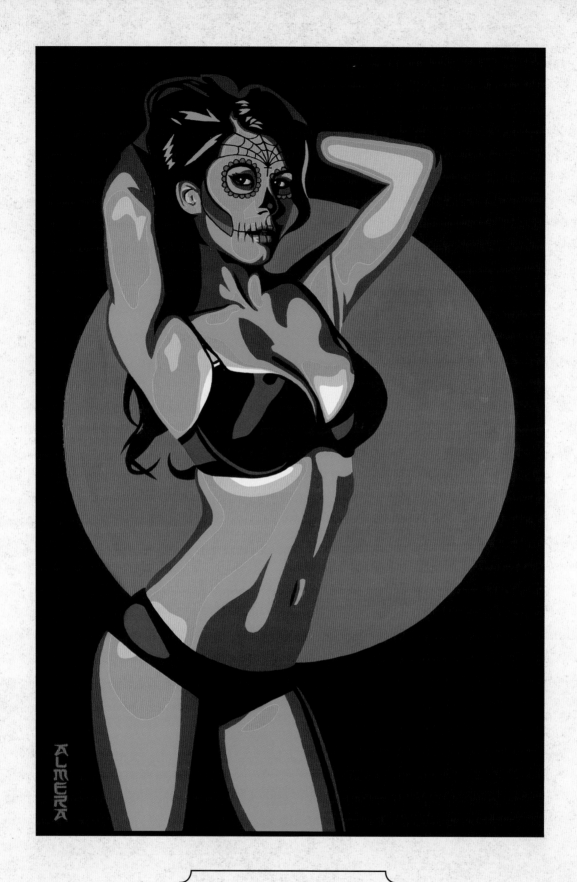

ABOVE: Sundown
Marco Almera

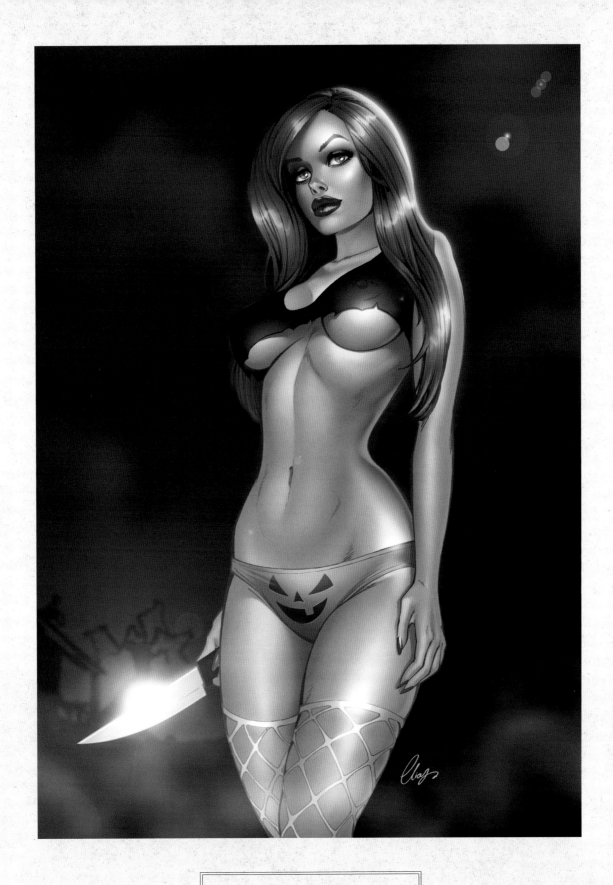

ABOVE: Loreina
Elias Chatzoudis

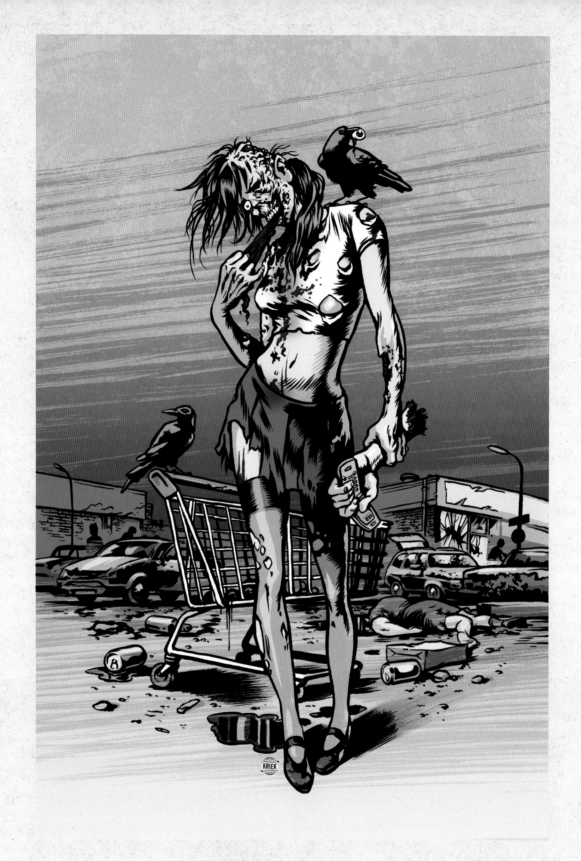

ABOVE: Zombie Bitch
Erik Kriek

RIGHT: Vampira
Leviathan

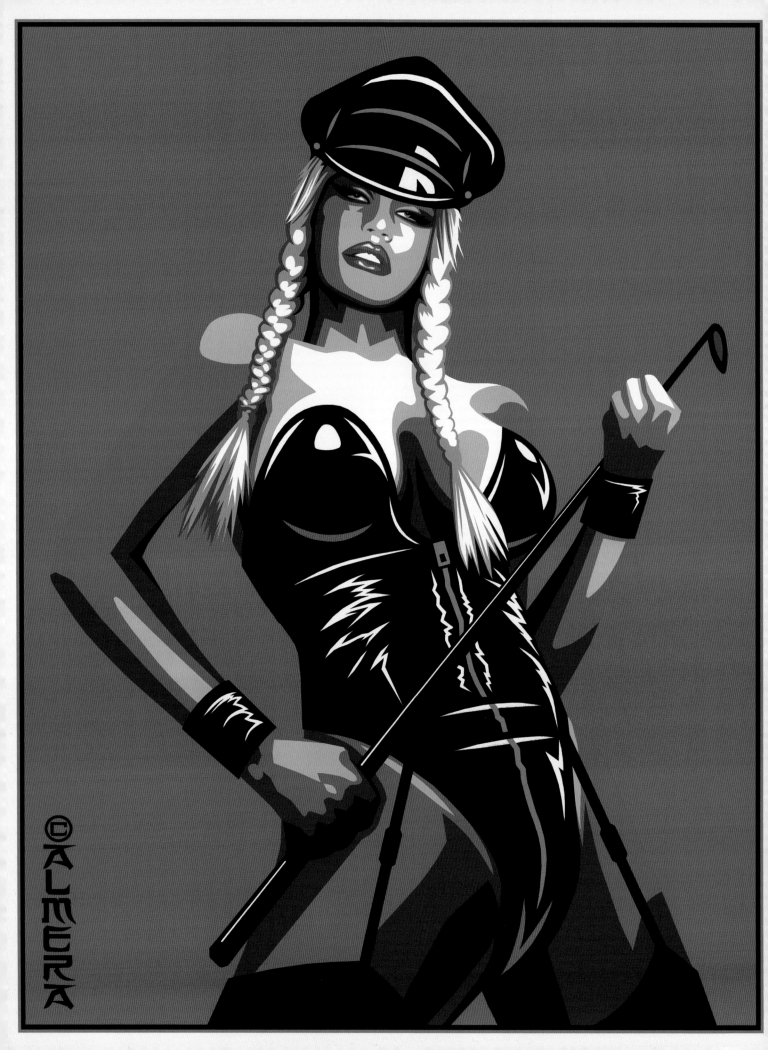

DOMINATRIX PINUP

The undisputed king of the dominatrix pinup was Eric Stanton. Reportedly saying, "A woman has to be strong. The bigger the better," Stanton was an American fetish and bondage cartoonist and illustrator, who started getting published in erotic bondage comics and daily panels in the 1940s, when he was just 16. Stanton, whose influence continues to be felt in erotic comics and beyond today, had what you could call a modern attitude to female sexual empowerment. Throughout his life he championed dominant women and bondage in all sorts of scenarios, and often used the recurring motif of gigantic females in his work.

The dominatrix label and images of 'dominatrix governesses' originally appeared on tiny advertisement cards in early-20th century tobacconist windows in Soho, London. These flagellating mistresses were part of the 'bizarre underground' of major cities like New York, San Francisco, Berlin and London and were kept largely out of plain sight. During the prim and proper 1940s, Irving Klaw became one of the first fetish photographers, and made waves in the 1950s by photographing pinup Bettie Page tying up other models and brandishing whips. It was actually Klaw who helped get Eric Stanton noticed, publishing his work in one of his popular erotic comics, which were the under-the-counter homes of dominatrix art at the time. In the 1960s these dominant dames could finally step out into the spotlight – with sadomasochistic leading ladies in Hollywood films *The Balcony* and *Venus in Furs*, and, in the UK, *The Avengers'* incredibly popular Emma Peel running the show in a skin-tight leather catsuit. Men's magazines soon followed suit.

Leather has become completely synonymous with dominatrix practice – partly thanks to 1970s *AtomAge Magazine*, which was published worldwide to help promote the company's successful rubber and leather fetish clothing line. Dominatrix pinups will nowadays very often (but not always) be pictured in leather, PVC, spikes or a corset, brandishing a whip, bondage ties, or other instruments of pleasure. The attitude may be cheeky and playful (with a contrasting subtext) or all-out mean. The key is the woman is in control and whoever her subject, she will choose the outcome.

LEFT: Dominatrix
Marco Almera

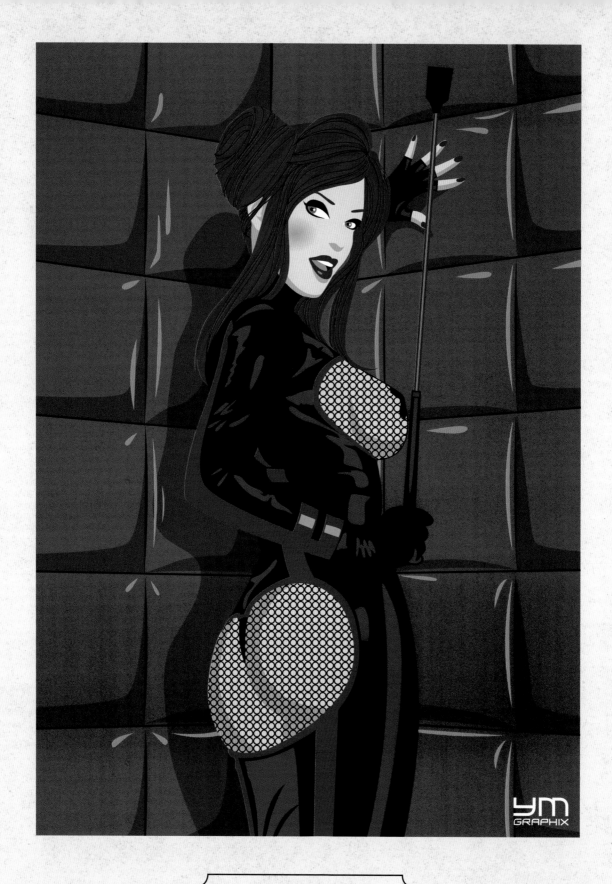

ABOVE: Rubber Doll
Yves-José Malgorn

RIGHT: Trixie
Andrew Hickinbottom

156

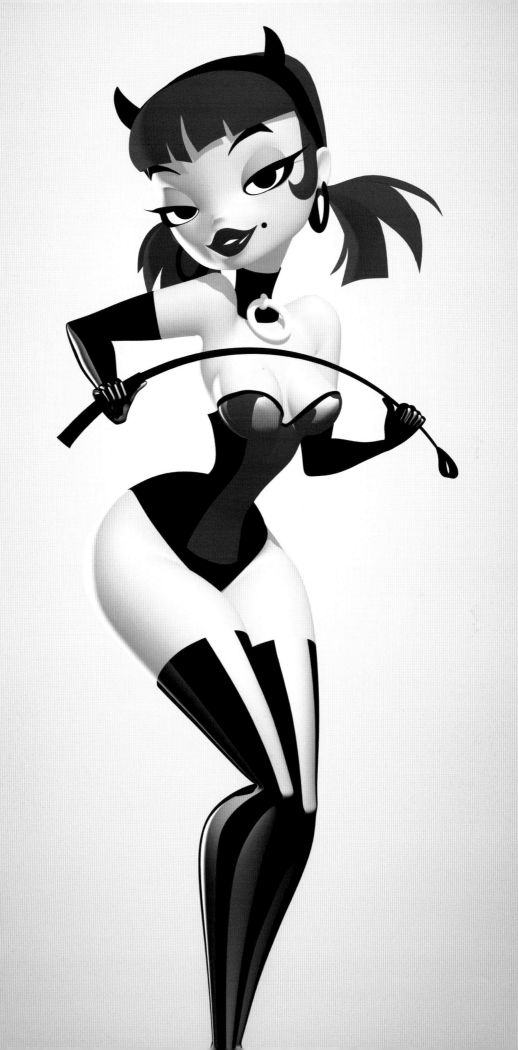

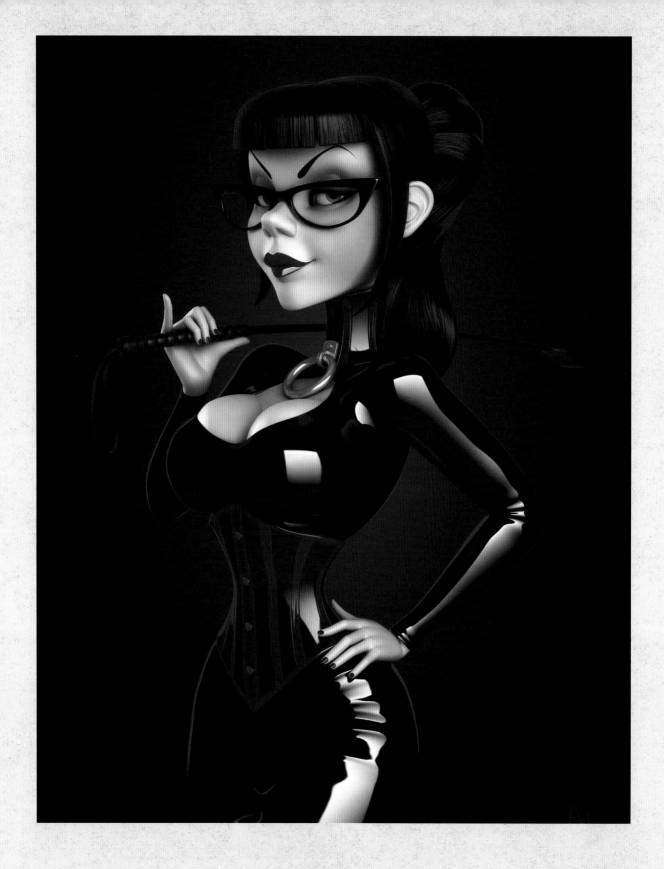

ABOVE: Maria
Andrew Hickinbottom
(based on a sketch by Serge Birault)

RIGHT: Sinister
Andrew Hickinbottom

158

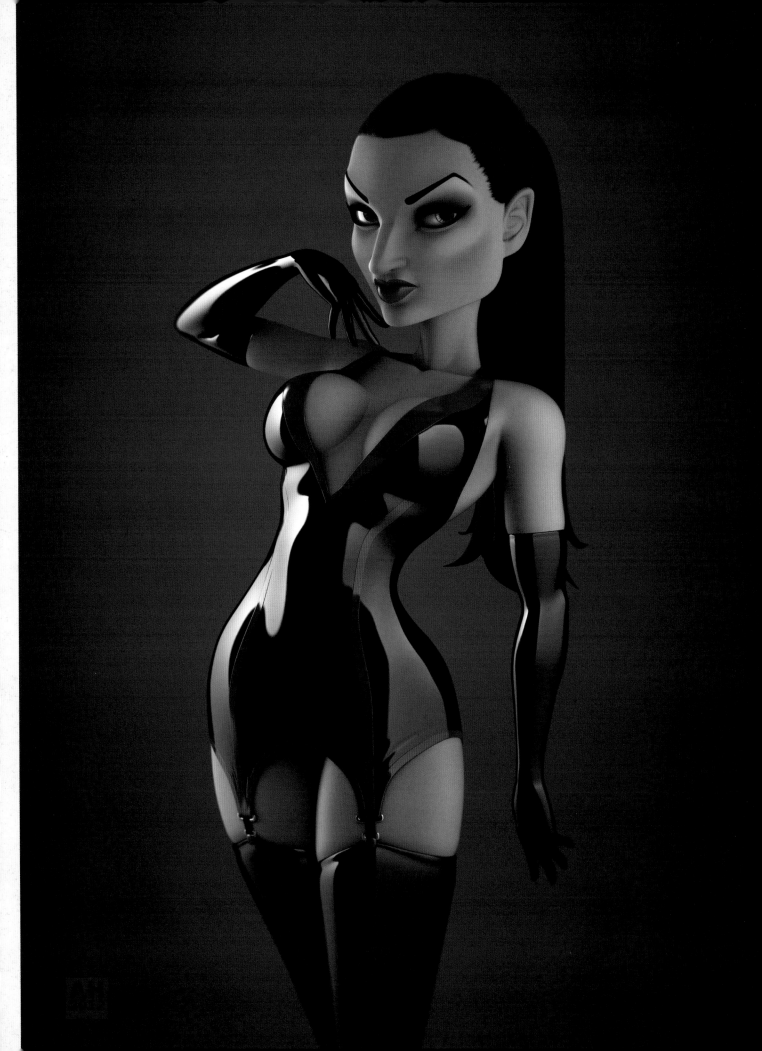

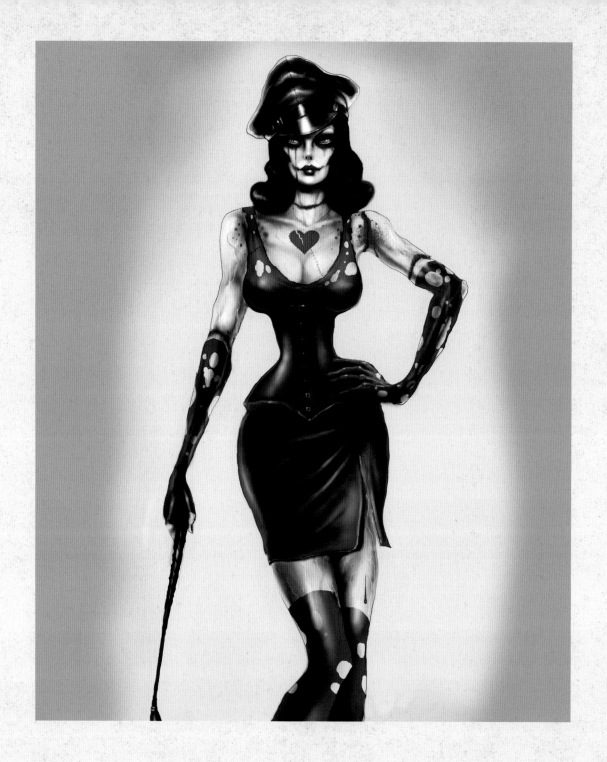

ABOVE: Madame Damned
Screaming Demons

RIGHT: Mrs Katrin Poster
David Vicente

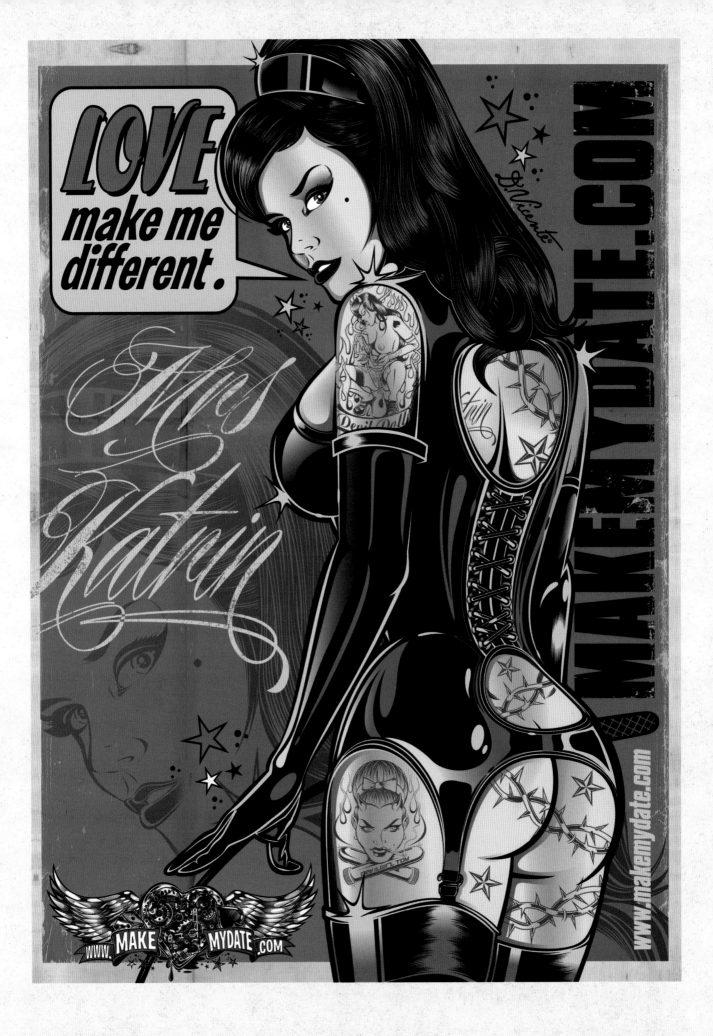

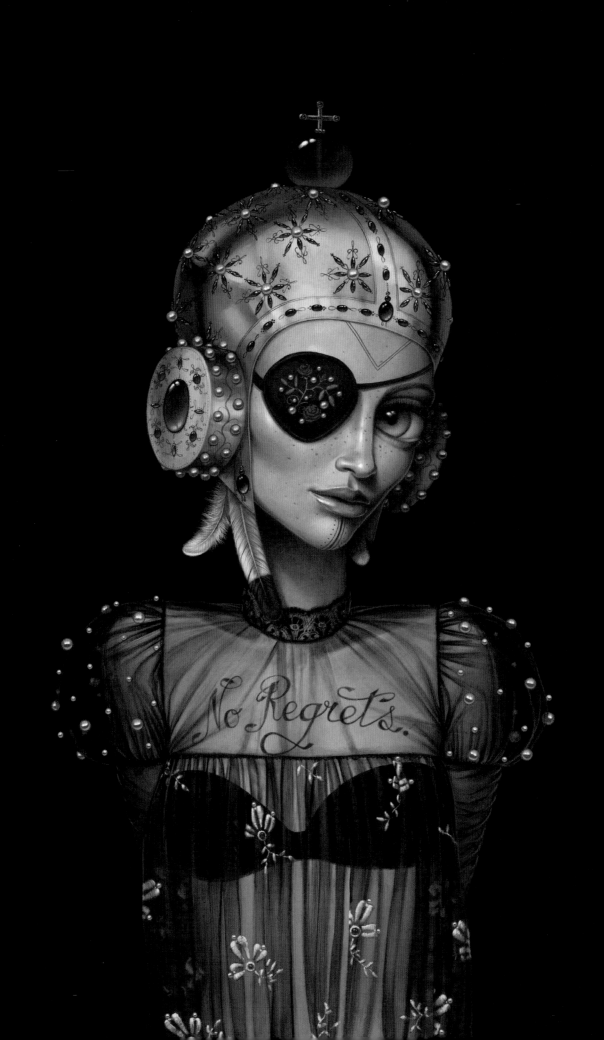

NEO-SURREAL PINUP

The neo-surreal pinup came out of a late '70s resurgence in interest in the early 20th Century Surrealists. Neo-surrealism plays with visions of dreams and the subconscious – something that can be surprisingly sexy when it comes to its pinups. The genre has snowballed in popularity in recent years, thanks to fantastic creators like Ray Caesar, Mark Ryden and Lori Earley, and a recurring motif is the neo-surrealist girl. She is an exquisite creature in a fairy-tale world – at once ethereal, beautiful and strange.

Leila Ataya, one of the leading painters in the genre today, tells us, "The extra appeal in the portrayal of neo-surreal girls I think is in their strength: they are beautiful, feminine and sexy but have a projection of very strong characters. They all want to carry across some kind of a message to the viewer through their gaze, gestures and surroundings." To look at, neo-surreal pinups are mysterious, knowing and womanly, often with piercing, disproportionately-large eyes, pale skin, full lips and sensual, slender bodies. Unique neo-surrealist Daniel Merriam believes he plays with his pinups' proportions to give them the strange appeal of dolls, and inflates their eyes to show their intelligence. Merriam says, "The neo-surreal girl twists the pinup genre. She echoes recent pinup history while hinting at the erotic and celebrating vanity. Why not make the female form the subject of yet another movement in art?"

Although a thoroughly modern pinup, the neo-surreal girl's clothing is often vintage and can hark back centuries. Neo-surreal pinups are often placed in luxurious settings, reminiscent of Madame de Pompadour or of decadent 19th Century interiors. Nature also often features – with some sort of butterfly, bird or flying panda hovering around the girl, but always ambiguously, so it's hard to pin down a precise direction or meaning. Occasionally, there is the uneasy juxtaposition of a pinup in retro underwear looking only slightly shocked and surprised at the suggestion of violence, or some kind of crime; the effect is at once unnerving and strangely alluring.

LEFT: Broken Eye
Leila Ataya

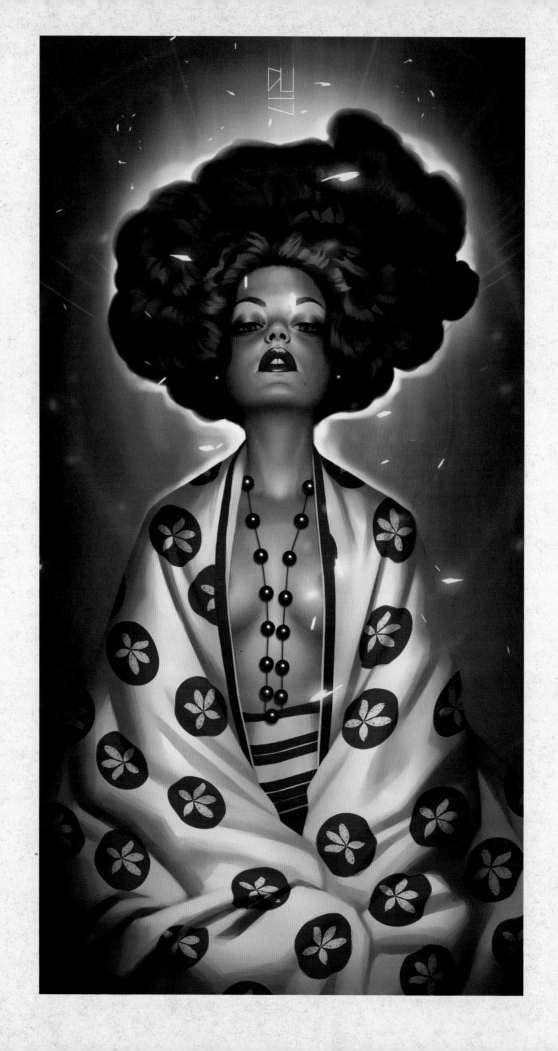

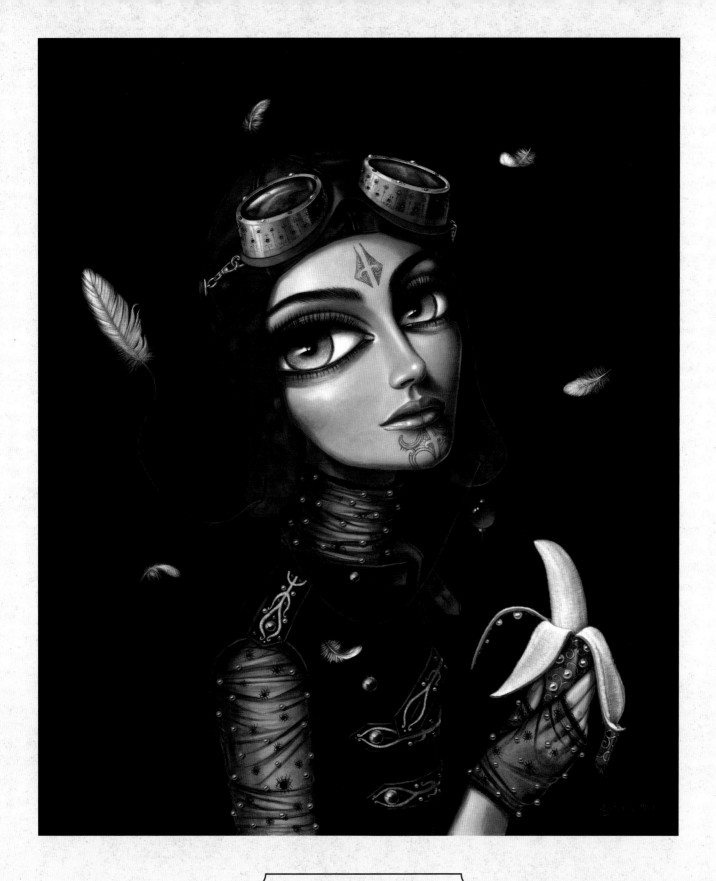

LEFT: Elsie
Daniela Uhlig
ABOVE: Eternal
Leila Ataya

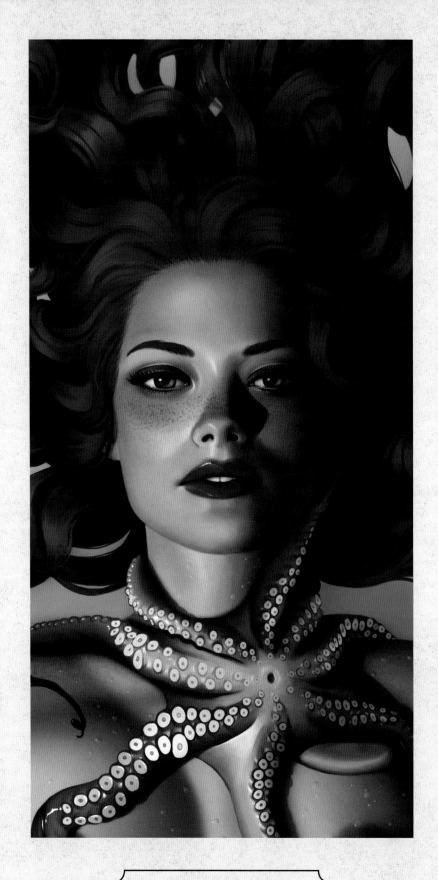

ABOVE: Octopus
Daniela Uhlig

RIGHT: The She
Leila Ataya

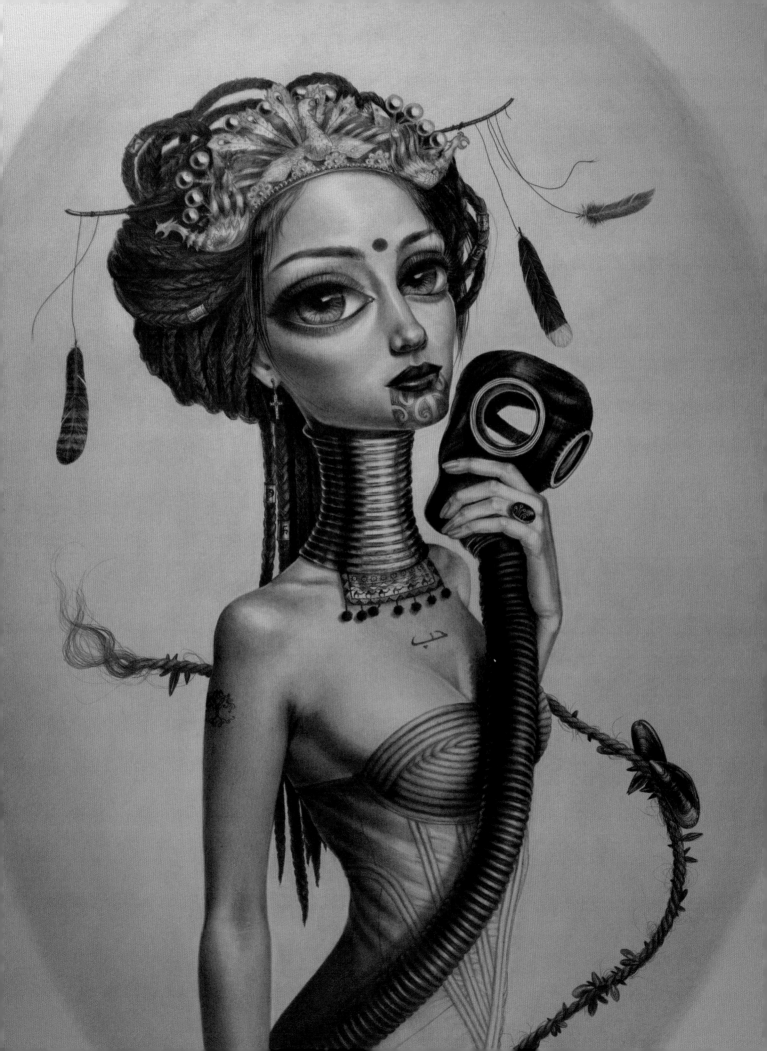

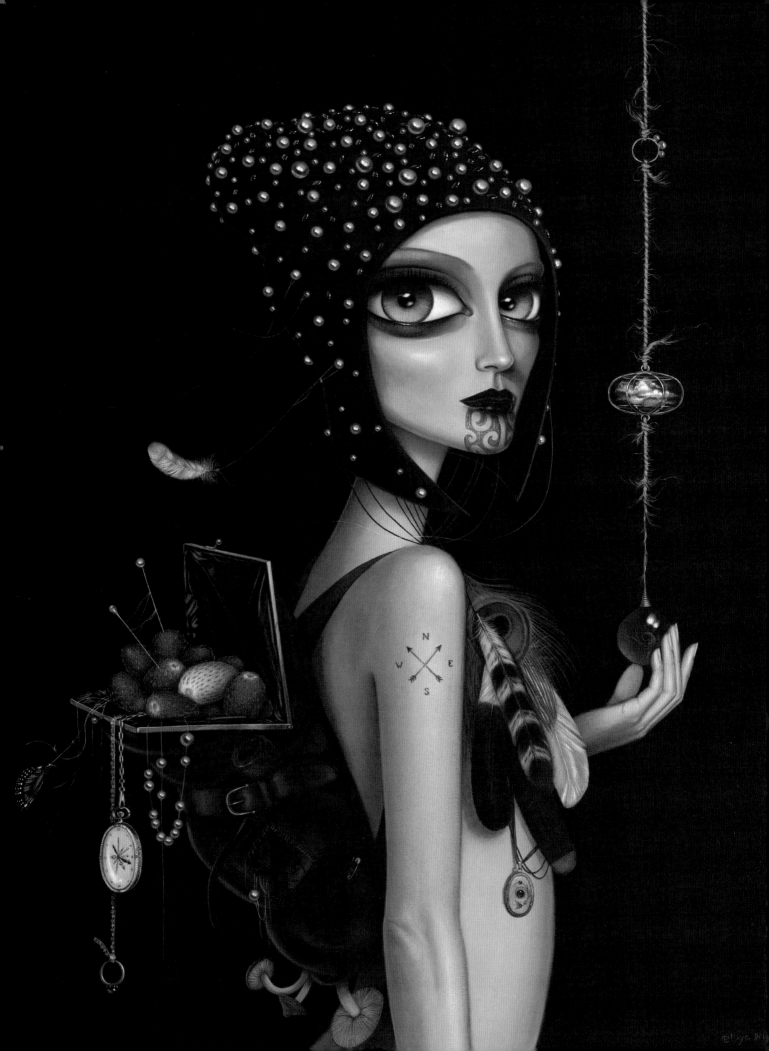

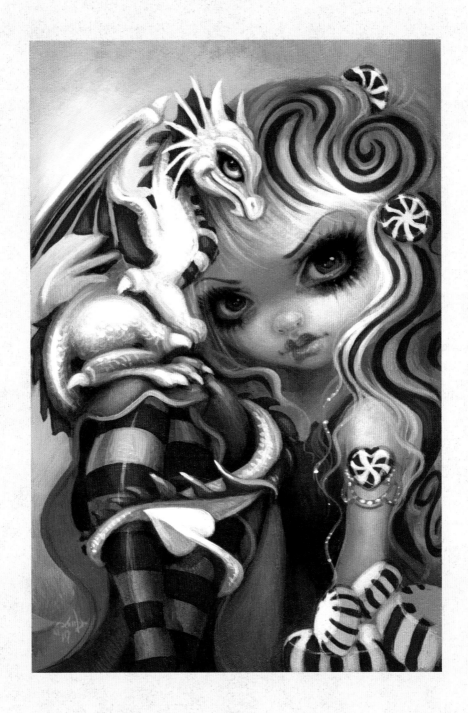

LEFT: Luggage
Leila Ataya

ABOVE: Peppermint Dragon
Jasmine Becket-Griffith

169

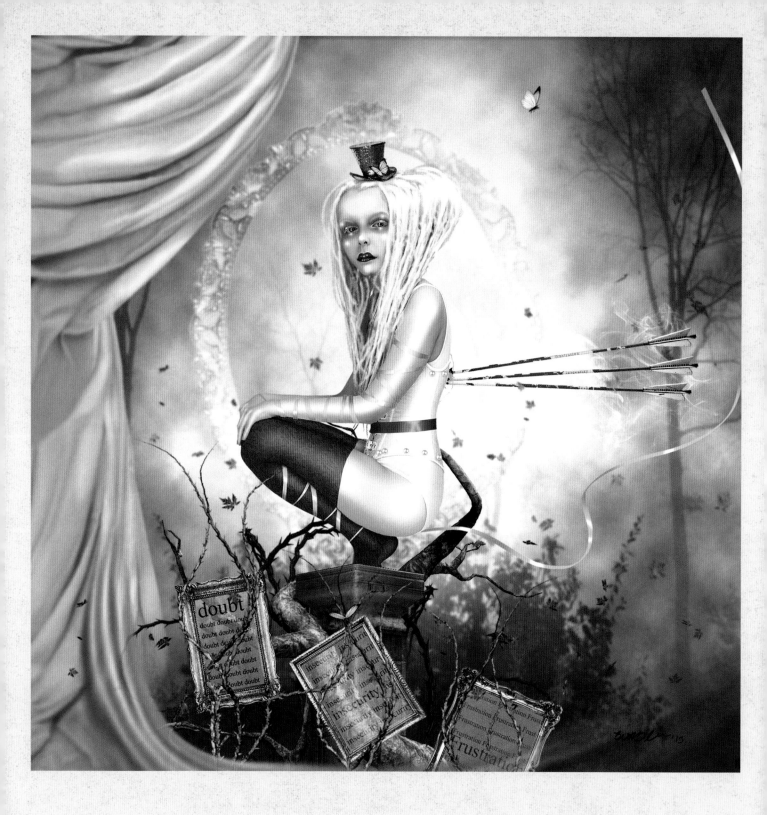

ABOVE: The Arrows
Beth Spencer

RIGHT: Delicate Material
Beth Spencer

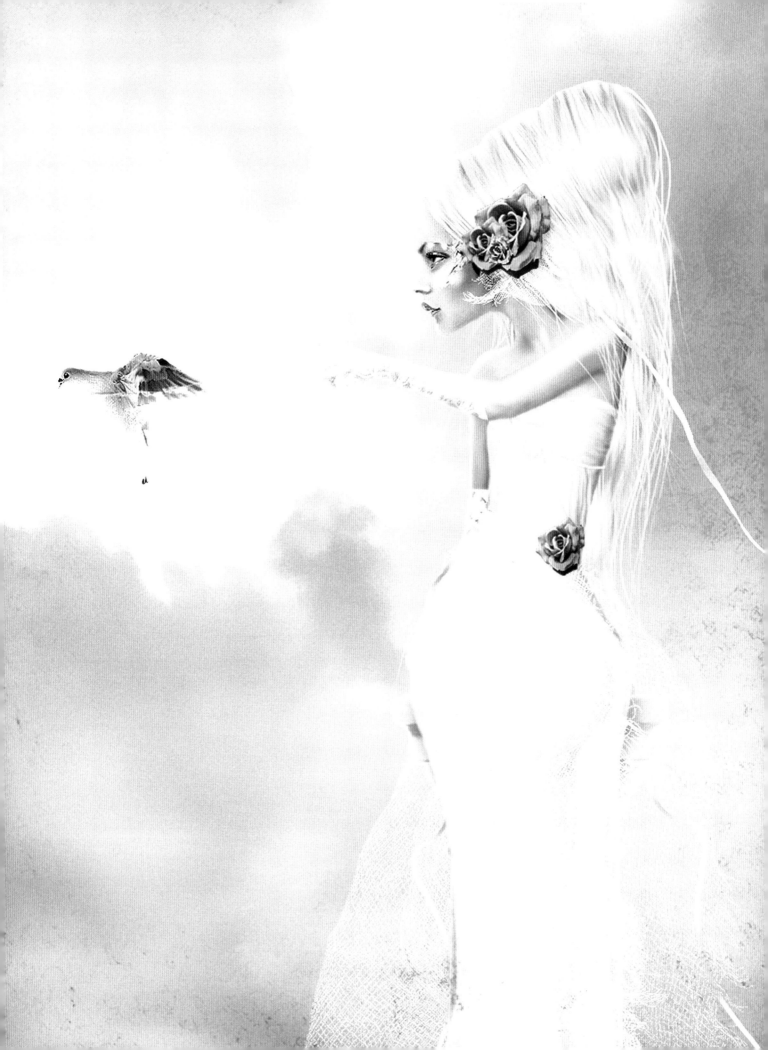

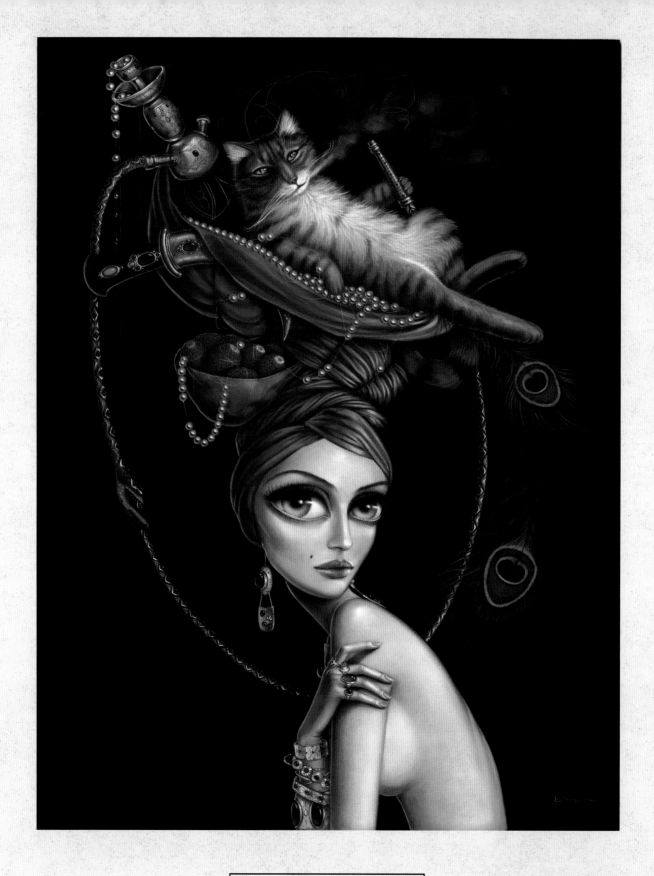

ABOVE: Pearls of Innocence
Leila Ataya

RIGHT: Centre Stage
Daniel Merriam

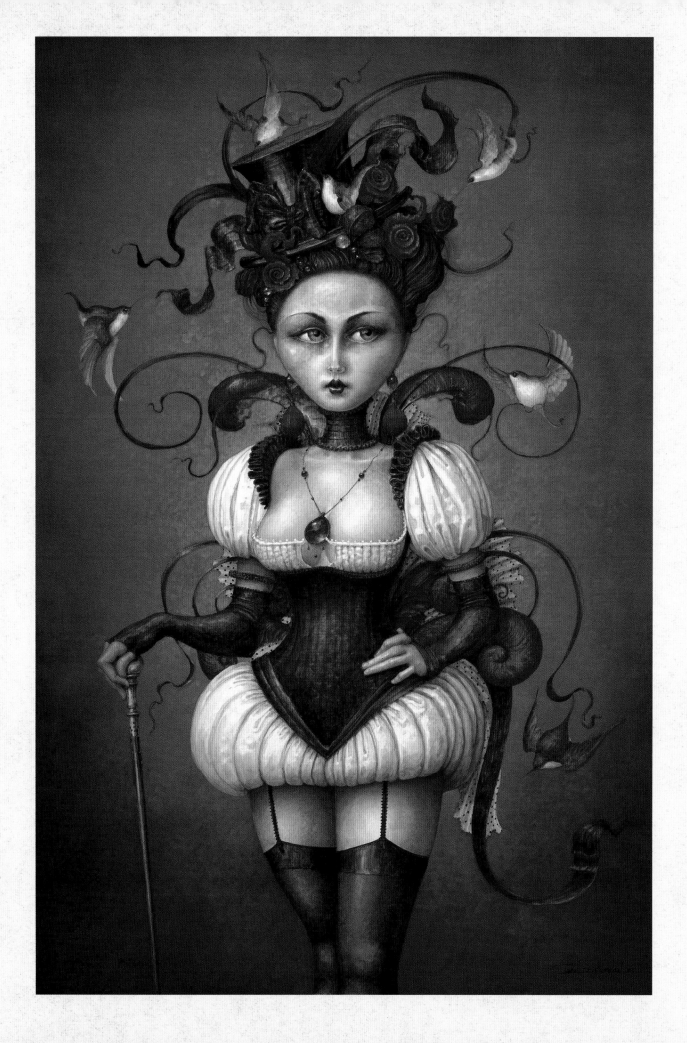

Artist Contact Details

Please contact artists directly for any futher information or to purchase artworks and prints.

All artworks are the copyright of the artists, unless indicated otherwise.

Marco Almera
Southern California, USA
www.marcoalmera.com

Anarkitty (a.k.a. Emma Geary)
London, UK
www.anarkitty.co.uk

Leila Ataya
Auckland, New Zealand
www.leilaataya.com

Valery Barykin
Moscow, Russia
www.behance.net/vaba66

Jasmine Becket-Griffith
Celebration, Florida, USA
www.strangeling.com

Syd Brak
London, UK
www.sydbrak.co.uk

Matthew Britton
Wales, UK
www.matthew-britton.com

Elias Chatzoudis
Athens, Greece
www.elias-design.gr

Matt Dixon
Nottingham, UK
www.mattdixon.co.uk

Sean Earley
Frankfurt, Germany
www.digitalgirlies.com

Damian Fulton
Southern California, USA
www.damianfultonart.com

Zach Gracia
Northern California
www.zachgracia.com

Ted Hammond
Mississauga, Ontario, Canada
www.tedhammond.com

Handiedan (a.k.a. Hanneke Treffers)
Amsterdam, The Netherlands
www.handiedan.com

Claudia Hek
Amsterdam, The Netherlands
www.claudiahek.net

Andrew Hickinbottom
London, UK
www.andrewhickinbottom.com

Mike Hoffman
Milwaukee, Wisconsin, USA
www.mikehoffman.com

Adam Isaac Jackson
Tacoma, Washington, USA
www.adamisaacjackson.com

Linda Vieweg Jackson a.k.a.
DarlinDesign
London, UK
www.freelanced.com/darlindesign

Erik Kriek
Amsterdam, The Netherlands
www.gutsmancomics.com

Michael Landefeld
Baltimore, Maryland, USA
www.facebook.com/
thepinupgirlsofmichaellandefeld

Leviathan (a.k.a. Manel LaVey)
Valencia, Spain
www.leviathan13.com

Yves-José Malgorn
Paris, France
www.ym-graphix.com

Mike Mahle
Morton, Illinois, USA
www.freelanced.com/darlindesign

Gianluca Mattia
Bari, Italy
www.gianlucamattia.com

Jan Meininghaus
Münster, Germany
www.jan-meininghaus.de

Daniel Merriam
Portland, Maine, USA
www.danielmerriam.com

Eamon O'Donoghue
Southampton, UK
www.eamonart.com

Poleta
Buenos Aires, Argentina
www.behance.net/poletas

Pinturero (a.k.a. Javier Fernández
Carrera)
La Coruña, Spain
www.pinturero.com

Guillaume Poux
Barcelona, Spain
www.elgunto.com

Nathalie Rattner
Calgary, Canada
www.nathalierattner.com

Dirk Richter
Hannover, Germany
www.diri-finearts.de

Enric Badia Romero
Barcelona, Spain
www.badiaromero.com

Screaming Demons
(a.k.a. Marcus Jones)
Bristol, UK
www.screamingdemons.co.uk

Sveta Shubina
Rostov-on-Don, Russia
www.etsy.com/shop/
SvetaShubinaGallery

Jim Silke
Woodland Hills, California, USA
www.jimsilke.com

Maly Siri
Montreal, Canada
www.malysiri.com

Beth Spencer
Virginia, USA
www.vacuumslayer.deviantart.com

Fiona Stephenson
Barnsley, South Yorkshire, UK
www.fionastephenson.com

Ben Tan
Bay Area, San Francisco, USA
www.bentanart.com

Daniela Uhlig
Berlin, Germany
www.du-artwork.de

David Vicente
Salles, France
www.dvicente-art.com

Caroline Vos
Cape Town, South Africa
www.carolinevos.com

Chris Wahl
Sydney, Australia
www.chriswahl.storenvy.com

Back cover credits

Clockwise from top left:
Marco Almera; Nathalie Rattner;
Ben Tan; Elias Chatzoudis; Leviathan.

Acknowledgements

The publisher wishes to thank all the
brilliant artists in this book; we only
wish we could have included more
of their images and insights on the
pinup scene today. Particular thanks
to David Vicente for his stunning front
cover and Nathalie Rattner for her
introduction and help with the project.
Many thanks also to Jim Silke.